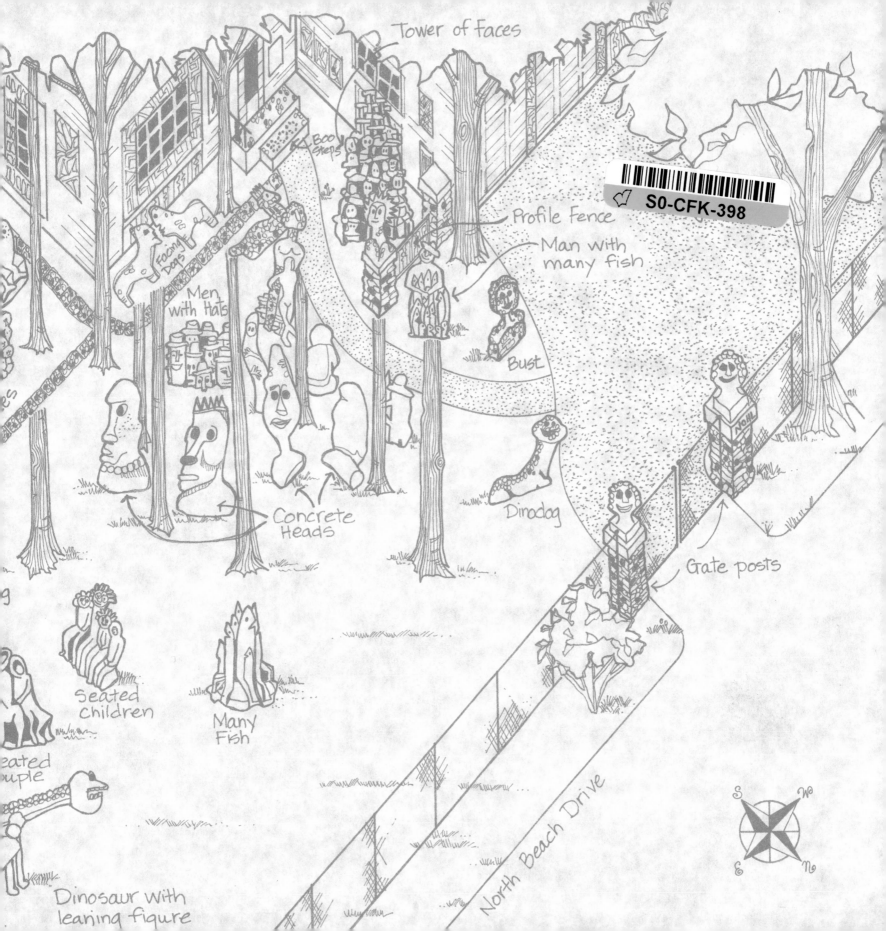

Tower of Faces

Boo steps

Profile Fence

Man with many fish

Facing Dogs

Men with Hats

Bust

Concrete Heads

Dinodog

Gate posts

NoHL

Seated Children

Many Fish

eated ouple

Dinosaur with leaning figure

North Beach Drive

Mary Nohl
Inside & Outside

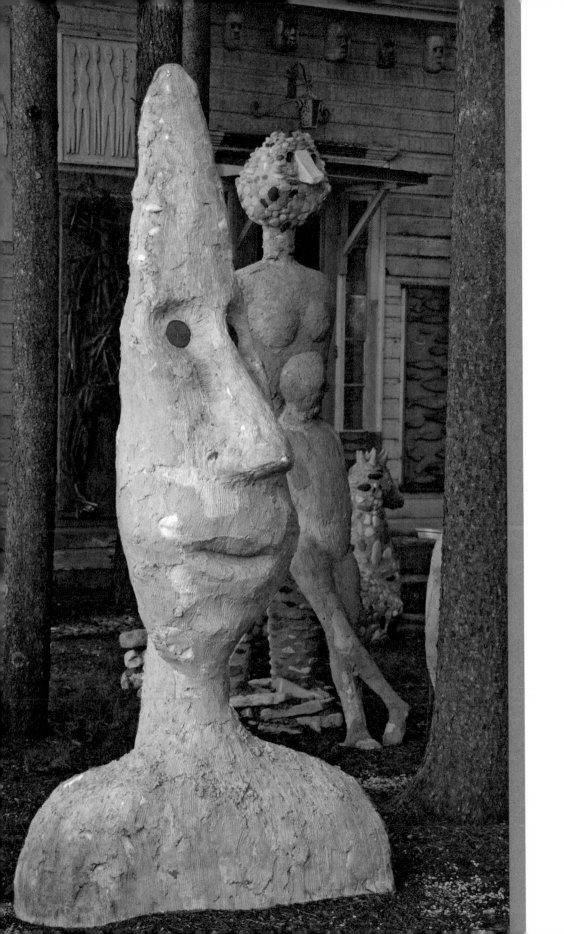

Mary Nohl
Inside & Outside

Biography of the Artist

Barbara Manger and Janine Smith

Published by the Greater Milwaukee Foundation.

Copyright © 2008 by the Greater Milwaukee Foundation. All rights reserved.

Printed by Berlin Industries, Carol Stream, Illinois.

Distributed by University of Wisconsin Press

Library of Congress Cataloging-in-Publication Data available.

No part of this book may be reproduced in any form without written permission from the publisher.

ISBN: 978-0-615-25118-9

Cover and book design by Janine Smith.

Cover photograph by Eric Oxendorf.

Dedicated to

The creative spirit of
Matthew Manger-Lynch
and to Bruce for his
unending support.

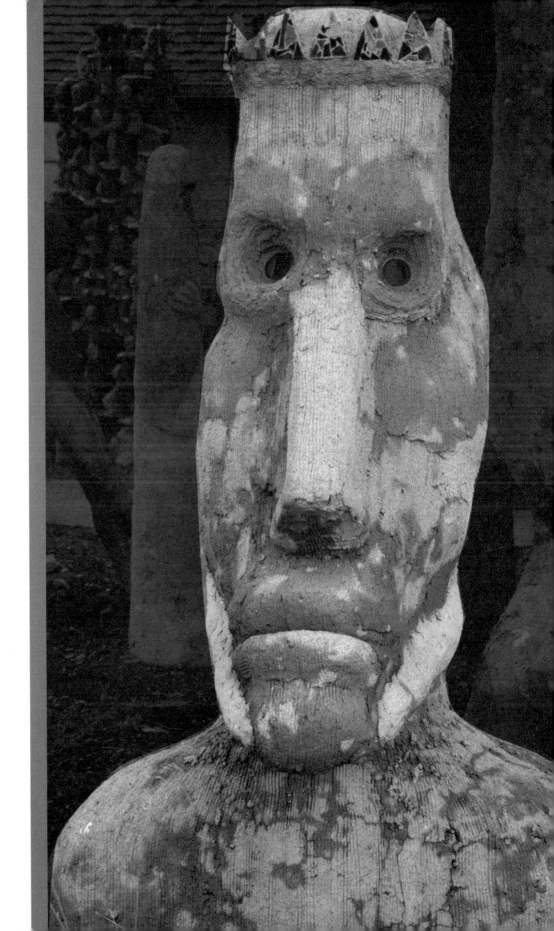

ACKNOWLEDGMENTS

With gratitude to:

The Greater Milwaukee Foundation whose support and interest in Mary Nohl's life made possible this publication.

Jim Marks of the Greater Milwaukee Foundation for his enthusiasm and support.

The Kohler Foundation, Inc. and the John Michael Kohler Arts Center for the generous use of and access to the Mary Nohl Archive and photographs.

Terri Yoho, Stephanie Hamilton, and Nancy Moulton for assistance, information, and tolerance.

Leslie Umberger, Jane Bianco, and Ruth deYoung Kohler for assistance.

Rosalind Couture, John Willetts, Vicki Preslan, and Sally Mollomo for insights about Mary.

Marcia Coles, Mary Kamps, Sierra Nimtz, Lucy Jelinek Hays, and Jenny Jackson for their generous proofreading.

Eleanor Crandall for her editing.

Kurt Chandler, editor, for his insights, sensitivity, and encouragement.

Carolyn Kott Washburne, copy editor, for her perceptive mind and eagle eye.

Dave Henderleiter for his design expertise.

Karey Servis for her detailed site plan of the property and her enthusiasm.

Ron Byers, Scott Dietrich, John Michael Kohler Arts Center, Barbara Manger, Eric Oxendorf, Vicki Preslan, and Janine Smith for their photographs.

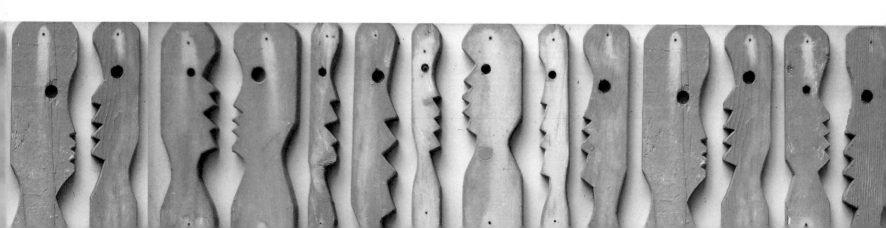

CONTENTS

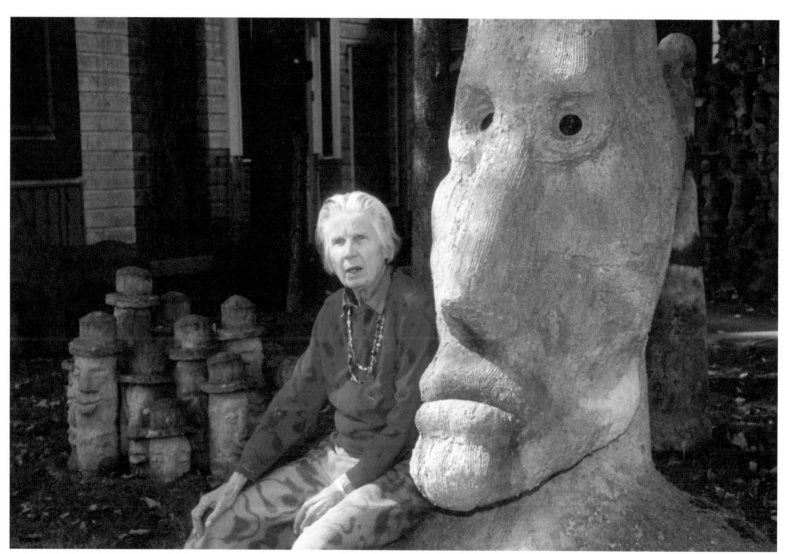

Mary, 1994.

Introduction

Creator of a Unique Environment

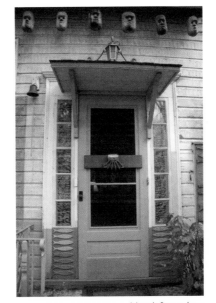

Mary's front door.

My first visit with Mary Nohl was much the same as my last. In the fall of 1989, a friend invited me to meet the artist known as "the witch." I saw for the first time Mary Nohl's haunting, fantastic environment on Lake Michigan in the affluent Milwaukee suburb of Fox Point. In marked contrast to the manicured lawns and well-maintained houses along Beach Drive, Mary's yard was bordered with a chain-link fence topped with barbed wire coils. Fanciful concrete sculptures surrounded a modest house adorned with wooden fish and animals. As my friend and I walked closer, I saw carved wooden heads swinging from the eaves and white wooden profiles hanging from the trees, and I could hear the gentle tinkling of wind chimes overhead.

After banging on the door with the hand-made door knocker, my friend and I heard the unbolting of heavy locks. The door swung open, Mary appeared, and in her gangly way she motioned us inside.

At 75, Mary was tall, angular, and spry, with a great wit. She was friendly, astute, and observant. I liked her immediately. She wore a red sweatshirt decorated with black paint swirls and lime green bell-bottoms. She graciously guided us through her house, proud to show her life's work. She offered droll comments on the brief tour. For example, she pointed out the heavy wooden locks, painted red, that she had made for the front and side doors, saying, "Nobody can get in here unless I let them in."

"Those heads rolled up on the beach," Mary said, referring to the carved driftwood sculptures arranged on the mantel." Indicating the paintings that filled the stairway wall, she said, "I have hundreds more of these."

She then led us outside into the autumn sun where we ambled among the concrete sculptures. I gaped and grinned throughout the tour, astounded and aware that there was more here than I could take in. Near the front door, a huge concrete head with blue reflector eyes and wearing a colored glass-chip crown was flanked by other gigantic heads. A craggy figure, over eight feet tall, made entirely of sticks painted white and bound with scraps of barbed wire stood ominously near the fence. Every corner of the yard was occupied with sculptures, and nearly every inch of the home's exterior walls was adorned with cut-out animal shapes or beach-pebble mosaics.

When we returned to her house, Mary sat with her back to the window, allowing her guests an expansive view of Lake Michigan beyond the sculpture silhouettes in the yard. We chatted, her low, pebble-topped coffee table between us. While it was difficult to take my eyes off the lake, I was equally drawn to the wonders surrounding us. Brightly painted antique chairs, suspended wire figures, carved wooden heads, and dangling mobiles filled the room. I tried to keep my mind on the conversation while I took in the surroundings.

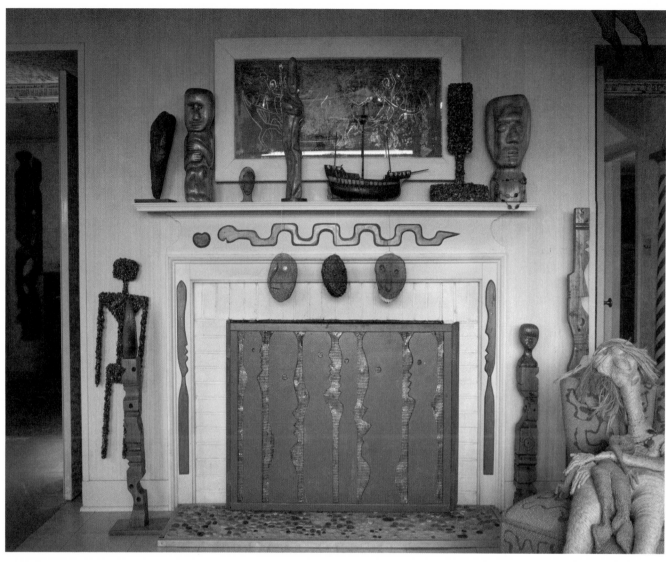

Mantel, c. 1960-1998.

I made many visits after this. Most often we simply chatted. The environment and house began to feel more familiar and comfortable. Each visit was essentially the same. Mary would usually ask me a few questions and then would tell me about her most recent projects, materials she was using, and a problem or two she was mulling over. She sometimes asked my opinion concerning the future of her property; other times we discussed less important matters such as the high cost of paints and brushes.

She usually brought up a story from the past, frequently punctuating her side of the conversation with the comment, "I wonder what mother would think." After an hour or so, it would seem like the time to leave, and I would. On occasion we went on outings together–a hike in the woods, a trip to some galleries or to my art studio, which she asked to see. She was a bright and insightful companion.

In my position as art gallery director at the local Cardinal Stritch College (now Cardinal Stritch University), I invited Mary to exhibit. She agreed, and in the course of planning the show, a retrospective of sorts, I came to know and appreciate her as the completely committed

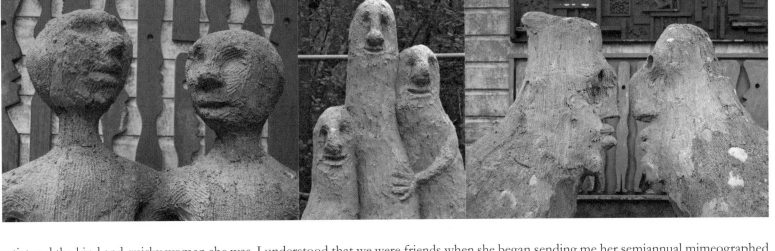

artist and the kind and quirky woman she was. I understood that we were friends when she began sending me her semiannual mimeographed letters–her way of staying in touch with friends near and far.

Mary was authentic, fresh, and refreshing. She cared little for material things, except for what she created. She was also an eccentric, possessed with saving everything, spending as little as possible even though she was a wealthy woman. She devoted most of her life to creating. I once called her "a true eccentric" in a filmed interview about her. After watching the interview, she looked up the word "eccentric" and called to say that she didn't like this label since eccentric meant "off of center." When I tried to explain that I meant she was unique, truly one of a kind, she would hear none of it. She abruptly stopped speaking to me. More than a year later, she happened to read something I had written for a Milwaukee newspaper and called to ask why she hadn't seen me for such a long time. Had she forgotten she was not speaking to me? Just as suddenly I came back into her good graces.

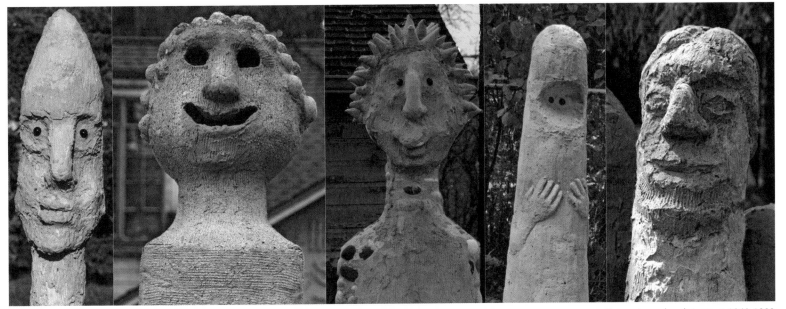

Concrete yard sculptures , c. 1960-1998.

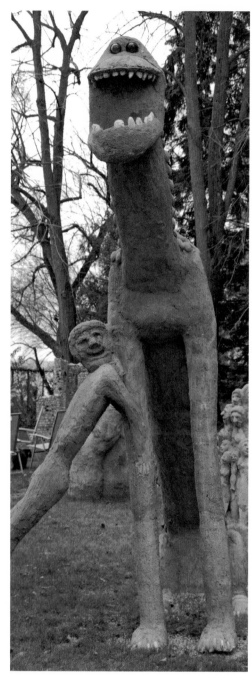

Dinosaur and leaning figure, c.1968-1998.

Michael Danoff, former curator at the Milwaukee Art Center (now the Milwaukee Art Museum) called Mary a "sophisticated naïve" in the February 1975 issue of *Midwest Art*. Although Mary was highly educated, Danoff asserted, she appeared to ignore her classical training in art and worked from her pure creative self in a personal style, free of desire to be part of mainstream art. Again she checked her dictionary and firmly asserted that she disliked being described as naïve, that it meant "simple" or "ignorant." Mary obviously did not like labels, although the label "witch," given to her by local school children, she absorbed with good humor.

She thought of herself as an artist, and her art does spring from her pure, creative self. Respecting her view, this biography considers Mary as an artist, disregarding whatever may be the current descriptors for artists who create total environments such as hers–environmental naïve artist, art environment builder, vernacular artist, outsider artist–all of which she has been labeled. She defied the assumptions of these terms and refused categorization, expectations, and boundaries in her art and in all aspects of her life. She claimed no influences on her work. She did not like art history and wasn't interested in reading it.

Mary was highly educated, well read and informed, independently wealthy, and, during some parts of her life, quite sociable. She worked free of any desire to show her art in galleries or museums, although she did exhibit several times. She simply was driven to make art. She devoted most of her waking hours to it. One of the very few comments she ever made about the meaning of her art was "it gives me identification."

On my last visit with Mary in late September 2000, when she was eighty-seven, I was accompanied by Janine Smith, this book's skilled designer, researcher, and collaborator. The three of us were joined by Mary's caregiver, Vicky Preslan, who offered us instant coffee, a gesture Mary had never made, and we chatted. Mary was thin and appeared tired. Her red sweatshirt and bell bottoms fit loosely around her, and her carved stone necklace seemed too heavy for her lean frame. But her acerbic wit was intact. When we proposed the idea of writing a book about her life, her eyes brightened. She smiled, asked if it would be a positive book, and, not waiting for a reply, said, "Yes, I think it is a good idea." Vicky piped up with, "Now is the time!"

Then Mary leaned over in her chair to pick up a brown envelope. "There are one hundred drawings in here," she said. "Have I showed you? There is a stack of them upstairs, one hundred in each envelope." She pulled out a few and showed the drawings to Janine and me. One was much like the next, created with marking pens in flowing, repetitive, concentric lines. Some combined marker with pastel rubbed in with her fingers. She explained that she drew most of them while sitting on her bed upstairs in her room. "Easier to work there," she explained, since she tired easily. "I don't know what's been the matter with me. I still get out on my walks though, with Vicky."

Mary died several months later. Fortunately, through the efforts of the Kohler Foundation in Kohler, Wisconsin, her work will survive her lifetime. The foundation supports education, arts, and preservation initiatives, primarily in Wisconsin. By bequeathing her property to the foundation and to the John

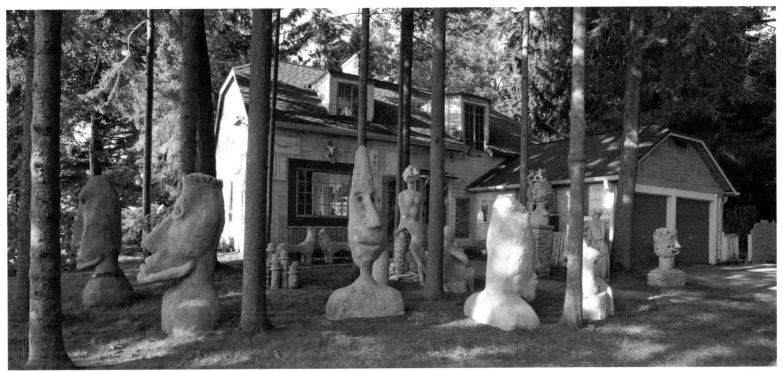

House and yard, 2008.

Michael Kohler Arts Center in Sheboygan, Wisconsin, Mary was able to ensure that her house and surrounding yard and various works would be cared for and preserved for the future.

As the foundation preserved Mary's work, we also wish to preserve the life story of the creator of a unique environment. Mary Nohl left an extensive record of her life, not only in her house and yard, but in her diaries and letters. The Kohler Foundation graciously made available a bounty of material, including her diaries, which provide a steady stream of information concerning the activities, daily schedules, plans, and encounters of her life up to five years before her death. Additionally, photo albums, scrapbooks, trip journals, and sketchbooks create a complete encyclopedia of facts about her life and her family. Janine Smith and I spent several years delving into the Mary Nohl archives and reading her diaries with a magnifying glass. My own conversations with Mary beginning in 1989 also provided information for this book.

On Mary's extensive travels she was attracted to ruins and captivated by stories of the past. In 1975, after a raft trip in the Grand Canyon, she visited Canyon de Chelly in Arizona, where she was fascinated by the 1,700-year-old cliff dwellings of the Anasazi Indians. The haunting remains of their civilization stand as testimony to the impermanence of our lives. Like most visitors to this site Mary probably asked, "Who were they? What happened here? How did they build this?" Similar questions are often asked about the site that she created.

It is my hope, and that of Janine Smith, that the story of Mary Nohl's life will offer insight about a complex woman and gifted artist whose creative life was intertwined with her home and its place on Lake Michigan. Her magical environment stands not only as a memorial to her individual artistic achievement, but also as a monument to the creative spirit.

Barbara Manger
Milwaukee, Wisconsin
January 2009

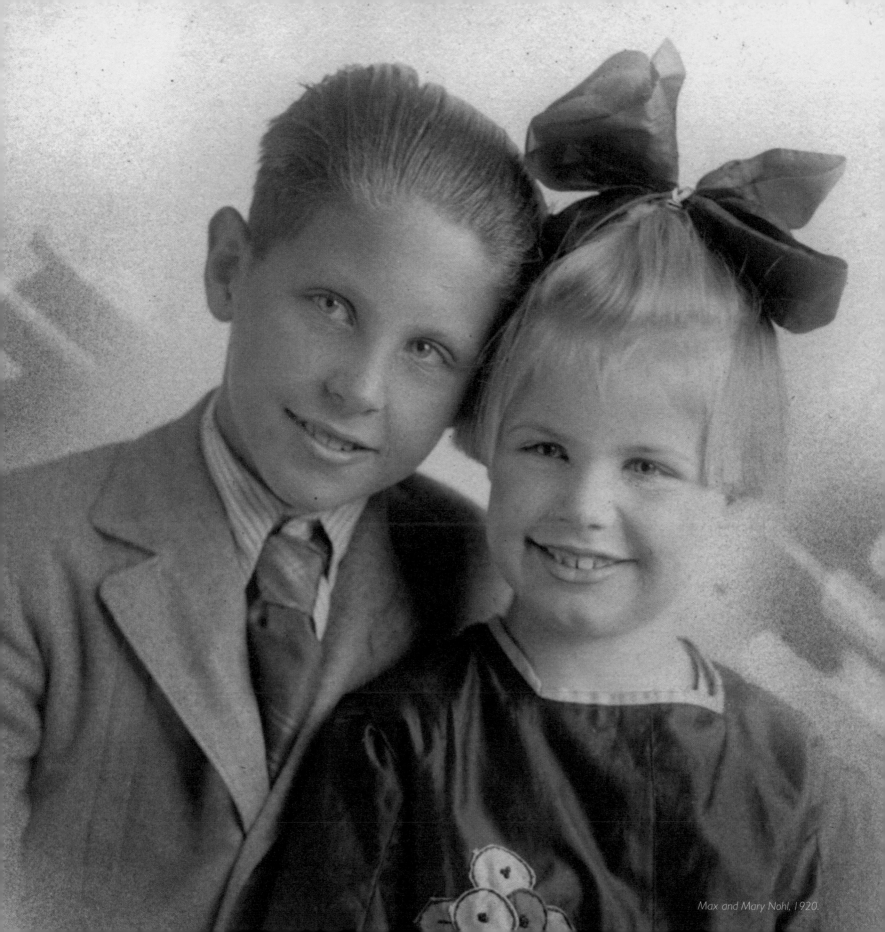

Max and Mary Nohl, 1920.

1

Childhood: Becoming Mary

"I like to read. I like to eat. I like to play."

An exuberant and determined child was born to parents Leo and Emma Nohl on September 6, 1914. Her energetic spirit brightened the family. Leo, a successful lawyer, and Emma Ely Parmenter, an aspiring singer, named their baby Mary Louise. They welcomed her to their family with love—as they had welcomed her older brother, Eugene Maximilian (called Max), four years earlier—and with every opportunity and privilege available in Milwaukee, Wisconsin, early in the new century.

Drawing, c.1918.

Leo Friedrich Nohl, a descendant of two old German families, grew up speaking German in Ripon, Wisconsin. After graduating from Marquette University Law School, he entered practice with his brother, Maximilian. He was a perfectionist, "stern, brilliant, penny pinching and exacting . . . the tall thin frail type who cannot depart far from the daily schedule," according to his son Max's unpublished 1933 autobiography. Leo was highly respected, not only for his "exacting and fine work" as a lawyer, but also for his community activities. He expressed his gregarious and outgoing personality in public through the International Optimists, the Masons, and the Red Cross. His ongoing commitment to these Milwaukee organizations, and his role as an accomplished and entertaining speaker, required numerous meetings,

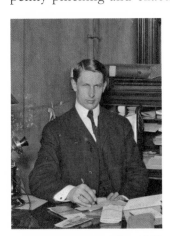
Leo Nohl in his law office, 1905.

dinners, and social occasions that frequently took him away from home and family.

Leo had feared yet respected his father and grandfather and vowed to bring up his own children as he had been raised. As Max wrote in his unpublished essay "Sketch of My Father," Leo was the "unquestioned ruler of the house" and "placed discipline higher than affection." He had a "passion for discipline and orderliness and orderly regulation of every detail of his and everyone else's life. Father was furious if things on his work bench were not perfectly neat. . . . Neatness had unquestioned priority. . . . At his law firm, he probably has lost many 1000's of dollars of income in the time he has spent salvaging discarded pieces of string, and tying them up in neat little coils." He diluted the ink used by the office workers, one part water to one part ink. "At the house he will save the sorriest pieces of junk that could not conceivably be of any use to anyone—but always very exactingly sorted out and placed on neat shelves," Max noted. "He wore ten cent store socks and ties—but made enough money to live luxuriously."

Emma, musically gifted and ethereal, had been raised in Menominee, Michigan, in a prominent, cultured family that ran a profitable lumber business. She graduated first in the

Emma Nohl, c.1900.

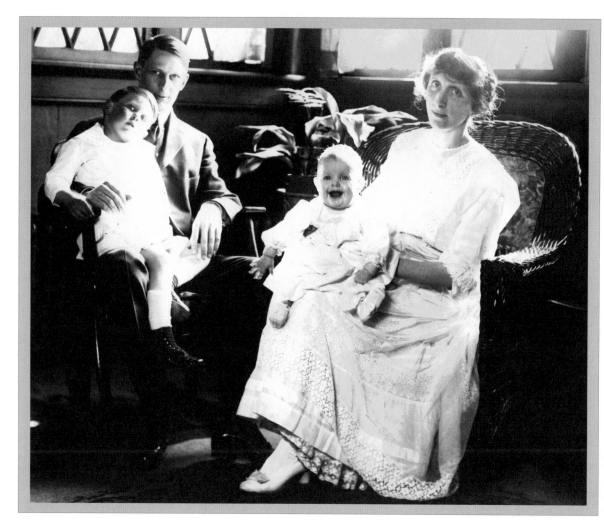

Leo, Max, Mary, and Emma, 1914.
Opposite page:
Mary and Max, 1918.
Stowell Avenue home, 1920.
Mary, c. 1925.

class of 1894 at Ferry Hall Seminary in Lake Forest, Illinois, a boarding school for daughters of the Midwestern social elite, and earned her bachelor's degree at Lake Forest University (now Lake Forest College). Before her marriage to Leo, Emma was known for her superb contralto voice and performed in solo voice concerts in churches and community venues. She also taught music in an orphanage for the children of soldiers and sailors in Cincinnati.

While Max and Mary were certainly loved, they were expected to be seen and not heard. It is likely that displays of affection were rare in this Germanic household. The contrast of personalities and parenting styles was evident. Leo was stern, Emma gentle. "My parents have always been above their emotions," noted Max. "In the

Nohl house we don't express our feelings. There have never been any outbursts of temper, tears, great happiness or anything else."

Before the birth of Max and Mary, a first child had been born to Emma and Leo, in 1908. But the life of Frederick Ely Nohl was cut short. While swinging in an infant seat, Frederick was impaled by the spring coil suspending his chair, and died at the age of nine months. Emma never fully recovered from the tragedy and lived most of her life withdrawn from the world. In his 1946 "Sketch of My Mother," Max wrote: "My father always maintained that although she had been a delicate type of girl, her nervousness and digestive disturbances and general neurotic symptoms . . . dated from this incident. Except for a small picture of him and a yearly visit to the cemetery, his name has almost never been spoken in the house."

As Max reflected, "Mother didn't fare well in social situations." She was so frail and anxious that she usually did not accompany Leo to his social and speaking events. Yet Emma influenced Mary in quiet ways, doing her best to raise her as a proper young lady, instructing Mary in correct manners and deportment. Emma's greatest gift to her daughter was sharing her love of music. Mary half-heartedly began piano lessons when she was twelve. "When I was in grade school Mother gave me nickels for every symphony I heard on the radio, and wrote . . . the name of the composition and composer," Mary noted later in life. "I remember my early experience in trying to make some sense out of what sounded just like a jumble of miscellaneous unorganized sound. These early confusions were probably Beethoven and Tchaikovsky Fifths. It was only after hearing them many times that the marvelous complexities evolved into beautiful patterns." These patterns enriched Mary's life, and her love of classical music lasted throughout her lifetime.

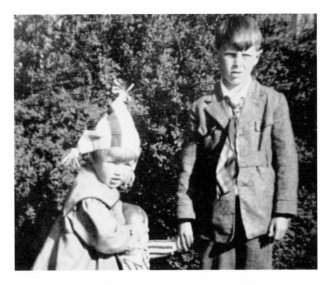

Frugal living was another lifetime practice that Mary learned from her family. The Nohls, although successful and prosperous, were parsimonious to the extreme, saving and reusing everything possible. Mary learned well their thrifty ways. They guided her lifestyle.

Cooking was done on a hot plate. There was never a real stove, nor did the family ever use the heirloom family silver. Emma kept close watch on the pantry, carefully marking the level in the jelly jars and counting the pieces of fruit. "Evening dinner was always a formal meal," Max wrote. "Emma was stingy with food" and would strictly mete out the portions. "For dessert, there would be four cookies on a plate if there were four of us at the table—never a plate of them and 'help yourself.'" While they ate, Leo would reprimand the children for their indiscretions in manners or speech. He carefully listened to Emma's report on the children's behavior and determined what disciplinary action was deserved. "We keep nothing from each other," Emma said. "It happened and he must know about it."

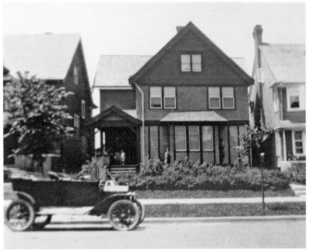

The Nohls employed young women to help with housework. Minnie, hired for summer work, complained in letters to Leo that she had to bring her own coffee to work, that a salary of seven cents an hour and lunch of half a boiled egg and half a wiener were not sufficient for a whole day of hard work. She begged him to please pay her two dollars more a week, noting that her husband was on strike and pointing out that some households were paying ten dollars a week. A subsequent letter pleaded that even fifty cents more a week would

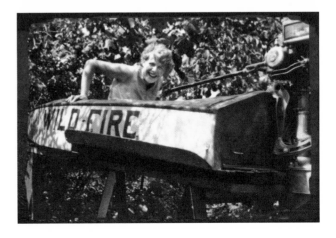

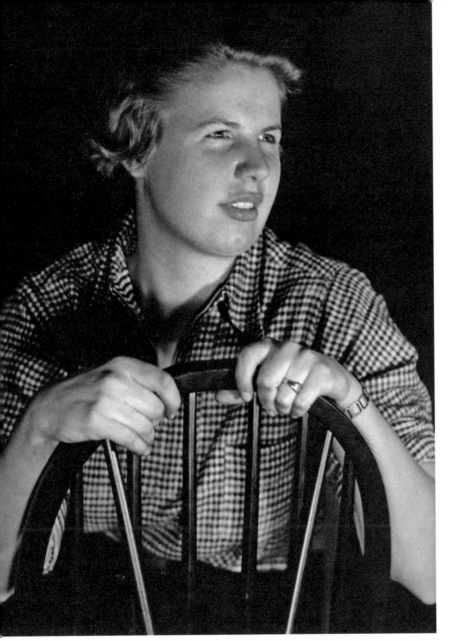

Mary, 1928
Opposite page:
Her Best Beloved Home, c. 1920; pencil.
Bottom: Mary's collection of cigar bands, c. 1920.

be acceptable. But her pleas were to no avail, and Minnie left her job with the Nohl family.

When Mary completed kindergarten, the family moved from their flat on the west side of Milwaukee to a larger flat on 29th Street, and then to the city's more affluent East Side, a house at 773 Stowell Avenue (now 3017 North Stowell Avenue). The substantial homes and ample yards of their new neighborhood provided endless possibilities for exploration and adventure.

Max described his childhood as plagued by "distress, constant fatigue, nervousness and extreme sensitivity to everything." He had a delicate stomach and indigestion, but claimed that he was always hungry. His worried mother, having lost her first child, was overly protective of him. Later in life, Max would attribute both his psychological and physical problems to family tensions and to his severe upbringing.

Mary, by contrast, was energetic, happy, and carefree; her childhood was full of delights and discoveries. She and her pals were free to roam the neighborhood by vaulting the hedges and fences in the backyards—"more fun than walking on the sidewalk." They climbed trees for strategic views of their territory. Mary loved biking and the speed of roller skating, which she accelerated by holding a sail while her Airedale, Jack, pulled her on a rope. When Jack spotted another dog, Mary would get yanked off course. "I dreamed of harnessing the power of the wind," she recalled in an autobiography she wrote for a writing class. "I wanted to make a kite that would lift me. I had in mind sort of a swing-like seat to sit on but it never worked out that way." She also repeatedly jumped off the porch railing holding an umbrella high in the air, but never achieved flight.

Beneath the front porch of her parents' comfortable home, nine-year-old Mary fashioned a secret meeting place with her new neighborhood friends, Helen, Charlotte, Georgia, Sonny, Walter, and Jane. They inaugurated the "Under the Porch Club" by decorating the foundation walls with crayon drawings. In their hidden space, they wrote notes and sealed them in glass bottles with melted crayon wax.

"We always had more bottles than secrets," she wrote. "I suppose some of the bottles still lie undisturbed. Those bottles that were found must have been quite a puzzle to the finder." The club

members plotted mischievous attacks on enemy camps and waged their spirited but harmless battles with hand-carved swords, lances, and garbage pail covers for shields. Years later, for a possible children's book, Mary illustrated the pranks they devised to outsmart their neighborhood enemies.

In a short story, "My Best Beloved Home," written in a creative writing class that she took in the 1950s, Mary described other shelters they created. In winter, they made snow houses. They would "curl up inside and speculate on the comfort of the Eskimo until they couldn't stand it any longer." In an open field near Mary's elementary school, Hartford Avenue School, the neighborhood kids dug subterranean forts, roofing and concealing them with boards covered with earth and grass. They illuminated the interior with kerosene lamps, "borrowed" from the City of Milwaukee Street Department, and peered at the world outside through handmade periscopes.

HER BEST BELOVED HOME

Mary and neighbor friend, Wally, constructed my "best beloved home": a piano box inverted on two-by-four stilts and boarded on the bottom with lumber scraps. They designed a main lounging room, entered through a small reception area, and devised a little oil-burning furnace from a five-gallon can. Occasionally it overheated and ignited the wallpaper—newspaper comic pages. She and Wally would spend hours just sitting cozily, ". . . happy within their own construction."

Wandering the neighborhood in search of cast-off materials was a favorite pastime for Mary, Wally, and their friends. After the holidays, the children gathered discarded Christmas trees for huts and forts. Mary had a perceptive eye for junk and was always on the lookout for useful items. Before she received an allowance for such things, she discovered in the dump a burned-out light bulb that she presented to her mother as a birthday gift. "I think she always liked it better than any other subsequent presents of the store variety," Mary remembered.

Mary considered paper cigar bands great treasures. They would show up "among the rotting leaves at street corners. When they were in reasonable condition the colors were usually a bright red and gold. I catalogued them alphabetically in an orderly manner." Mary made her quest for castoffs into a lifetime habit, a practice she eventually would incorporate into the creation of her artwork.

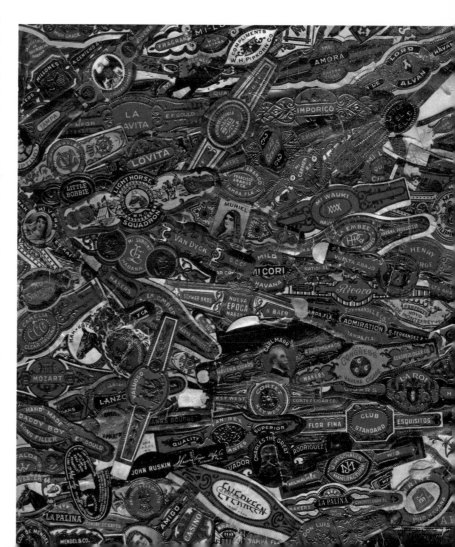

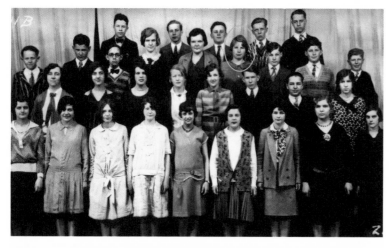

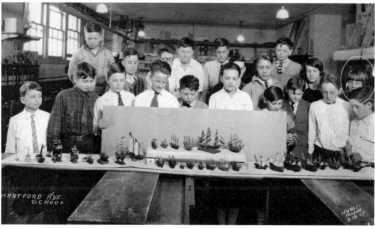

Top: Mary's eighth grade class at Hartford Avenue School, 1927.
Bottom: Mary's industrial art class, 1927.

Mary and her gang of friends constructed puppet theaters and made dolls and hobby horses. They clogged the corner sewers to make Venice-style canals in the street, although the officer on the beat always intercepted this activity. With an old wooden box, a dolly, and the grinding arm from a coffee mill for a throttle, the kids engineered a steel-wheeled pull trolley, "very noisy for nap-takers as the wheels banged over the cracks in the cement walk," as Mary observed. "The cost of riding in this vehicle was one cent a block. . . . A jar with a slit received the pennies."

The children contrived their own fun and were fearless in their pursuit of it, using even the aid of a streetcar in their efforts. Mary wrote: "I believe my earliest interest in abstract sculpture began with the flattening of various sized nails on the street car tracks. The street car made a special thundering sound as it passed over the spikes on the rails. Flattening them with force sort of welded them together into interesting shapes."

While Mary was boisterous and mischievous with her friends, she was quiet around adults. "When I was small I was well behaved to the point of no expression," she recalled. "My parents always said they were never afraid to take me anywhere. When asked how I was, I would grin and say 'fine.' That was the whole conversation. I never said the wrong thing because I never said anything more than just 'fine.' I could grin indefinitely and that was a nice quiet sort of thing. It gave Father a lot of time for expressing his ideas on all subjects. Instead of giving him competition, I added one more to his audience."

Mary walked through grassy fields between her house on Stowell Avenue and Hartford Avenue School. Beatrice Raynor Smith, Mary's fifth grade teacher in 1925, reminisced in a 1967 letter to Mary: "There were fields south of the school and we could still enjoy the beautiful oak trees on our school grounds. We probably hiked to Lake Park . . . to see the birds . . . and learn a bit about them. Perhaps we even found a killdeer's nest in the cinders at the far end of the playground or watched a meadowlark fly up from the field. What changes there have been since those days!"

Mary was happy at Hartford Avenue School with her neighborhood pals. Her father, stern but always Mary's supporter, did woodworking as a hobby and understood her love of inventing and building. To encourage her self-reliance and creativity, he arranged for Mary and

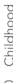

her friend Lydia to join the boys' eighth grade industrial arts class. Both girls preferred this over the usual home economics class, and the opportunity was pivotal in Mary's life. She delighted in the precise line-up of the tools in the shop room and learned to use each one.

Alexander F. Bick, the industrial arts teacher, reminisced years later in a letter to Mary, "Lydia and Mary were the first girls to crash the gates of an exclusive boys' domain—the wood shop. I hope you continue to show up these smart boys." Mary was proud to earn first place in her class for patiently sawing, planing, sanding, and squaring a block of wood. Her persistence, determination, and patience served her well. The prize was a small chisel, which she treasured and used all her life.

Mary demonstrated her newly acquired skills in designing and constructing model airplanes. She boldly joined the boys of her class in a citywide model plane building contest. It's easy for one to imagine thirteen-year-old Mary, chubby and shy, as the only girl at the school district plane flying competition:

On March 24, 1928, in the hushed gymnasium of Plymouth Congregational Church, the contenders assemble, nerves and energy high. Mary holds her breath as she draws back her arm to zing her plane into flight. It soars silently upward, reaches its peak, then coasts to a successful landing. The judges sigh and chuckle. The boys and Mary jitter and wiggle, waiting as each contestant takes a turn. Finally the announcement is made. Mary's plane beats the other twenty-six with a flight of thirteen seconds, qualifying her for the citywide competition the following month.

Mary was the only girl to ever win a place in any of the district airplane contests, a remarkable achievement. In addition to the cash award of five hundred dollars, Mary and the five boy winners were treated to a ride on a pontoon-equipped Hamilton plane. "Girl is Winner in Plane Test," a headline in the April 8, 1928, issue of *The Milwaukee Journal* announced. "Miss Nohl sprang something a bit new in the tourney competition," read the article, "when she came with a brace equipped with a hook to wind up the rubber band that furnishes the propelling power."

A month later, Mary and seventy-one boys from throughout the district gathered for the final flight competition. Perhaps it was the rubber band and hook feature of Mary's plane, or the mere fact that it had been made by a girl, that prompted a newspaper photographer to pick up and examine her plane. Just moments before flight time, he accidentally broke the delicate balsa wood structure, eliminating her from the final event. More than six decades later, the repaired plane hung from her bedroom ceiling, with Mary still lamenting this turn of events.

Airplane accident aside, this was the highlight of Mary's grammar school years. She graduated from Hartford Avenue School in 1928 with good grades, earning Gs (good) in manual training and Es (excellent) in drawing. For every grading period at Hartford, her report card bore her father's bold and firm signature of approval.

In 1924, the Nohl family purchased one-and-one-third wooded acres "out in the country" on the shore of Lake Michigan. Here, on Beach Drive in Fox Point, a forty-five-minute drive north of their Milwaukee

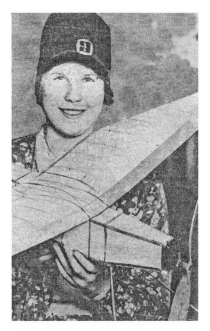

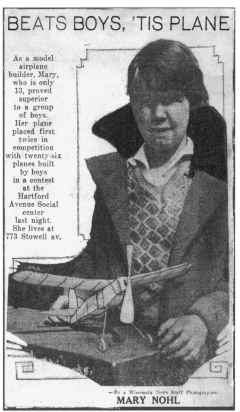

BEATS BOYS, 'TIS PLANE

As a model airplane builder, Mary, who is only 13, proved superior to a group of boys. Her plane placed first twice in competition with twenty-six planes built by boys in a contest at the Hartford Avenue Social center last night. She lives at 773 Stowell av.

—By a Wisconsin News Staff Photographer.
MARY NOHL

Wisconsin News, 1928.

home, they planned to build a summer cottage. They drove out to the property from the city on weekends for picnics, bonfires, and beach walks. Twelve-year-old Mary and her father built two stone-and-concrete gateposts to mark the entrance to their land. "The joy of being paid twenty-five cents an hour for having so much fun I long remembered," Mary reflected in her semiannual letter to friends in December 1991. "The pleasure of mixing concrete in a wheelbarrow and straining sand from the beach for concrete—I'm sure my sculpture-filled yard had its origins in the gateposts." Indeed, the concrete posts marked the beginning of a lifelong passion—and the start of Mary's public work.

The Nohls bought a twenty-two-by-twenty-six-foot, fir-sided, prefabricated cottage with a front and rear screen porch for $950. It was delivered by truck and set into place. There was no hot water or heat. Four years later, they built a basement under the house and a second floor, and they insulated the original structure. From then on, the family spent entire summers in Fox Point.

The Willetts family, the closest neighbors, also spent their summers on Beach Drive. Here, Mary, then fourteen, and John Willetts, four years younger, began a lifetime friendship. Together they explored the wooded ravines below the bluff between Lake Drive and Beach Drive and passed carefree days along the wide, sand beach. Besides daily swims, sailing, and boating, they collected washed-up logs to build the rafts they hauled up and down the lakeshore with ropes. They secretly smoked pipes stuffed with corn silk as they hid from view in the woods along the shore.

In a February 1, 1996, article in *The Herald*, published in New Berlin, Wisconsin, Willetts remembered that "Mary was very clever. She helped figure out a propulsion scheme for the miniature boats we built and raced in a nearby creek that used to run into the lake." Mary claimed a rock that emerged from the water as hers, and regularly perched on it to watch the changing moods of the lake and sky. Everyone recognized it as "Mary's Rock."

When she was twelve, Mary began to keep a diary, the start of a lifelong practice. Among her first entries in 1929 were comments about a hike to Fox Point: "Saw boys push boat out. Got pussy willows. Rode home with Mom. Got a couple of angle worms in the face. . . . Saw a robin. . . . Played 'keep away' and got all full of mud."

She maintained her diary habitually through September 13, 1995. Her concise non sequiturs, written in tiny script, record the course of her life and reduce all thoughts, observations, and life events to equal significance. "My entries, day after day in my grade school diaries, consist of the stock phrase 'nothing doing.' In high school I settled down to a rigid eight lines a day." Mary claimed she never wrote anything in the diaries that she wouldn't want the whole world to read.

In spite of the great amount of material, there is sparse written reflection from her teen years, nor as an adult did she mention anything of consequence about these years. Were her adolescent years less memorable than those of her childhood? Although she continued to keep a journal, she apparently tore out the pages

Mary, c. 1928-1932.

documenting her high school years, perhaps while reorganizing and editing the family records, photos, and scrapbooks, a task she periodically undertook in later years.

Still, some details of her adolescence emerge. Although she feigned sleep and illness to avoid Sunday school as a child, Mary joined Plymouth Congregational Church when she was sixteen and participated in the youth Plymouth League as a discussion and devotions leader. She attended the neighborhood Riverside High School for one year, then, most likely at her parents' insistence, transferred to Milwaukee University School, a private high school for privileged children, where she was one of eight girls in a class of twenty. Clearly Leo and Emma wanted the best for their daughter.

Milwaukee University School, then located on Hartford Avenue, was exclusive, expensive, and intellectually challenging. "I had my father buy some eyeglasses for me because I thought they would make me think harder," Mary wrote. "The people who were able to think the hardest always seemed to be the ones with the glasses. My eyes didn't need them, but the optometrist was apparently not opposed to selling one more pair. And they did keep my eyes on the books, because everything blurred looking in any other direction."

Tall and athletic, Mary was picked as captain of one of the two teams into which school

athletics were divided. She excelled in basketball and volleyball, a sport she would play well into her fifties. Years of swimming in Lake Michigan contributed to Mary starring on the swim team and leading her team to a championship. Following in Leo's footsteps, she also became accomplished in oratory, participated in the Dramatic Club, and performed in several school plays. A better-than-average student, mechanical drawing was her favorite class.

Listed in the 1932 yearbook was her nickname "Demosthenes," the Greek orator and statesman. The explanation beside her senior photograph reads, "It is said that Demosthenes practiced his oratory at the seashore—maybe that is why the Nohls moved to the shores of Lake Michigan." The class prophet enigmatically proclaimed under Mary's senior yearbook photo, "Look at Mary Nohl out there in the mid-Atlantic. She's crossing in a row boat."

Plenty of friends and an active social life rounded out her high school years. "I had a special driving license when I was fifteen. My car was green with red wheels and a rumble seat. We lived in Fox Point (in the summers)—then considered the country—and my social life demanded speedy access to the city."

On June 8, 1932, Mary graduated from Milwaukee University School and enjoyed a carefree summer with friends at a girls' camp near Green Lake, Wisconsin, before going off to college.

NIGHT IN THE SCIENCE LAB
Mary Louise Nohl '32

Tops off the jars,
Bugs crawling out
Shaking with laughter
Romping about.

Pickled in gin
In which they had been,
Each swaying slowly.
Full to the brim.

Gravely the crab,
Robbed of his head,
Turns in his shell,
Quelled but not dead.

Frogs try to hop,
Tattered and torn,
Some boy has carved them;
They look forlorn.

Up speaks the skeleton
Tied to his base.
Says, "A hot night!"
With a grin on his face.

"Drink to your captors
Now far away!"
"Here's to a snooze!"
Good night, said they.

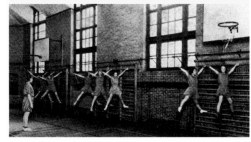

Mary's gym class (fourth from the right), c.1930-1932

"The kids are amusing themselves by reading my diary—but I never put anything in there that I wouldn't care if the whole world knew."

Untitled (Mary in her dorm room), c. 1933-1935; lithograph.

2

College Years: The Artist Emerges

"One thing about art students that distinguishes them from the ordinary run of students is that they never seem to be through with going to school."

Rollins College was founded in 1885 by a group of New England Congregationalists whose mission was to bring their style of liberal arts education to the frontier of central Florida. Sheltered along the shores of Lake Virginia in the picturesque community of Winter Park, Rollins is Florida's oldest recognized college.

But, more important to eighteen-year-old Mary Nohl, Rollins College was twelve hundred miles from her Wisconsin home. The school, as she wrote in her diary, "sounded like my state of independence far away from home would be complete. There was a country club style about it that I liked."

Mary at Rollins College, 1933.

pledging to devote herself to her studies. Her classes included German, public speaking, English literature, sociology, canoeing, and art, both drawing and sculpture.

The drawing class searched for scenic spots, sketching old train stations, run-down houses, markets, beaches, and palm trees. In letters to her parents, Mary spoke of George Etienne Ganiere, renowned sculptor, who sat on the Rollins faculty and taught Mary's first sculpture class. From him she learned mold making and casting. Widely recognized for his powerful sculptures of Abraham Lincoln and other heroic military figures, Ganiere's work represented the state of Florida at the World's Columbian Exposition of 1893 in Chicago.

Mary entered Rollins in the fall of 1932, and found the graceful southern campus to her liking. She was reminded of the friendly atmosphere at Milwaukee University School. "Everyone says hello and is friendly. I am just getting sick and tired of being nice to everyone," Mary wrote in her second letter home. In spite of her "niceness fatigue," she stepped into a whirlwind of social activities. In her frequent, dutiful letters home, she described the constant flurry of teas, dances, bonfires and beach picnics, and dates.

Her focus was fun. She joined the art club, served as secretary for the Chi Omega sorority, and worked as staff artist for its newspaper, illustrating many invitations for the sorority teas and church events. Missing in her letters home were very many details about her academic work, although she had taken the Rollins student oath,

While Mary studied at Rollins, her brother Max, who had graduated from the Massachusetts Institute of Technology, was developing a diving company in Tarpon Springs, Florida, with the intent of salvaging sunken ships. An advance of his inheritance supported this enterprise and many subsequent efforts. In spite of their lingering childhood disagreements, he often visited Mary at Rollins. Both Mary's and Max's writings reveal their sibling rivalry and the struggles that persisted throughout their lives. For a number of years, they did not speak to each other. Mary held a deep grudge against Max for opening, in their childhood, her secret box—and she had opened his. "There was nothing world-shaking in either of the boxes—only the idea of a place for something private was

"OOT"

MARY

"MITCH"

JEAN

"JINNY"

"DUCHESS"

???

SAND

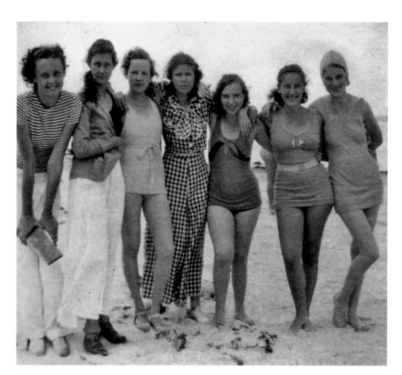

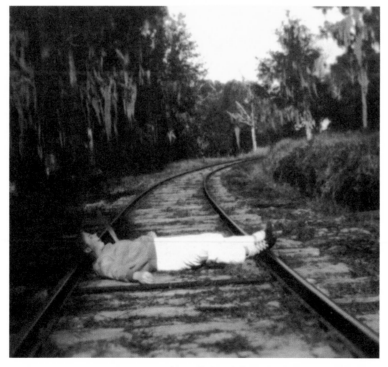

Above: Rollins College sorority sisters, 1932-1933.
Below: Mary on the railroad tracks behind Rollins College, 1932.

important. In mine were some treasure maps sealed with melted crayons. . . . These maps led under the front porch where some glass jars probably still lie buried."

It is also likely that Mary was resentful and jealous of the attention Max had commanded by his negative behavior and childhood ailments. He could be difficult and demanding. In their periodic tiffs and fallings out, Mary demonstrated a stubborn, immovable streak. In an undated letter, a cousin wrote to Mary later in her life, "I do not blame you for having it in for Max for he really got it all . . . Max had whatever he wanted." However, at this stage in their lives, their relationship was positive enough that they could enjoy each other's company and travel together.

Mary's difficulties with relationships did not start and end with Max. She often wrestled with her emotions in relationships with her friends. She could be blunt, outspoken, and unforgiving and did not hesitate to voice her frank opinion. Yet in spite of frequent disagreements, she formed strong friendships at Rollins and maintained many of them throughout her life.

A daring and adventuresome spirit made Mary popular among her friends. She became the instigator and leader of outings and antics. On a hitchhiking trip from Winter Park to Miami, Mary and a pal came upon an old country schoolhouse and slept overnight on top of the desks. They stayed another night in the tumble-down shack of a good-hearted man who drove the girls there to meet his tubercular mother. After a breakfast of eggs and potatoes, the girls were on the road again, thumbing their way south. Several of the drivers who gave them

rides were alarmed at the boldness of the girls, who were oblivious to dangers. Fortunately their adventure ended safely. Hitchhiking, of course, was against Rollins' rules. Still, the Dean of Women appointed Mary as proctor in her dormitory.

Her dormitory room was something to write home about. "I wish you could see my room," she said in a letter to her father, ". . . red, green, blue, and yellow streamers on the ceiling across strings with a background of palm branches. Jump ropes, valentines, cotton chickens, Washington hatchets, paper snowballs, Mickey Mouse, rubber peanuts, pipe cleaner animals, wooden and wire dogs . . . hang suspended from the cross strings." Her peculiar style of decorating reappeared over and over later in her life.

Mary was a privileged child among many at Rollins, some who were even more indulged. Her letters home typically nagged her parents for more money, clothes, new shoes, or trips to exotic destinations and anything else she wanted. "The real reason for my writing this time is to tell you the banks down here refuse to cash checks from northern banks," she wrote. "As you know the banking systems in both Maryland and Michigan have collapsed and the southern bankers are taking no chances . . . so if you can, send me a postal money order" This possibly was the only moment the Great Depression had any affect on Mary, or her well-off classmates.

"Rollins isn't making any improvement in me," Mary declared near the end of her freshman year in May 1933. "Of course I've never been to any other college but Rollins. I don't know what more I could want and I couldn't be having a better time—and yet I don't feel I'm accomplishing as much as I might somewhere else." To Mary's satisfaction, Emma and Leo agreed that their daughter was not sufficiently challenged academically and, because Rollins offered only a few art classes, they determined a transfer was in order. "When I decided it was more art that I needed, I switched to the School of the Art Institute of Chicago."

The Chicago Loop was a marked contrast to the palm-tree campus at Winter Park. "My parents allowed me the school of my choice and then worried about no campus at Michigan and Adams," she wrote years later. "But, what could have been a nicer campus than the galleries of the Art Institute of Chicago?" Designed for the World's Columbian Exposition of 1893, the Beaux Arts-style building, with bronze lions guarding the entrance, is located on the

Untitled (woman reading), c. 1933-35; Ink and watercolor.

edge of Grant Park on Michigan Avenue. A world class museum, it housed premier collections of Impressionist and American art and legendary collections of prints, drawings, photography, and sculpture from all over the world.

The School of the Art Institute of Chicago stood at the forefront of arts education. In the first half of the last century, it primarily taught classical art and architectural design. Mary had found the challenge and stimulation she and her parents had sought. Her nearly six years at the Institute were formative and key to her growth and development as an artist. Throughout her life she reread notes

from her favorite classes, relying on them as meaningful and timeless guideposts.

For $102.50 a semester, the School of the Art Institute of Chicago offered the privilege of studying with great artists and inspiring teachers, including prominent art historian Helen Gardner, whose comprehensive text, *Art Through the Ages*, now in its twelfth edition, is still in use today. Known for her enthusiasm, knowledge, and humanity, Gardner taught Survey of the History of World Art in an unorthodox way. She included crafts along with fine arts as part of the total expression of an age, introducing students to the arts and crafts of indigenous peoples of South America, Africa, and Oceania.

"To see the significant aspects of commonplace things is to transform what is mediocre, if not ugly, into something that is lovely and worthwhile," Gardner wrote in another of her publications, *Understanding the Arts*. In her lectures, Gardner conveyed her love of art, art history, and travel to her students. Gardner described the beauty of Florence and Venice in her lectures on the Italian Renaissance. She recommended that the class augment their understanding of Italy and its art by reading *The Life and Letters of St. Catherine of Siena, The Life of St. Francis,* and *Canticle to the Sun.*

Notes from Giesbert lecture, 1934.

Mary was powerfully influenced by this impressive woman. "Gardner loves Italy with a passion, its jagged mountains, the Alps and the Apennines and Venice with its canals," she wrote in her class notes on the Italian Renaissance. "People were industrious and ambitious—life was festive. Artists were versatile—thought nothing of being painter, sculptor, and goldsmith all in one." Mary thoroughly and thoughtfully absorbed this Renaissance concept of an artist. Yet she was not a great student of art history, and later developed something of an aversion to it. "Those darn Italian paintings—I don't know who did what, and I don't think I ever will know," she wrote to her parents.

Gardner occasionally took her classes to the Field Museum of Natural History to study the artifacts of non-Western cultures. Mary also enjoyed drawing at the museum, inspired by the vast collections, drawing "gazelles, turtles, lizards, and monkeys and cabbages, and kings and sealing wax and other things."

A full spectrum of art courses filled the six years: basic courses in drawing, design composition, pattern design, and still life were followed by more advanced classes in anatomy, lithography, fresco painting, and watercolor. In the fall of 1934, she studied life drawing

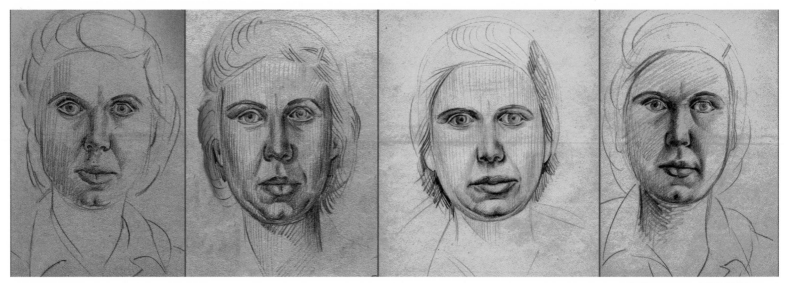

Self protraits, c. 1933-1936; pencil.

with Edmund Giesbert. "The idea that people come to the Institute and study because they want to be an artist is silly," Giesbert announced at the start of the class. "We study at an art school so we can sing our song more clearly."

Giesbert, who studied in Paris and Vienna as well as at the School of the Art Institute of Chicago under George Bellows, was active in the city as a painter, illustrator, lecturer, and teacher. Immediately he became Mary's hero. "What he says is worth listening to," Mary wrote in a letter home. "I have picked him as my guiding star. . . . Giesbert is a most inspiring man." He guided Mary in technique, helped to develop her eye, and touched her creative spirit with his inspirational instruction.

Mary savored his advice and tried to live up to it. His words echoed in her 1934 sketchbook notes. "Work for the fun of it. Three things we are concerned with in drawing—nature, medium, technique. We are concerned with the developing of the intellect, the developing of emotions, the training of the eye." She wrote pages of notes from his lectures and reread them throughout her life. In large block letters in her sketchbook, Mary recorded Giesbert's directives: "Make up your mind to do something, and then do it. Do not be timid. Really say what you have to say. Don't be half-hearted. Have Courage!!!!" Mary took to heart this bit of wisdom for her art and for her life in general. She would need courage to walk the independent and idiosyncratic path she chose.

Giesbert encouraged students to draw everything around them, claiming, "This business of not knowing what to draw is bad. We should have so many things to draw that we don't know where to begin—which to do first!" Mary followed this direction and began drawing everything: her classmates, her room and all its contents, views from the windows, all in her sight.

Under Giesbert's guidance, Mary's skills and confidence blossomed. "Today Mr. Giesbert advised me to look up Pieter Breugel in the library. . . . It seems that Pieter, that great man, draws in much the same way as I do—or rather I draw in much the same way as he does. So I spent the noon hour looking at colored prints of his work."

Giesbert drew a foot for Mary in her sketchbook, explaining that the foot she had drawn resembled a sack of potatoes. Mary responded that *his* foot looked out of proportion. Her classical figure drawings from Giesbert's classes are accomplished and often elegant, demonstrating not only a thorough understanding of anatomy but also insight into the models' character and mood.

Clearly her self-confidence was building. "I wonder if it's conceit or overestimate [sic] of my ability, or a profound understanding (and I have great hopes it is)—but when I look at an acknowledged good piece of art work, such as the murals in the school cafeteria, I feel I could do as well," she wrote to her parents. "And I wonder if every artist has the same feeling—but I suppose I'll never know—because very few are frank about these things.

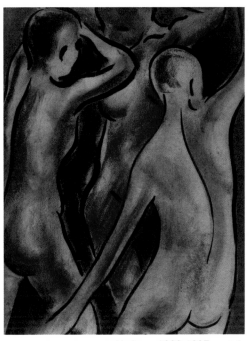

Nudes, c. 1933-1937; pastels.

I believe, as does Max, that you never get anywhere unless you're conceited, so if conceit is all it takes to get anywhere, I'm all set."

Mary wrote home three or four times a week, providing Emma and Leo with commentary about her studies. "I've substituted a course in modeling for a course in composition. . . . We've been working on all-over design in design class; Greek Architecture in art survey; 'storm' as a subject in composition; and life drawing class goes on in the same old manner," were typical updates. "Aren't you tired of these commonplaces?" Mary asks, referring to her letters, "but I really wouldn't know what else to write unless it was the inner workings of my soul and I am

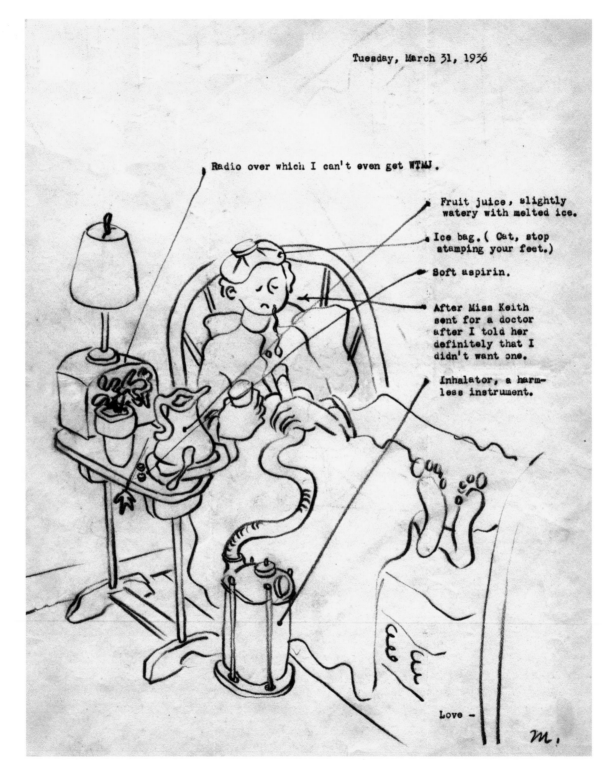

Letter to Mary's parents, 1936.

Letters to Mary's parents, 1936-37.

not sure enough about them." She often signed the letters, "Love—from your problem child, Mary."

In addition to a solid schedule of art classes, she studied philosophy, psychology, poetry, drama, anthropology, and English at the University of Chicago, where classes in liberal arts would allow art students to satisfy requirements for the Institute's new Bachelor of Fine Arts Degree. On June 14, 1936, at the end of her senior year, she wrote her parents that she had received faculty honorable mention, "which is your cue to respect my talent and to coax it along with agreeable methods." The students' best works were selected for an annual exhibition, and although no work by Mary was shown in her first year, by 1939 twelve of her works were included in the exhibit.

An array of the most illustrious artists of the day visited the school and exhibited their art in the prestigious galleries. Mary attended their lectures and exhibits, and critiqued their work and philosophies. "This afternoon, Grant Wood, a chubby little rascal of an artist from Cedar Rapids, Iowa, lectured in Fullerton Hall and was most amusing," she wrote in 1935. Wood was an outstanding artist of the day, part of the popular 1930s movement of Regionalism. He portrayed Midwestern themes—the virtues of the rural heartland—landscapes of rolling hillsides, farms and fields, and the lives of ordinary folk. Most widely recognized of these works is Wood's *American Gothic*, the famous 1930 portrait of a tired and tight-lipped farming couple in gingham and denim.

Mary also attended an exhibit of Walt Disney's cartoon characters and viewed Rockwell Kent's dramatic landscapes and seascapes. A popular painter of the day, Kent presented a lecture, "stressing the story telling element in great art—much to . . . my distress," Mary said. "He recognizes Surrealism as the dawn of a new art because it involves ideas at least and is not pure abstraction." Her interest in abstraction was developing.

Mary gravitated to the art of Dada, which rejected all moral, social, and aesthetic standards. The art was absurd and irreverent, relying on chance and coincidence. She also felt an affinity with Surrealism, which had developed as both a literary and artistic movement in the 1920s. This cultural movement focused on the elements of shock, paradox, surprise, and unexpected juxtaposition. The Surrealists' intrigue with the unconscious and dreaming mind, primitive art, and the art of children attracted Mary. They reached into the psyche for subject matter, their work depictive, abstract, and psychological.

Galleries in Chicago were showing Surrealistic work—Salvador Dali's paintings were particularly shocking. Mary undoubtedly was aware of the 1936 exhibit at the Museum of Modern Art in New York, *Exhibition of Fantastic Art, Dada and Surrealism or Art of the Marvelous and Fantastic*. This significant and eye-opening exhibit caught the attention of the American public, although not with great favor. While the exhibit included fantastic art of the past, such as sixteenth century prints by Pieter Breugel, it highlighted groundbreaking work by contemporary European artists. Max Ernst, whom Mary admired, was represented by his fantastic

SHALL WE OR HAVE WE?

A BOUT WITH A TYPEWRITER

PICTURE SNATCHERS

ALL OF GODS CHILDREN GET MEASLES

Sketchbook drawings, c. 1933-1937; pencil.

collages of engravings of Victorian ladies growing appendages and transforming into eerie creatures.

Mary also admired the inventiveness of André Breton, a founder of the Surrealist movement. "The mind which plunges into Surrealism relives with burning excitement the best part of childhood," Breton wrote in *The Manifesto of Surrealism* in 1924. "Childhood comes closest to one's real life—childhood, where everything conspires to bring about the effective, risk-free possession of oneself."

The exposure to enormously talented artists was astounding—a heady experience for the young and impressionable Mary. Lorado Taft, Chicago's foremost sculptor of monuments and fountains, welcomed a visit of Mary's sculpture class to his studio near the University of Chicago. Students were familiar with his monumental, powerful *Fountain of Time* at the west end of Chicago's Midway Plaisance. Mary also had the opportunity to meet Laszlo Moholy-Nagy, who was a proponent of new media, technology, photography, and film and founded the New School of Design, now the Institute of Design. She consulted him about her career options. "Nagy said I was like a fresh piece of paper and wanted to know whether I was too revolutionary to live at home," Mary wrote. He told her she had "excellent work."

Mary also had the opportunity to meet Amédée Ozenfant, French painter, theoretician, and founder of Purism, a variant of Cubism. Mary bought, then outlined, his book *The Foundations of Modern Art*, published in 1931, and referred to it throughout her life. Ozenfant's book is an

artist's appreciation of the interrelationship of all forms of human creativity, from painting to writing, science to religion. The book's cover explains that Ozenfant endeavored "to isolate the great constants underlying all art from Paleolithic cave-paintings to twentieth-century French movements. . . . The author was one of the founders of the Purist school, which tried to demonstrate that 'modern art' need not be a rootless chaos, but followed an artistic tradition running through human activity since the dawn of man."

Additionally, Mary attended Forbes Watson's lecture on "art for the people." Watson spoke about murals and other public art forms being created through the federal programs begun by Franklin Roosevelt. Watson, an art commentator for *The New York Post* and an outspoken ally of progressive American artists, worked in the government's New Deal Public Works of Art Project. This program benefited artists along with other workers during the Depression, giving rise to murals in buildings throughout the country. It appealed to Mary, who had studied mural painting. Later in life, Mary would create her own "art for the people"—the sculpture she created in her yard.

The city provided a vibrant, rich cultural dimension to Mary's education. For several years, she held season tickets to the Chicago opera, and she and friends attended concerts regularly. Mary considered music a necessity. Besides the convenient galleries of the Art Institute of Chicago, a wealth of other art galleries and museums provided art viewing opportunities throughout the city. On most Saturdays Mary and friends took

Art with a Capital A, c. 1933-1937; pencil.

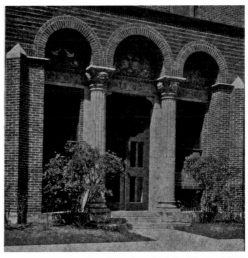
The Three Arts Club Building, c. 1935.

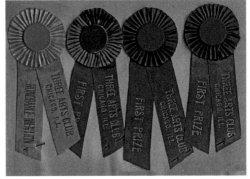
Awards from juried exhibit Three Arts Club, c. 1935.

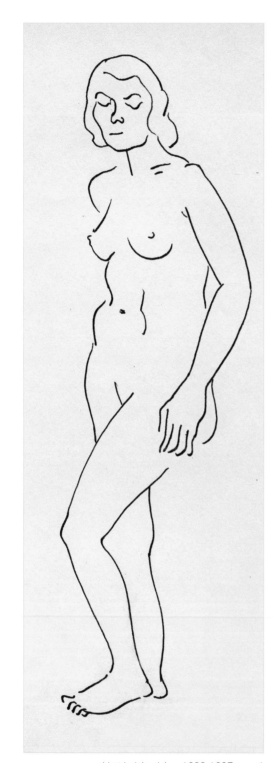

Untitled (nude), c. 1933-1937; pencil.

to the streets to visit galleries and world class museums to see new exhibitions.

Mary delighted in the unexpected encounters and discoveries in the city. From the steps of the Art Institute, she happened to see Franklin Roosevelt drive by after his speech at Soldier Field on October 2, 1933. In spite of this sighting, and Roosevelt's successful programs to employ artists, she voted for Alf Landon in the 1936 election, following in the Republican footsteps of her father.

There were discoveries of all kinds. Mary, always alert to a good find, made periodic searches through her friends' wastebaskets and the school's trash cans, salvaging old paint brushes, half-used drawing pads, squeezed paint tubes, and the stubs of drawing pencils. She informed her parents how wasteful the other students were. One day Mary spotted a ladies' white kid glove on Michigan Avenue, reassuring her parents that picking it up from the street was all right because "such gloves are only worn by the best sort of people." After washing the glove, Mary planned to use it for working with plaster.

For the six years she studied in Chicago, Mary lived at The Three Arts Club, a project started by a group of progressive women, at 1300 Dearborn Street. Just a forty-minute walk to school down Michigan Avenue from the near north side, the club provided a safe, affordable, and respectable residence for young women who were studying the arts. Recommendations by a clergy or teacher were required for residency. A housemother kept order; a curfew was enforced; formal dinners and afternoon teas were served; and residents were given free tickets to

concerts, operas, plays, and lectures. The residence itself provided notable speakers, musical evenings, and entertainment, including poetry readings by Robert Frost, Carl Sandburg, and Vachel Lindsay.

The residents arranged their own informal discussion groups. "At seven this evening we started in again rereading aloud Emerson's essay on friendship and now at eleven-fifteen . . . we've just finished," she wrote to her parents. "I don't know when I've enjoyed an evening as much, and I think the other four, Betty, Virginia, Chenault, and Peggy, feel the same way. This subject of friendship is one that we all want to understand and have unconsciously thought about extensively . . . a thoroughly enjoyable, highly interesting evening"

Besides the demanding work in her studio classes, Mary expressed her creativity through play. She convinced the operator to answer calls by saying, "Free Hearts Club." The women residents constantly played pranks on each other, with Mary as both the perpetrator and the recipient. The roof of The Three Arts Club provided a perfect site for ball games and a vantage point from which to drop pebbles down on taxis in the street. They floated paper boats in the bathtub, carried on snowball fights out the windows, and conducted hollering conversations with the young men living across the street. Mary decorated her room from floor to ceiling with junk scavenged from classrooms and from the street and dressed the fake skeleton hanging in her closet in red pongee pajamas, brown silk stockings, goggles, and clodhoppers.

The inveterate inventor, Mary entertained her pals with her creations. "Went snow-

shoeing down the hall in the covers of a suit box with a yardstick as my staff last night, which decided us on making a surrealist moving picture," she wrote home. "Been splashing my stockings walking to school in this wet weather, so I resolved to make some celluloid mud guards . . . and thumb tacked them on my shoes. Had my suitemates worried for a time when I flooded the bathroom floor and paced up and down to see if they really worked."

Mary and a friend set up a stone carving studio in the basement of The Three Arts Club. Mary carved a three-foot nude and told her parents, "I'm going to get a regular ordinary fence post and plant it outside my bedroom door and put the little figure up to keep away the evil spirits." This stone sculpture hinted at a practice Mary would take up later in her life. At the end of a busy day, she hung a sign on her door, "Not to be disturbed, have business in a dream."

Mary became a momentary celebrity among her friends when Max Nohl, at the age of twenty-seven, achieved world acclaim for his world record-breaking dive. In a self-contained helium-oxygen suit of his own design, he submerged to 420 feet in Lake Michigan on December 1, 1937. He made the dive from the Coast Guard

Cutter Antietam about twelve miles southeast of Port Washington, Wisconsin. The front page of *The Milwaukee Journal* featured a photograph of Max and an impressive full-page article about his accomplishment.

As a student at the Massachusetts Institute of Technology, Max designed many diving devices, including, as his thesis, the self-contained diving suit, which he wore in his historic dive. He collaborated with Dr. Edgar End, a physiology professor at Marquette University School of Medicine. End determined the correct ratio of oxygen and helium to make the dive possible. Following the dive, Max lectured on tour around the country, was featured in articles and advertisements, and claimed a page in *Ripley's Believe It or Not.*

Leading the life of an adventurer, Max was constantly borrowing money from his father and others to pursue his grandiose plans. He sailed the West Indies and the Bahamas in search of sunken treasure. When prohibition ended, he attempted to salvage a sunken rum runner near Martha's Vineyard. But after months of dangerous underwater work, he discovered that the $350,000 worth of Scotch

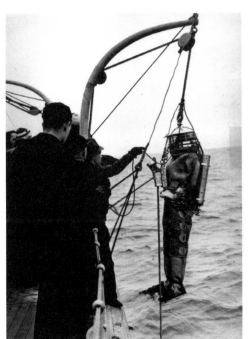
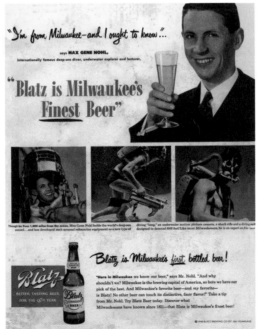
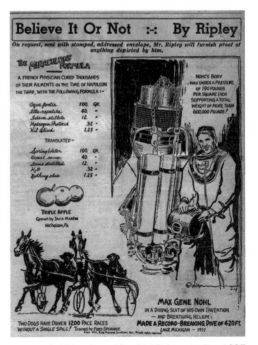

Publicity about Max Nohl's historic dive, 1937.

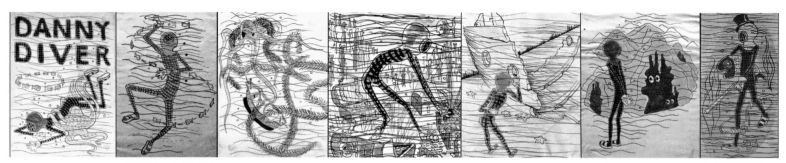

Sketches for the Danny Diver book, c. 1933-1938.

whiskey had been ruined by salt water, and the safe (rumored to have contained $250,000) was found empty. Several of the companies he founded ended in failure, and his efforts to salvage anything of value were unsuccessful.

To his father's disappointment, Max consumed his inheritance in risky, sometimes foolhardy ventures, leaving a trail of debts in his wake. *Skin Diver Magazine* summed up his life in a May 1960 article titled, "Tribute to a Diving Pioneer":

> Max Gene Nohl was a controversial figure in life and his career will probably always remain so, but no one can dispute his place as a pioneer diver and his ability to fulfill the dream of every diver—to live and work wholly in adventure, salvage and treasure hunting.

Max's wild and dangerous ways diminished with the stabilizing influence of his marriage to Eleanor Hecker, a high school friend of Mary's, at Plymouth Congregational Church in Milwaukee, June 23, 1945.

In spite of their differences, Max's passion for diving affected Mary. She was both proud and jealous of her brother's accomplishments. This attitude may have sparked her strong work ethic and drive for her own accomplishments. In 1933, four years before his most famous dive, Mary began a children's book, *Danny Diver,* a sad tale about a lonely deep-sea diver who searches for friends beneath the sea. Max encouraged Mary's efforts. She revised the writing and drawings several times, completing it in 1938, and although she devoted considerable time and effort to it during summers and the school year, she never followed through in attempting to have this poignant tale published.

Danny Diver book, c.1938.

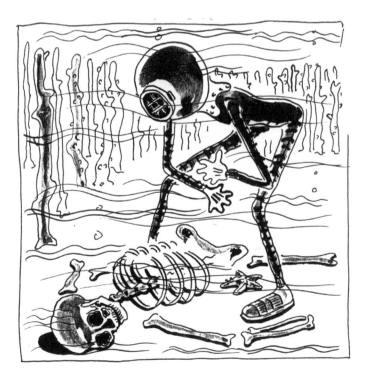

Danny Diver sketches, c. 1933-1938.

Fashion illustration class, c. 1933-36.

In 1936, as Mary's senior year of art school came to a close, she was uncertain about her next steps. "Now that I am in my last year of professional education, I spend all my time being sad that it is my last year of professional education," Mary wrote to her parents. With her bachelor of fine arts degree in hand, she applied for a number of design jobs. Sears, Montgomery Ward, Roe Peterson Publishing, *The Chicago Tribune,* and *Esquire Magazine* all turned her down. Several potential employers told Mary her art was too sophisticated, that they were interested in realistic, not abstract, art and that New York City would be a better place for her. "Another," wrote Mary, "judged my work as too profound, too intellectual, better for exhibition purposes."

When her job search yielded nothing, at her parents' suggestion she decided to fulfill requirements for a degree in art education so she could teach. On a whim, Mary had done volunteer teaching at the Howell Settlement House in Chicago, "endeavoring to pound art into dirty, smeary, little kids," she wrote. "They grabbed and swore and told dirty jokes. It was sort of fun." So she dutifully completed the requisite courses in three terms, and although she liked the classes—stage design, ceramics, weaving, school pageantry and mechanical drawing—she was not enthusiastic about the prospect of teaching.

But the BA program had other benefits: during these three terms in 1938-39, Mary earned class honorable mention in School Crafts, a course that covered every conceivable material, from raffia, pipe cleaners, plaster, and linoleum to clay, fingerpaint, crepe paper, burlap, chalk, and sequins. The other art education students praised her design abilities, but Mary doubted her career choice and, perhaps hoping for a way out, asked her professor if she thought she belonged in the art education department. The professor answered that, yes, she did.

Mary worked diligently to acquire a repertoire of approaches and techniques for teaching. In stage design class, she gained experience working with the Goodman Theater's production of *Emperor Jones* by Eugene O'Neill. In ceramics class, she learned to throw clay on the wheel, formed her first water jar abstractions of human figures, and made a ceramic piece that she titled *Spanish Ruin #2.* For practice teaching, she taught twenty kids ages seven to nine in the Saturday School of the Chicago Art Institute and worked with high school groups at Lucy Flower Technical School for Girls. "So many things to do and so little time to do them," Mary lamented. "With so much to do, I don't make friends, which I miss."

"The fashion figure is simple mechanics and anyone can draw the fundamental structure. It's the pleasing composition that isn't so easy for everyone."

While Mary was in Chicago she thought frequently and longingly of her beloved cottage on Lake Michigan. During her college years, Mary anticipated returning to Fox Point to enjoy the leisurely summers. She basked in the slowed-down pace and lazy days of swimming, sunning, and reuniting and relaxing with her friends. While she was home for the summers, she watched her friends prepare for marriage as they packed their trousseaus and bought china. Although she expressed jealousy of her friends' happiness with their beaus, Mary observed her recently married friends sinking into the narrow box of domesticity. She commented in her diary, "The only certainty in life is relativity."

During the summer of 1938, between her fourth and fifth years of art school, Mary began secretively working in stone and cement in the bushes behind the house on Beach Drive. "Everyone curious about what I am making in the bushes but I don't bother to explain. Folks want to know what sorta animals I am building out of stone and cement." Mary also began to work in wood. "Walked the beach looking for some wood to carve, emulating African Negro sculptures." Other artists at this time were also looking to non-Western art and pre-Classic art for fresh influences.

She also strolled on the beach that summer with her special friend Carl Hostetter, with whom she shared the only clearly romantic relationship she ever mentioned. During her fourth year of school and the following summer and fall of 1938, his name appears in her diary. She wondered if she loved Carl and thought, "I have no definite plans and time is weighing." She illustrated the first six stanzas of Christopher Marlowe's *A Passionate Shepherd to his Love:* "Come live with me and be my love, And we will all the pleasures prove. . . ." In her diary, she wrote lines such as, "Liking Carl dangerously much. Got lumps in throat." When he left for Arizona for unexplained purposes, Mary wrote, "I wonder what is to become of me." She waited and watched expectantly for mail from Carl and spent most of her time alone. "I don't call or see anyone. There is only one I want to see. Rather, I draw to symphonic music."

Carl visited Mary in Chicago in October 1938. After this visit, his name does not appear again, although here and there in her diary that year, several lines are inked out or pasted over with tiny strips of paper, evidence of Mary's editing. Whatever the relationship with Carl was, it did not come to the conclusion for which Mary might have hoped.

In the spring of 1939, with her bachelor of art education degree accomplished, Mary greeted recruiters who came to the School of the Art Institute, searching for the best trained, most highly qualified art teachers. She was fortunate to be among those offered a position.

"I read and dream and wonder about the future, mostly."

Life drawing class, c. 1933-36.
Diploma from the Art Institute of Chicago, 1937.

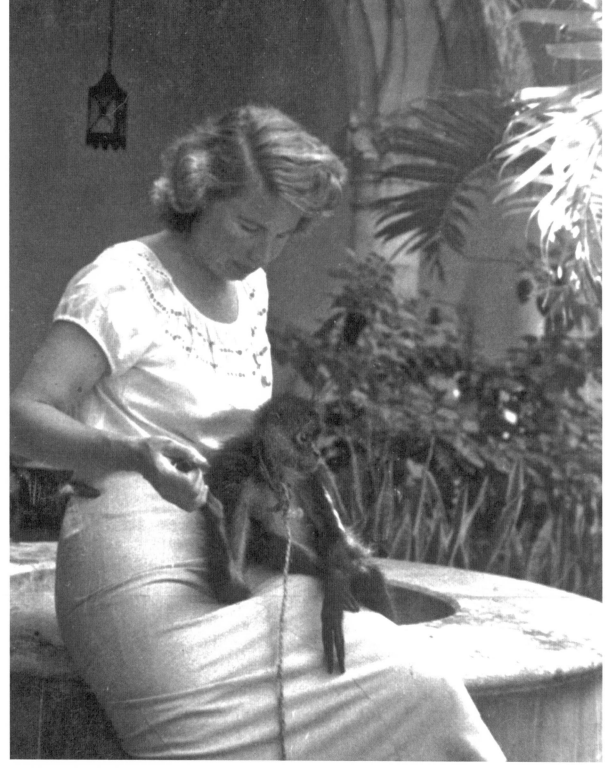

3

Wanderlust

"Adventurers who feel the call of the open road strongly don't let thoughts of danger or lack of money stand in their way."

*T*ravel was a passion of Mary's, and a profound influence on her creative endeavors. Her wanderlust and yearning for adventure were fueled by an intense curiosity about the world. Nerve and boldness, nurtured by her position of privilege and her inquisitive nature, allowed Mary to travel fearlessly. Her annual trips spanned the globe. When friends weren't available to accompany her, she took off alone. When there wasn't an opportunity to stop and draw or paint along the way, she observed and took notes. "Three weeks in a foreign country is just right—just long enough to renew my appreciation of the good old American way of doing things," she quipped.

Mary on the Normandie, 1940.

Mary was firmly rooted to her home along Lake Michigan's shore, a constant source of images as well as materials for her art. Yet her art was also strongly informed and inspired by traveling. Travel was her life blood, an intrinsic piece of the pattern and rhythm of her life. Travel was a stimulation and well-needed diversion from the regularity and exactitude of her daily schedule. Travel opened the door to new ways of seeing the world and offered a vision for the world she was creating on North Beach Drive.

Leo and Emma instilled in Mary a love of travel by providing luxurious trips, beginning when she was thirteen. On a 1927 cruise to Cuba, Haiti, and Jamaica with her parents, for which she missed weeks of school, Mary began documenting her travels in a tiny blue book stamped "MY TRIP." She noted her first ride in a taxicab

and commented, "It took two hours to get to Chicago. There I found my dress was inside out in my great hurry." In childish handwriting, she described Havana's boulevards, lined with stately royal palms, and poor black children begging in the streets. Even as a thirteen-year-old, her powers of observation were acute and her sensitivity to the underprivileged keen.

Over the years, she kept travel diaries of each trip, filling the books with memorabilia—post cards, receipts, menus, coins, stamps, clippings from tourist brochures, and snapshots and drawings of the sights and her companions. Some are beautifully hand bound and cloth covered, others are constructed of simple hand-cut pages held by metal rings. Her writing is insightful, witty, and at times poetic. When Mary drove through Kentucky with college friends, she observed, "scenery in such gorgeous confusion as to outview the imagination, and we artists love natural beauty." On seeing the Alps she saw "children romping in waving fields of daisies, our little petaled pals."

At the age of twenty, in 1934, Mary took off with three girlfriends on an extended motor trip in a roadster with a rumble seat. They drove from Chicago to New York, then south through Charleston, South Carolina, and Savannah, Georgia. "We gum-chewing vagabonds were off," she wrote in her diary, "anxious to burn up the roads behind us. . . . Traveled 3,330 miles in 13 days at forty-three dollars and thirty cents."

Sketches from Mary's travel notebooks, c.1939-1970.

In the summer of 1935, following her first year of college at Rollins, Mary and two friends breezed through Europe on the Condé Nast Grand Guided Tour. They soaked up the pleasures of France, England, Belgium, Switzerland, Italy, Germany, Portugal, and Algiers. "Tried my best not to look like a tourist so I wouldn't be bothered with post card vendors, but they spotted me every time," she wrote in a thick booklet based on the tour. Her observation of Notre Dame Cathedral captured her youthful sarcasm: "If you believed in God it would have been a lovely place to pray."

In Italy, the girls went shopping for Venetian lace wedding veils. One shopkeeper told Mary to come back for her veil in a few years as she admitted to not having a beau. "Too bad our language isn't universal—some of those good looking Italian gentlemen might have proved interesting," she noted.

Mary honed her powers of observation as the young women flitted from country to country. In Switzerland, they hiked in the Alps, marveling at "waving fields of daisies, bright in color, against a background of snow-capped mountains . . . sunlight on the tops of trees and still darkness below . . . little white villages nestled in the green shrubbery." In Germany, they walked along streets lined with Nazi flags and past shops displaying pictures of Adolf Hitler in the windows. In Cologne, they followed Mary's tourist map along the Rhine River, trying to identify castle ruins on the way. But their castle tour soon became tiresome.

"Monotony of beauty," as Mary put it, "as we'd found in the Alps, after we'd seen the first Five hundred mountain peaks." And in Paris, Mary walked for miles around the Louvre. "Saw the Mona Lisa, Winged Victory, Watteau, Hals, Rembrandt. Then I dragged myself home and I was so tired I couldn't feel myself walking."

She wandered through the ruins of Pompeii, storing the ancient images in her memory until years later, when she erected her own rendition of ruins and archways in her lakeside yard. In London, she rambled through Queen Elizabeth's 1583 apartments, noticing "holes in arches through which to throw boiling water on unwelcome guests," perhaps finding inspiration for dealing with her own unwanted visitors later in her life.

 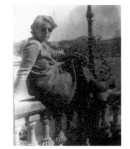

Sailing home on the ship *Normandie*, Mary reflected on what she'd seen. "A glorious happiness fills my heart like a song. At least we have seen the world before it blows up with the next war." The tour was memorable in every way and set the pattern for future travel until age and health problems would keep her at home. At least once or twice a year—sometimes more often—Mary set off to explore another corner of the world, traveling to Europe twelve times in as many years. Except for road trips within the United States, she most often joined organized tours lasting two or three weeks, reluctant to leave her dogs for too much longer.

Travel photos of Mary,
c. 1934–1974.

Following her first year of art school, Mary set out on a summer adventure with her brother Max. In August 1936, they drove to Mexico and along the Pan-American Highway.

Travel notebook (in Missouri), c. 1936; watercolor.
Travel notebook (camping), c. 1936; watercolor.
Travel notebook (Mexico), c. 1936; watercolor.

Extremely frugal in their travel style, they swiped corn from the fields, shot and grilled stray chickens for picnics, and slept in the car by the side of the road. Once, when they arrived at a river bank, Mary wrote that she would "almost rather drive around the river than pay 50 cents to cross" on the barge!

She was filled with awe at the site of the Aztec temple of Teotihuacan outside Mexico City, intrigued by the mystery of bygone worlds of splendor. The Temple of the Moon was under archeological excavation, so they picked through upturned rubble in search of artifacts. Mary loved Mexico and returned on several other occasions. At one time, she considered living there in an artists' colony for part of the year, but instead committed herself to the work in her house and yard.

Two years later the entire Nohl family headed to the West Indies for tropical adventure. Mary, still quite impressionable in her early twenties, found the experience exotic. "Naked Haitians, naked as needles, swam out to meet the ship—to dive for silver coins. Shining copper bodies with oil, kinky black hair and mouths full of money. . . . On the women, wrinkled bright colored dresses hung loosely from strong shoulders. Old shoes with the whole front part cut out to make room for un-pinched feet unaccustomed to the confinement of shoes. Sometimes I saw one or two hats on top of violent violet or red bandanas."

Often Mary would find out-of-the-way, secluded spots to draw, or sometimes she'd sit in the very middle of a busy square. Wherever she settled down to draw, someone would tell her that it was unsafe for a young woman to be there alone. She disregarded the warnings and wandered everywhere to sketch the colorful people, the lively markets, and the architecture.

When Mary traveled, she preferred tents to hotel rooms and outdoor picnics to restaurants. Camping was a favorite pastime. In July 1939, she drove north to Escanaba in Michigan's untamed Upper Peninsula with two Milwaukee friends including Eleanor Hecker, who would later marry her brother Max. The three friends explored haunted houses and ramshackle barns and churches, finding in them rich material for their drawing. "We wanted to stop at every haunted house for a meal, which we cooked on my gasoline compression stove," Mary remembered.

Her far-flung travels would continue well into middle age. In 1949, Guatemala captured her imagination. From the ruins of the indigenous people and the crumbling Colonial cathedrals to the Temple of Kululcan and the Temple of 1000 Columns, the Central American country became the focus of many drawings. Anywhere from Wisconsin farmland to Tangiers, the mysteries of lost civilizations and the remnants of ancient cultures fueled her inspiration. The shapes and forms and figures from her journeys would appear over and over again in her silver jewelry, paintings, pottery, and yard sculptures.

Unable to find a traveling companion in 1971, Mary ventured to Nepal, India, Afghanistan, and Iran on her own. "We were frisked and had to pass metal detector tests at all the airports in all of the countries we traveled in," she said. "I had a bundle of pens for sketching—which looked as though they could be loaded with bullets. They were examined, but otherwise I didn't light up any of their pistol-detecting machines, or make any of their buzzers buzz." Just before her departure from the Milwaukee airport, a television news reporter interviewed her about the trip. "I was questioned as to what kind of a nut wants to fly as far as Nepal at a time when so many planes are being hijacked. I said something about having made a large down payment [on the trip] six months ago. After I got back I was pleased to find that everyone and his dog watch the evening TV news."

The next year Peru was her destination. There she was naturally drawn to Machu Picchu, the fifteenth century "Lost City of the Incas." She marveled at the temples, aqueducts, and steep agricultural terraces. She hiked the trails and stairs of the craggy terrain and ran her hands over the expertly cut stonework walls. "Always had a weakness for ruins," she confessed. "Even old barns make me quiver. And these ancient ruins pitched high in the Andes with clouds swirling by at eye level are particularly spectacular—wonderful for sketching." The tour group camped and paddled on the Amazon in dugouts with outriggers. Mary sent a post card to her dogs, Basil and Sass. "We had a first class adventure in the jungle—like no trip I've ever taken." Fortunately, the tour group left Peru just four days before a devastating earthquake.

In 1972, it was Pakistan. And in 1973 Egypt, where she encountered another perilous near miss. "We were trying to get around sand storms and into Cairo the same afternoon that a Libyan plane was having the same problem. That plane was [later] shot down by Israel with 100 lives lost," Mary reported. In Egypt, she recalled, "I had more time for sketching, which I liked. The Giza Pyramid could be seen from our hotel window. Climbing into them bent in half gave me my first real feelings of claustrophobia. . . . The ancient massive stone carvings, the catacombs in Alexandria, the tombs in the Valley of the Kings, submerged temples that we got to by boat and walked on top of—all contributed to a fine trip."

facing the sea, commanding a fine view - vista of distant mountains, blue sea, and the Gulf of Salerno. And then we continued on the Amalfi Drive which goes through Amalfi up to Napoli. Donkeys with little bells, all dressed up in brightly colored gear. Pink oleanders - our guide picked

Top: Car camping with friends in Mexico.
Middle: Greek village, n.d.; ink painting.
Bottom: Postcard of Italian ruins from travel notebooks.

Clearly Mary was drawn to adventure. In September 1975, she decided to see America by rafting three hundred miles down the Colorado River, camping along the way. "In the roughest water it was important to hold on tightly, and there were quite a lot of thrills," she wrote. "Sleeping out under the stars and watching the moving moon change shadow patterns on the canyon walls, sleeping on soft air mattresses on patches of sand among the boulders made a lovely adventure." Following the trip, she confided to friends in a letter that she loved the thrill and freedom of travel "I haven't missed a trip out of the country for at least ten years. And I have progressed to the point where not being able to find someone to take a trip with hardly bothers me at all."

Spain and Portugal, Yugoslavia and Hungary, Trinidad and Barbados—her trips stretched to every corner of the world. She visited the easternmost outpost of Polynesia—Easter Island,

"Just sketching with a pencil opens up a world of ideas and possibilities."

WAUPECAN VALLEY PARK

Above: Tent camping at Waupecan Valley Park.
Below: Travel journals.

or Rapa Nui, where the unique topography, ancient ritual sites, and petroglyphs cast their spell over her. From the town of Hanga Roa, she hiked to the archaeological complex of Tahai to view Tongariki, where the enormous twenty-ton, sixteen-feet high *moai* heads have their backs to the sea. Chiseled from volcanic rock by a prehistoric culture and hauled around the island without the use of wheels, these giant forms remained filed away in Mary's imagination and would one day appear in concrete sculptures in her yard.

As the house and yard progressed toward Mary's vision, vandalism increased, and because she lived alone after her father died and Emma eventually entered a nursing home, leaving for several weeks became more of a risk. In December 1977, she wrote of her departure to Eastern Europe: "I am sure that I was the only one on the trip who left [home] from a second-floor porch door and down a ladder in order to leave all the doors on the first-floor securely bolted from the inside."

Travel enriched and expanded Mary's life and art. With each trip, she absorbed new ideas and gained fresh outlooks. Indigenous pottery and the Colonial cathedrals of Mexico, cemeteries in India, the arches of Pompeii, and Easter Island's *moai* heads found their way home with Mary and appeared in her yard, in and on her house, and in paintings and drawings, ceramic work, silver jewelry, and sculpture.

All artists are influenced by what they encounter in the world, and Mary was no exception. However, she never admitted that she was affected by her travels or by any art she saw anywhere. Despite what seem to be obvious connections between what she saw and drew on her travels and her art—inside and outside—Mary denied them. If she were aware of the relationships, she did not admit to them. Her one or two annual trips were among the very few luxuries she allowed herself. In travel, she sought needed relief from the constancy of her rigid daily routines as well as adventure and stimulation. Yet she practiced a frugal lifestyle, like her parents. They cooked on a hot plate at home, but motored in luxury along Italy's Amalfi Coast for one of their vacations.

When age restricted Mary's travel, she could review the complete documentation of all her trips in the travel books she had created. She read and reread them, enjoying the memories they stimulated.

"Travel is as much a disease as athlete's foot."

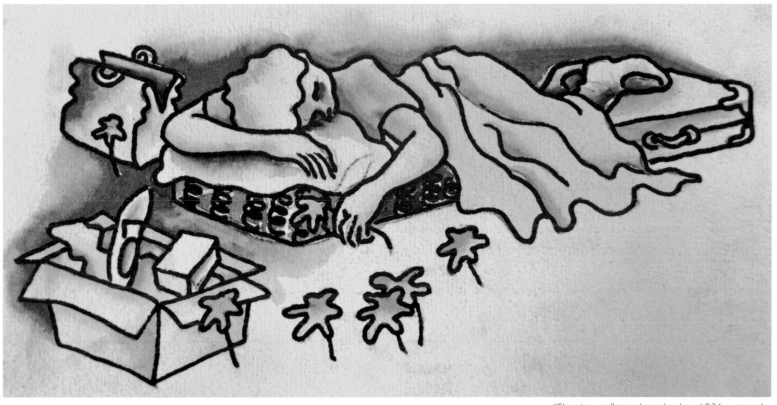

"Sleeping out", travel notebook, c. 1936; watercolor.

Drawing had been her foremost pleasure on every trip. She wrote, "Shiny black wet old-fashioned fountain-pen lines to smooth white rectangles of bond paper is my favorite occupation on trips and particularly in countries loaded with good sketching material. Never seem to see too many castles and palaces, and forts and ancient towns. The most fun parts of each day were out sketching, and I am sure more people would take up sketching if they knew how delightful a way it is to see things."

"We inspected, inside and out, castles, palaces, cathedrals The nearest thing to a romance was with the ice cream man at the top of the Spanish Steps in Rome."

Untitled , c.1940; watercolor.

4

Teaching: Her First Job

"Why I wasted five years school teaching I will never know. . . . The kids were having all the fun."

At the outset, Mary was pleased to be hired to teach art for the Baltimore County Public Schools in Maryland. She came to the district highly recommended and well prepared and began teaching with determination, if not enthusiasm.

In a letter to her parents in September 1939, she wrote, "I am going to feel like a country doctor. I have to cover so much territory. I have five schools, high school and elementary, and all rural, which means I spend a lot of time on trains. For that reason, I am centrally located in the city where I can get all manner of transportation readily." Also for that reason she bought a 1940 four-passenger Chevy coupe for $710 so she could get around more easily. From 1939 to 1941, she taught thirty art classes weekly—forty students to a class—traveling among the schools. In addition to teaching, she was required to register men for the draft and take the census.

Untitled, c. 1942; watercolor and ink.

principals start coming around to review my work and be critical I'll probably drop in a dead faint."

After visiting her class, one of the principals announced that "He wanted to make art compulsory for all freshmen because it was so valuable—that's how good I am," Mary wrote. She also had to give a talk on "pleasing bulletin board arrangements. . . . I don't like the idea very much."

The logistics of the correlated art proved unsatisfactory. The typical problems and challenges that face all art teachers—heavy schedule, lack of preparation time, large classes, the interference of tests and class work—frustrated Mary. She quickly became aware that the other teachers didn't value art as highly as she did, but they did value and respect the knowledge and teaching skill she brought to the classroom. Cooperative and helpful, Mary made herself a vital part of school life, even chaperoning dances. Her construction skills came in handy; while studying Colonial days, she and the kids built a ten-by-eight-foot log cabin in the art room. Mary also constructed sets for the plays and operettas in three schools, built puppet theaters, made puppets with the children, and helped put on puppet shows. "My biggest problem is keeping the kids quiet. Art is so new they find it too recreational for good classroom order," she wrote home.

The work was difficult and physically taxing. Mary was exhausted much of the time. "My special art classes are easy, but the correlation of art with other subjects is being emphasized," she wrote to Emma and Leo. "I have to go into geography, history, French, etc., classes and teach them art in relation to their classroom activities, which is not too easy. . . . I'm becoming less scared of the kids, but when my

February 13 – 1940

19 Hanover Road, Reisterstown, Maryland – % Russells

Sunday, October 22, 1939

Upper left: Untitled (Mary's room), c. 1939-1940; woodcut.
Left middle: Untitled (buildings), 1941; woodcut.
Lower left: Cold Saturday Farm, 1939; woodcut.
Top right: Untitled (students), 1939-1940; woodcut.
Bottom right: Mary's boarding house, 1939; woodcut.

As a young, unmarried teacher, she rented a room in the home of the principal and his wife in Reiserstown, Maryland, and ate dinner with them and other boarders. In letters to her parents—at first frequent and regular, then more sporadic—she hinted at her loneliness and spoke frankly about her dissatisfaction with the work. She informed them that she waited only for the weekends. "This is Friday night—the best time of the week—with two absolutely beautiful entirely free days ahead," she wrote. She socialized with other teachers, but friends of like interests were difficult to find. "The country is wonderful. . . . Today is Sunday and I want to take a hike and it's very difficult to find anyone around here who wants to take a hike."

More at ease in her second year in Maryland, she had time to explore the countryside and the back roads in her Chevy coupe. "I have a backwoods district which will be fun except for the dogs and buckshot," she told her parents. Mary didn't hesitate to take off on her own in search of drawing subjects and quickly discovered the old houses, abandoned mills, and rundown barns she loved to draw. Social outings, bowling with other teachers, and several trips to Washington, D.C., to see museums and galleries provided refreshing escape from the daily grind of teaching.

Mary put forth her best effort, but her interest in teaching soon waned. "Don't know how I can possibly stand it for even one more year," she confided to her parents on October 20, 1940. Once accustomed to the work, the children, and the demanding schedule, she found teaching boring. She derived no particular pleasure or satisfaction from her classes, but rather yearned to be doing the art herself. In later years, when Mary mentioned her brief teaching career, she often said that the children had all the fun.

While Mary was away, Emma and Leo were making more improvements to the house on Beach Drive, staying at the Cudahy Tower in downtown Milwaukee while the renovations were underway. They built a new structure to replace the prefabricated section, dug a basement, and added on to the south side of the house to make it more comfortable for a year-round dwelling. Mary had strong opinions about the new design and voiced them clearly

Untitled (landscape), c. 1939-1941; woodcut.

Untitled (figure reading), c. 1939-1940; watercolor.

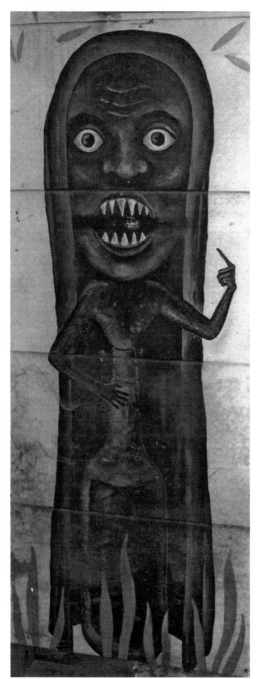
Basement witch, 1941; mural.

in her letters home. When the time came for the final touches, she emphatically demanded green and white stripes for wall paper and a lock on her bedroom door "if Max is going to be around," she remarked. "Hope you'll save the lumber from the old house so I can play—maybe another raft could be made."

On March 25, 1941, she submitted her resignation from her Maryland teaching job. In June, she returned to Milwaukee to live permanently in her beloved lakeside home with her parents. Without a firm plan for alternative employment, she took a job as art teacher for one semester at North Division High School in Milwaukee in January 1941.

The following summer, looking for a new career direction, she went to work at a silkscreen shop in the city, to learn the process. But she quit after two weeks due to the wandering hands of the boss, who indecorously nicknamed her "school teacher." That summer she painted murals in the basement. On one wall, she painted a witch holding a rack for beer mugs. Mary dubbed the basement "Den of Fire." This was a place she could retreat from her parents, drink a few beers, and socialize with her neighbor John Willetts.

In the fall of 1941, with few options available, Mary went back to teaching, this time at Milwaukee's Steuben Middle School. Rosalind Tubesing arrived as a new art teacher in 1944, and the two began a friendship that would last fifty-seven years. Together they shouldered the trials of teaching middle school students. Ros remembers that Mary ran a tightly controlled classroom and was a harsh disciplinarian. When she would enter Mary's room, the children were completely quiet, working on their drawings—a difficult feat with thirty middle schoolers.

Still, Mary was ill suited for the classroom. "She just didn't like teaching," Ros remembers. Mary and Ros unofficially started teaching glass blowing, sneaking around in order to bring this about since it wasn't part of the standard curriculum. The children and their teachers created hundreds of tiny glass animals and imaginative creatures. Mary and Ros also shared a love of adventure and the outdoors. They enjoyed camping and drawing trips and traveling to wooded northern Wisconsin and to Michigan's wild Upper Peninsula. Mary considered Ros a gifted watercolor painter and found her companionship enriching and fun.

Filling her free hours at Steuben, Mary also found a source of fun working in clay, as she had done in art school. The feel of clay, the mystery of the firing process, and the chemistry and precision of the glazes and glaze formulas provided an antidote to the tedium of the classroom, engaging her interest and intellect in ways that teaching did not. After school, Mary worked with clay at home for up to four hours a day. "The bathroom is the clay works now," Mary announced in her diary. She worked on figures, pitchers, and a variety of forms, exploring the ways her ideas could be molded into clay.

On September 6, 1944, Mary's parents handed her an important letter informing her that she would inherit the house and land at 7328 Beach Drive. The letter explained that the property

would be hers to equalize the advance inheritance payments they had extended to Max for his diving ventures. This was good news. With great anticipation, Mary began to formulate plans for a career change and for the more distant future.

Ros left Steuben Middle School to be married in 1945. Mary left the following year. Although the principal had praised her discipline and teaching abilities, Mary was relieved to make a break from teaching and set out on a new path. Later in life, when young people would tell Mary that she had taught their parents in art class, Mary would recall, "If truth were known—I used to beat the kids to the door of the school house on the way home almost every afternoon."

While still at Steuben, Mary already had developed a plan for another career focus. In the summer of 1945, she convinced Ros to find a place where they could learn the pottery business. Ros came up with apprentice jobs for each of them at the Midwest Pottery Company on Milwaukee's south side. As the two friends arrived for their interviews, Mary looked over the pottery. It occurred to her that she might be able to translate her love of ceramics into a profit-making venture. "Would like to learn the business myself and start one of my own," she shared with her diary. Mary and Ros apprenticed at the Midwest Pottery for six weeks, renting a room nearby and working long hours on decorative pieces—bowls, vases, lamp bases, and animals in an art deco style. At night they worked making molds and clay models.

As Mary learned more about production work, her inclination to start her own pottery studio grew. Young, ambitious, creative, and eager to try a new direction, she mulled the idea over. "I keep telling myself that there isn't any reason why I couldn't make a huge success of a pottery venture—and goll darn it, there isn't," she noted in her diary. She begged Ros to forget about her marriage plans and start a pottery business with her. "I've got to get married," Ros told her. "I'm in love." And soon she left for Madison, where her husband would finish law school, leaving Mary on her own.

So she focused on a new challenge: a way to make full use of her creativity, her skills, and her education, while bringing some more fun into her life. With a twinkle in her eye, clay on her hands, and the encouragement of her father, Mary identified a new path.

"Teaching is the penalty I have to pay until I get original."

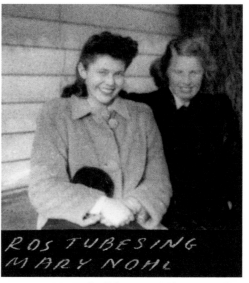

Ros Tubesing and Mary Nohl, 1941.

Johnny Willetts, 1942.

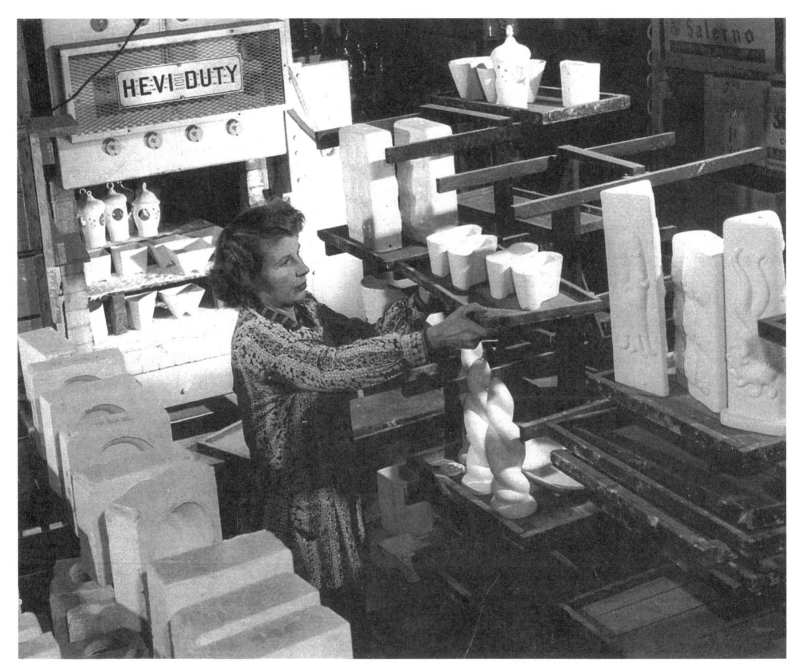

Mary in her pottery studio, 1948.

5

A Most Unusual Pottery

"If I am capable of accomplishing anything, now is the time—while I have my health, time, financial independence. I'll soon find out."

Sketch of ceramic process from sand to ceramic, 1948.

*H*appy to put her teaching career behind her, Mary consolidated her supplies into the house on Beach Drive and continued experimenting with clay. She was motivated and inspired by the challenges of working with clay, a craft she had learned in art school.

She started by mixing clay in the bathtub, using the bathroom as a temporary pottery studio. The cramped space was less than ideal for her early attempts at ceramic pitchers, beer mugs, and playful human figures. Leaning over the tub was awkward and clay inevitably got tracked throughout the well-kept house.

"My bathroom is the clay works now and Mother hasn't said anything," Mary wrote in her diary, hinting at her mother's disapproval.

When Mary began lugging one-hundred-pound sacks of clay and plaster into the house, Emma and Leo finally allowed her to move her ceramic work into the basement. While her parents, particularly Emma, were not overly fond of Mary's art, they didn't want to deprive their daughter, often saying, "Well, if it makes Mary happy . . ."

Mary's father became her biggest supporter, encouraging her to develop a plan to start her own pottery studio. "Dad thinks I ought to build a cement block building and get a town car for lugging stuff," she wrote in November 1945. "He's way ahead of me! I get so scared sometimes and doubt the whole enterprise." Doubt aside, by March of the following year she had designed a forty-by-forty-foot cement block building to function as a studio and shop. "Latest news," Mary wrote. "A cement block building with steel windows and rafters may be built."

Meanwhile, Mary and Leo traveled to Chicago to look at kilns, and, after careful study and comparison, she identified the seventeen-cubic-foot capacity Hevi Duty electric kiln as the one to purchase. A month later, Mary persuaded her father to buy a lot on Green Bay Road a mile from their home for $2,400. This would be the site of the studio. Leo, though, did not need much persuading; he understood his daughter's need for creative challenge. Already committed, he was eager to do all he could to help Mary realize her plan. "I am a property owner!" Mary wrote.

Filled with anticipation, Mary picked up the pace, spending so much time in the basement working with clay, creating inventory, that she had trouble accomplishing anything else. Sketches came first, then face pots, a Christmas head, bells, and hundreds of tiny tea cups and miniature vases. "I can't stop making them!" she exclaimed. She created ashtrays adorned with little figures and an angel on a cloud, his robes flying behind him. She molded a rectangular vase with

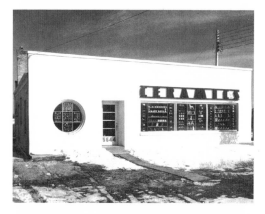

Top: Mary's original sketch for building, c.1946.
Middle: Mary's ceramics building, c.1947.
Bottom: Mary's Hevi-Duty kiln.

dancing figures, a square vase with three chorus line nudes, and a box topped with a fish. Next came a bust of a Negroid woman balancing a dish on her head, then horses and covered wagons, mothers hugging clusters of children, and a lamp base with forty miniature faces.

Working at a frenetic tempo, by April 21, 1946, she had created 118 two-piece molds from which she would produce thousands of pieces of pottery for the shop. In May, she designed a sign for the pottery studio. "Don't know one day from the next—they are all Saturdays," wrote an energized Mary. "There are such limitless possibilities in ceramics—one idea grows into the next."

Construction began in the fall of 1946. Mary checked the progress of the building nearly every day and by October had already finished a wood sign for the front. In November, she designed promotional pieces with tiny clay pots attached for the shop's opening.

With construction almost complete by January 1947, Mary hung the sign "Mary Nohl Ceramics." The wall plastering was completed in February, a truck delivered the weighty Hevi Duty kiln early in March, and Mary finished moving in her supplies and equipment at the end of the month. She inaugurated the kiln with a first firing on the second of April. Pulling open the heavy door to reveal her newly fired pieces stacked inside, Mary was euphoric. When the work had cooled and she had examined it for flaws, she arranged it carefully on the shelves in the circular display window for customers to admire.

Then she gazed around the shop, sighing with satisfaction and relief. Finally her dream was realized—Mary Nohl Ceramics was a reality. She was ready to open for business.

It was a one-woman mass production. She made the plaster molds, poured the white clay into them, fired the pieces, did the glazing, and completed another firing. Although some of her creations were conventional—utilitarian bowls, vases, planters, lanterns, candle holders, and kidney-shaped ash trays—others were fanciful, imaginative pieces. Prancing horses, dragons with curled tails, ghouls and spooks, torso-shaped mugs, and human-headed fish filled her display shelves. Underwater creatures were favorite forms, many resembling the characters she drew for her book, *Danny Diver*, the tale of a deep sea diver in search of friends. Tiny ceramic figures also multiplied in great numbers, dancing, hugging, lolling, and cavorting.

Mary was likely influenced by the streamlined forms of the American Art Moderne Movement. But her pottery more strongly reflects the popular taste and esthetics of the early 1950s, partly because she intended to sell it commercially to florists, gift shops, and individual buyers rather than galleries. She preferred glossy glazes in avocado, gold, grey-blue, red-brown, rose, black, and turquoise.

She had learned well the craft of ceramics at the School of the Art Institute of Chicago and referred frequently to her old class notes, as well as sources such as *The Potter's Craft*

Sketches for lamp bases, c. 1948-1955.

by Charles Fergus Binns, considered the father of American studio ceramics, and Bernard Leach's *A Potter's Book,* dubbed "the potter's Bible." She relied on Leach's book as a guide for glazes, but did not seem to follow his precept, "Form follows function and decoration follows form." According to Leach, pottery blended art, philosophy, design, and craft and brought about a meaningful lifestyle.

It definitely became a lifestyle for Mary. Once the pottery studio opened, she kept a strict schedule, working every day from nine to five, while her dog Pooh kept her company, seated in the window. Determinedly, in the private world of her studio, she created 376 molds and thousands of pieces of pottery. She built shelving, made a test kiln, and engrossed herself in the challenges and problems of the clays and glazes, the kiln, and mold making.

She loved working with clay, but also loved devising equipment and gadgets, preferring to create her own versions of whatever tool she needed. "Working with a new idea, like my test kiln, is the most fun of any of my activities," she wrote. When she saw improvement in her work, she smashed the old molds with an axe and with satisfaction. The physical work was exhausting and satisfying, requiring a nap before dinner. "My hands throb with their new strength and the veins bulge."

Optimistic that the pottery would become a success, she made little souvenir cups to give away and mailed out one thousand promotional cards, telling her diary, "Things ought to start percolating pretty soon. . . . When I get started selling wholesale, I'll get a new lease on life. . . . I'd like to know when I'm going to get my pottery on a

Sketches for vases, c. 1948-1955.

sound financial basis. . . . I have a goal and a means to get to it, even if I'm not there yet. Some one of these days, things will break."

But crowds did not throng to the pottery. "No busy-ness all day, but what have I got to worry about. I should be getting busy on sales, but it baffles me," Mary wrote in February 1948. Her friend and former fellow teacher, Ros Tubesing, now Ros Couture since her marriage, was not baffled. Coming to the rescue, she assisted Mary with sales, advertising, and promotion ideas. Together they filled Mary's car with pottery and set out for selling. When they pulled up at a florist or gift shop, Mary waited, sometimes sleeping in the car, while Ros talked to potential customers. Their first attempts were in the city of Milwaukee, then in surrounding towns of West Bend, Waukesha, and on to Manitowoc and the Fox Valley to the north. Some said the work was too modern, but one purchaser advised Mary, "Your day is coming. . . . More and more people are appreciating this kind of thing." Still, Mary lamented, "The designs I think are the weakest are the ones that sell the best."

Ros helped to increase the number of wholesale customers to over two hundred in Michigan, Indiana, Illinois, and Wisconsin. "Sounds better than it actually is," Mary wrote. Every time they went on a sales trip, Mary's head would ache. And she worried because Ros was going to have her second baby and soon would not be available to sell pottery.

In anticipation of Ros leaving her on her own, Mary read Dale Carnegie's book *How to Win Friends and Influence People.* "Guess I'll have to do what Dale Carnegie says—'Do what you most fear'—and deliver my ceramics."

Ceramic "spooks", c. 1952.

It becomes a challenge rather than a fear." She discovered that selling wasn't so bad, but still experienced "pottery selling headaches," and delayed sales trips for rain, heat, cold, and headaches. "I can think of more damn reasons to put off selling and yet at the same time I enjoy it—though it doesn't have the security of being at 5644," the address of her pottery studio. "Wonder how many important people I miss at 5644 when I'm out selling."

Around the same time that Mary Nohl Ceramics went into business, a number of other pottery studios appeared. The Midwest Pottery was active in South Milwaukee, the Wisconsin Pottery near downtown Milwaukee opened their doors, and The Milwaukee Potters' Guild also launched their studio on the corner of East Juneau and North Astor. Mary was familiar and friendly with some of these artists; they were both competition and community.

Making a go of a pottery studio and shop was not easy. Besides headaches, she experienced nightmares. "When I wake up in the middle of the night and start worrying about pottery, I just have to dismiss it from my mind—because I can't get anything solved then." Mary watched as her hair suddenly began to turn gray. "Silver strands among the gold—all of a sudden. How to get gray—have a pottery! Sometimes I . . . feel like the only thing to do is to scream. . . . If I had financial problems too, I think I'd go crazy. . . . I could take things easier if I didn't keep thinking that Mother and Dad want to hear of progress."

To Mary's annoyance, Leo inquired daily, "What's new?" After a few

Sketches for "spook" figures, c. 1952.

months, he stopped asking, but he shook with tension whenever they talked about the pottery. "Wish I could tell him I got a $10,000 order," she mused.

Leo announced that it took $17,000 per year to run the pottery, advising Mary to work up a sales talk and put more effort into sales, but her interests did not lie in that direction. She considered living at the pottery, undoubtedly hoping for more independence from her parents, but Leo told her that would be too expensive. Emma and Leo couldn't restrain their concern over Mary's venture. They stopped in weekly to check on business, to bring their thirty-four-year-old daughter ice cream cones, and to help with chores such as dusting shelves or raking. Mary felt smothered by their probing questions and their intense attention to the everyday goings on at the pottery studio. Of course she realized that their financial investment in her effort had been crucial to getting started, but nevertheless she chafed under their watchful eyes.

One day she sold thirty-five dollars worth of pottery and was gleeful. By the end of February 1948, Mary was selling a piece or two daily, amounting to five or ten dollars worth, to customers who dropped in to the pottery. She tried new approaches to making a profit. People constantly asked if she gave lessons, so she did—eight for eight dollars—but soon tired of this. Thinking that ceramic tiles might improve business, she devised a tile press, and created a series of tiles displaying sayings such as, "You must dare all things to gain all things." Still, business remained disappointingly slow.

In addition to lining up a respectable number of wholesale and retail outlets for her ceramic wares, Mary also sold work at the Milwaukee Art Institute, now the Milwaukee Art Museum, in annual seasonal sales organized by the Wisconsin Designer Craftsmen organization, which she had joined. In 1949, the first year she participated, her work sold out, thirty-three pieces, mostly horse-and-wagon pieces and candy dishes. She entered other exhibits but was annoyed by the arbitrary nature of jurors. She was discouraged, for instance, by a rejection notice from the prestigious Syracuse Ceramic Show in New York. She had submitted her glossy mold-work pieces, but the art world was more interested in hand-built or hand-thrown pottery.

"It's funny how I go up and down in this pottery business. When I'm down it's not too bad though—because I know I'll be up again before too long," she told her diary. "I wonder when I'll meet with real success. I expect to get there sometime—I have to, there's no turning back now—but when? When will I get there?"

The pottery was an obsession. As *The Milwaukee Journal's* "Meet Your Businessman" column, Sunday, December 2, 1951, described it:

An ear shattering bell rings when the door opens to advise her of a customer's entry. She is usually in the back shop, wearing blue jeans, a sweater and a smock. She might be making or casting molds, pouring slip or dipping bisque-fired pieces in glaze. She has a hot plate to make coffee, an orange crate to sit on, surrounded by shelves bearing 350 molds and pieces ready to be fired. She is evidently comfortable in

Mary's pottery wares, c. 1948-1955.

these surroundings, and pleased with her pottery, if not always with its products. "You never know until you take it out of the kiln," she observes, "and then, if it's wrong, it's too late.... Working with ideas is the most interesting phase, and translating them into ceramics comes next."

Her Rollins College Chi Omega sorority magazine also published a favorable, chatty article about her pottery venture, labeling it "Milwaukee's most unusual pottery." These articles brought in more customers, but not nearly enough.

Mary's friends occasionally stopped by the shop and eagerly offered to buy her pottery. But Mary refused to take their money, preferring to give away her work. One friend pleaded to let her buy something, but Mary told her to send somebody Mary didn't know to make the purchase instead. Her friends tried to convince Mary not to be so relaxed in her business approach, yet she was not dissuaded from her own eccentric style.

Several commissions came her way, including an order for one hundred cocoa bean dishes, which Mary enjoyed producing. In 1948, Schuster's, Milwaukee's premier department store, wanted Mary to produce some conventional ceramic ware for them. Leo encouraged taking this opportunity, but Mary declined, saying it would be a last resort. The fact that she did not need to earn money allowed her to reject less-than-perfect opportunities and hold to her ideal: "Being conventional is worse than all other sins." Nevertheless, she longed

for her business to improve. "Wish I knew how to find a pottery public. They are certainly coming slowly," she complained.

Mary pestered Leo to turn ownership of the pottery over to her, believing she would feel more at ease and less guilty about her lack of financial success if she were the sole owner and if her parents were not so closely connected to her work. Mary got her wish. On December 31, 1950, Leo transferred ownership to Mary's name, a value of about $13,300.

"My one thought in the matter," wrote Leo, "is to have you happy in this undertaking and to leave you free to run the ceramics business as you see fit. I have always been confident of your very careful supervision of your finances." He not only gave her the property, but freed her from repaying the six thousand cash he had advanced. Happy for this gift and free of the financial strings, she continued to hope for success. "One of these days I'll have lots of pottery, no flaws, lots of money."

While Mary operated the pottery studio and shop, inklings of future creative efforts appeared in her diary. Most of the ideas she recorded were eventually realized. "Looking at stones on the beach with a new eye, but they are frozen into the sand," Mary wrote. She tucked this idea away and some years later incised angular faces into smooth, round stones, binding them with silver to create stunning and heavy necklaces. "Have the desire to do some painting—occasionally—makes me feel strength when I know I can express myself in that

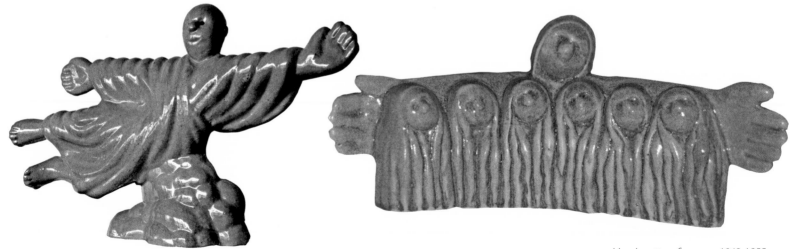

Mary's pottery figures, c. 1948-1955.

way. Golly, it's wonderful to have that feeling." Her unstoppable creative drive constantly sought new outlets and propelled her forward. Not content to work in one medium, she better fit the model of the versatile Italian Renaissance artists she had studied in Helen Gardner's art history class.

The routine at the pottery, Monday through Friday, was followed by Saturday household chores and yard work for which Leo paid Mary. Sundays brought visits and dinner with elderly relatives and brother Max, and later with his wife Eleanor. In the evenings, Mary usually stayed in, despite her father's urging for her to go bowling at the University Club, and on Saturday nights, her mother would bring four caramels up to her room, ". . . sort of a consolation prize, I guess," quipped Mary in September of 1949. Her mother had cause to worry about her daughter's social life.

It was limited. Occasionally Mary, her father, and sometimes a friend attended travel talks. Now and then Mary, Emma, Leo, and family friends had dinner out at their private club. Television came into their lives and provided an extra diversion. They liked mysteries and *The Trouble with Father*, and Mary particularly liked nature and travel programs. Often they watched the news together while eating dinner on their TV dinner trays.

Because of delicate health and nervousness, Emma was reluctant to attend public affairs, so Mary accompanied Leo to several events nearly every week. Leo, charming and entertaining in public, often presided as master of ceremonies or featured speaker at Masonic dinners, Optimist Club dinners, banquets for the Red Cross, and other organizations. Mary enjoyed the drinks and dinner, and at evening's end she would circle the dining room, collecting meat scraps for her beloved dog Pooh.

A black cocker spaniel Pooh, was an integral part of Mary's life. He rode in the car to the bank and grocery store and was her constant companion. Throughout the years, she had other pets as well: Sass, a schnauzer; Tico, a poodle; Basil, a beagle-cocker mix; and Icky and Tinker, mixed breeds. The dogs enjoyed living in what had been Mary's childhood playhouse, and each received lavish amounts of love and attention. The family of raccoons she befriended and fed for a year and two monkeys all thrived in her care.

Pottery shop window display, c. 1948-1955.

Mary's five-year diary, 1953-1957.

Mary's relationships with old school friends also remained significant. She visited friends from the Chicago Art Institute who lived in other cities and saw that their lives had changed in ways that hers had not. She was not envious of their husbands and children but rather was happy to be unencumbered, appreciating her life as it was.

During the years that Mary pursued clay, 1946-1954, her diary was her silent friend and sounding board. The diaries contain a full account of her activities but reveal little of her inner world. Nor do they hint at her motivations for making art. It may be that her art was so completely entwined with who she was that insights and observations about its meaning were impossible for her to make.

Her entries are not introspective; on a typical day, she noted her ongoing work with glazes and molds, mentioned who came in to buy or look, and listed the tasks of upkeep and maintenance. Frequent were notations about her weight, the condition of her complexion, what she ate, and what she ate too much of, such as gumdrops, chocolate candy, or ice cream. She noted mundane matters such as buying horsemeat for Pooh, or thirty-six pints of toffee ice cream—on special at Walgreens—for herself. Infrequently she commented about the outside world, as on April 10, 1951: "Listened to MacArthur's speech to Congress in Washington—saying goodbye to military life," and again on April 23: "Milwaukee getting ready for MacArthur's visit on Friday."

In April 1954, in a rare moment of self-examination, she commented about her diary keeping: "Sometimes I question the value of accounting for my life this way. . . . Very seldom reread it, though I do, occasionally. Helps me remember where all the time has gone. . . I'll never want to throw them (the diaries) away—and there is no one to inherit them. But there is some kind of drive that keeps me writing in them." Although Mary never said as much, it is likely she was lonely during many periods of her life. Her diary was a safe and silent friend with whom she could share the mundane matters of her life, a constant companion.

Characteristic of the family's regimented nature, the Nohls saved the evidence of every transaction and accomplishment and apparently all and every sort of written communication. Emma watched over and organized all notes, letters, photographs, receipts, and report cards. Mary carried on the custom. While she recognized that there would be no Nohls following her, nevertheless it seems that she considered her diaries a piece of the family history. It is likely she believed that someone else would read them. As a teenager at summer camp, after her pals had playfully grabbed her diary, she wrote that she never put anything in the diaries that she wouldn't want the whole world to read.

Even though Mary enjoyed the company of others, temperamentally she was a loner. For periods of her life, she experienced the isolation shared by many women artists. She was not part of a community of artists, but was on friendly terms with some and was not totally lacking a support structure. She met other women artists in Milwaukee, including Elsa Ulbricht, who ran the Wisconsin State Teacher's College WPA arts project; Charlotte Partridge, director of the Layton School of Art; Dorothy Meredith, weaver and professor at State Teacher's College, now the University of Wisconsin–Milwaukee; and Lucia Stern, a painter.

In the spring of 1950, Mary was invited to join the Walrus Club, founded by journalist Faye McBeath, painter Gustave Moeller, and others, to bring together journalists, artists, and musicians for discussions, lectures, and social occasions. Mary was reluctant at first, but then accepted. The Walrus Club became one of her main social connections and a significant link to other artists. She exhibited occasionally with Club members and attended their events, dinners, and get-togethers. She had encountered a lively group, expanding her social life, opportunities for fun, and contact with others of like interests.

Elsa Ulbricht, who became Mary's close friend, directed the Summer School of Painting, later known as the Oxbow Summer School, in Saugatuck, Michigan. She convinced Mary to attend in June of 1950. Under the auspices of the School of the Art Institute of Chicago, this residential summer art school, in an idyllic wooded setting, attracted artists from throughout the country. Mary studied landscape painting and silver working with Robert Von Neumann, who was among the many outstanding teachers. The woods and sand dunes on the Michigan lake shore, the comfortable run-down cottages, an old lighthouse and rickety boat house, and, most of all, the fun and camaraderie, were memorable.

Mary loved the weeks spent here. It was a carefree, creative time of painting, picnics, walks on the beach, and cocktail parties in the evenings, at which Elsa Ulbricht, a free spirit, performed her scarf dance. Mary, always ready for fun, attended the "cliché party" wearing a playful get-up of hundreds of paper thumbs pinned all over her, representing "I'm all thumbs." Reluctant to leave Saugatuck, she wrote, "My days here are numbered—counting them up so they won't pass so quickly."

Inspired by the silver-working class, Mary returned from Saugatuck and immediately ordered equipment for a work area where she could continue making jewelry. After working with clay all day at her pottery studio, she delved into silver for several hours in the evening. "Got all worn out from being so creative the last few days. Can't sustain those streaks indefinitely," Mary recorded. Indeed, she drove herself to create. As she noted in her diary: "Don't get much reading done—have to be producing." And from the time she opened the pottery she referred to the constant up-and-down nature of her moods in relation to her art.

Between 1950 and 1960, Mary created 350 pieces of silver. "Silver is my favorite craft material. . . . It is more beautiful than gold because of the contrast of the polished and oxidized parts—and much less expensive to work with. I have made several hundred pieces of jewelry, combining silver with stones and enamels. I keep most of them in my box at the bank, just in case our wooden house burns down. When the attendant pulls the box out from the wall she nearly tips over backwards with the weight—and I am sure she thinks it is something illegal. . . . I am thankful for tolerant parents, who, if they don't understand my approach to painting and my designs in silver and clay, they don't interfere with my efforts and say that if Mary is happy that is enough. If this does not constitute enthusiastic support, at least it is no hindrance to production."

The silver pieces—pendants, necklaces, bracelets, rings, and earrings—bear Mary's characteristic iconography; they reflect her love of the lake and her life lived beside it. Tiny figures in boats, waves, fish, fish-like people, and mermaids are frequent subjects. The other pieces are an array of abstract shapes, mask-like faces, and dancing and flying figures. Some of Mary's titles—or they may simply be her way of designating the pieces—indicate familial themes: *Father and Son—Long Noses, Mother and Child, Figure Holding Two Kids, House, Moon and Two Figures.*

Several had ingenious moveable parts; a silver book ring had tiny pages that turned. On one ring, two tiny silver figures embrace behind a door; on another are four fish, a tiny figure in the mouth of one. Still another ring supports a miniature figure in a bathtub, complete with soap dish. Mary liked the challenge of this small scale. "There are a lot of things that can be done on a one-inch-by-three-quarter-inch surface," she asserted.

Silver book with moveable pages, 1958; 1¾" x 1" x ¾".

Silver medallions, c. 1958; 2 ½ " x 1/4.

She reworked a number of these rings into bracelets. Throughout the years, Mary reorganized and recombined pieces and parts to create new configurations. Pins became pendants and bracelets became necklaces. She used silver coins and also melted down her mother's silver souvenir spoon collection and later several of her parents' silver wedding gifts, considering her jewelry a better use for the material she loved. "It is only fair to warn people to check their sterling silver after I have visited," she wrote to friends in her December 1977 letter. "There is an affinity between me and silver—I hunt it up and melt it down."

Mary took efforts to exhibit the silver work; some was included in the Wisconsin Designer Craftsman exhibit at the Milwaukee Art Institute in December 1950. Painter Lucia Stern told Mary that her silver caused more comment than any other work in the show. Mary was elected to the board of Wisconsin Designer Craftsmen and was nominated for president, but she declined this responsibility, most likely because she wanted art as her life focus and needed to maintain her daily schedule. The obligation of organizing others sounded much less appealing than organizing her ideas and materials into new forms.

In August 1951, she submitted paintings and ten jewelry pieces to the Wisconsin State Fair Exhibit, which, at the time, was a reputable venue for artists. Her paintings were rejected, but seven silver pieces were exhibited. She was in good company. Harvey Littleton, renowned glassblower, also showed work in this fair. The exposure brought in new customers and curious viewers to the pottery shop. In 1955, The Huntington Gallery of West Virginia, under the auspices of the Smithsonian Institution, included a silver pendant of Mary's in a traveling exhibit.

In March 1949, Mary discovered the treasures and pleasures of the village dump and began to make frequent forays there. Her lifetime practice of scavenging, begun in childhood, was as much a part of the rhythm of her life as were the sounds of waves on her shore. "It's too wonderful what you can find out there!" She gathered earthenware jars, rolls of wallpaper, rope, twine, boards, dishes, colored glass. She couldn't resist any free material, of any kind, that she might come upon, anywhere.

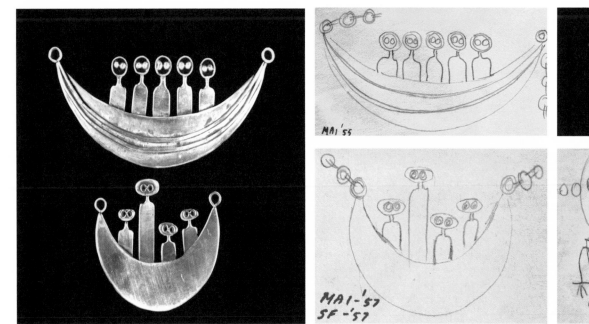

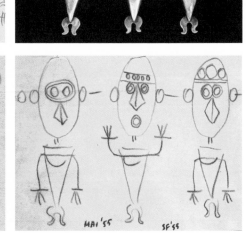

Silver pendants with preparatory sketches, c. 1955-1957.

Over a period of months, Mary hauled home approximately thirty bricks a day—old bricks that had been removed from Walnut Street in downtown Milwaukee, then dumped off near her pottery studio. She stashed them in the bushes behind the house. "Now I have thousands of bricks and mother doesn't want me to do anything with them," she wrote in September 1951. "Mother says no more bricks home—so those bricks will just have to wait until I'm president here—and then there will be plenty to do with them." Her parents also rejected her plan to make the yard into a pine forest. But other ideas were percolating. "Would like to arrange this house sometime—on the outside."

Mary's efforts in clay and her commitment to the pottery business were gradually dissipating. "Glaze fired and I think another element burned out!!—and I am slowly burning out myself," she told her diary. A growing awareness of her wealth likely played a part in Mary's diminishing interest in running her pottery. "Wore my dark glasses and ankle socks in to the bank. It's sure nice having all the money I need—prospects of a lot more, and freedom to create just as I please." Mary was grateful to Leo for the comfortable lifestyle he provided. His wise investments and thrifty ways resulted in an accumulation of wealth that enabled the family to live as they wished.

In many ways, Mary followed in his footsteps; she valued frugality in all things, led her life with a rigid sense of discipline, and maintained order at all costs. Like her father, who hated Franklin Roosevelt, she was a Republican. "Voted for Taft in the primaries," she declared on April 2, 1952, then the following day, "Joined the Republican Party." Politics aside, Mary's

marked sympathy and sensitivity to others was often evident in response to news items, such as the June 16, 1953, demonstrations against Julius and Ethel Rosenberg. "Anti-communist riots spreading," she wrote, and on June 19, when the Rosenbergs were electrocuted, added: "Makes me feel sort of sick every time I think about it."

While Mary worked at pottery and silver, the idea of painting kept recurring, "so it will probably break out one of these days." She responded to this urge and by November 1952, had set up an area for painting in her pottery studio and was pondering her progress with watercolors. She moved on to casein paint, a flexible, alkaline paint that can be transparent or opaque, smooth or textured, and then to oil paint. "I experience the heights and depths of oil painting all in one day. . . . My pottery has the turpentine stench now," she observed about the switch she had made from clay to oil paint. Pleased with her development, she exhibited six of her paintings with Walrus Club members.

When Emma and Leo made their periodic visits to the pottery studio, Mary quickly hid away her painting supplies. She feared they suspected painting rather than potting. This was indeed the case. "Mother asks me occasionally if I do any painting at my pottery. I evade the question." In December 1952, Emma told Mary she should think about selling the pottery to stay home to care for the house full time. "Father looks around without saying much . . . but he suspects other activities and can't find them." By September 1953 Mary had packed almost all the pottery in wooden apple boxes, planning that she might leave the pottery studio. Gradually, clandestinely, she moved the thousands of pieces of pottery

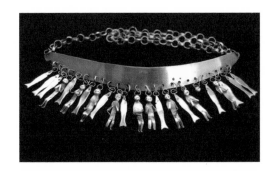

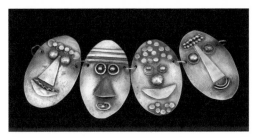

Silver jewelry, c.1955-1957.

Friendly Enemies, c.1936-38; pencil.

Mary sized up the ping-pong room in the basement with an eye to having the pottery studio there at some later time. "I see no reason to not do creative work all the time since I do not need money." On June 10, 1952, she recorded her net worth as $43,242.50 including stocks and bonds and her pottery studio and 7328 Beach Road. "Maybe sometime I'll adopt a war orphan to spend my money on," she wrote. She spoke to Leo about wanting to leave money in her will for prizes for Wisconsin artists and for Layton Art School scholarships, inspired by having her silver work on display in the Layton Art Galleries. But Leo recommended leaving her money to Max, an idea Mary firmly rejected.

On October 23, 1953, Mary pondered her future, envisioning how life would be when she was alone. "When I think how old Mother, Dad and Pooh are, I get the shivers—I'll be the only one left, I suppose, in a few years. Dad's breathing is almost groaning sometimes – makes me nervous." The following day, Leo had a stroke. It significantly affected his speech, and although he recovered, Mary observed that her father, after sixty-two years of practicing law, was mostly reading law journals at his office and had become uncommunicative.

Their relationship was strained; Leo often would not reply when Mary spoke to him, perhaps harboring anger and regrets over the fate of the pottery. "Poor father—can't figure out why his children act the way they do," Mary wrote of Leo's changing attitude. "We give him the same stuff he's been giving us over the years—and he does not like it—nor recognize it as originally his. . . . [Meanwhile] Mother's palsy causes the dishes to rattle." As her relationship with her parents grew more difficult as they aged, Mary struggled to have her own independent life as an artist. She was approaching a crossroad.

After a stretch of years with an active social life with other artists and her Walrus Club companions, Mary seemed to withdraw, disappointed by people and annoyed by relationships. She was overly sensitive to small slights and disagreements. She would not forgive someone who forgot to call her or showed up late for a date. "Maybe I expect too much of people. There are so darn many I have to get sore at," she noted. "My pleasure will have to be in perfection of my painting and in Hawaiian dance."

home to the basement and continued painting in the pottery studio. "Worries me what I'll do with all my jewelry after I make it."

In 1953, Mary wrote for the first time about the future of the body of work she had been creating. "If anything happened to me, what would become of all my silver, my bonds in my box at the bank and my paintings?! End up the day by sitting in the display room. Nice end to days. I'm feeling peaceful . . . It unfolds so gradually. Wonder how much more there is to unfold. Wonder if next year I'll feel the same about what I'm doing now. I hope so. There are so many changes I'd like to make around the house. Keep counting all my wonderful blessings—I certainly have them."

Mary set aside clay but she was constantly expanding her interests. She was inquisitive, curious, and open to new, and sometimes quirky, possibilities. On hot summer days, she lay down on the pottery studio's cool cement floor to rest after a long session of painting. And when she was cold on below-zero days, she practiced her Hawaiian dancing to warm up. At home, after her mother and dad were in bed, she would gyrate to Hawaiian music in her bedroom.

In January 1954, Mary had the kiln disconnected in her pottery studio as surveying began for a new road that would cut through the property. When referring to the demise of her pottery Mary always explained that it closed when the road went through. While this was true, her interest in making pottery and in operating the business had faded well before the clover-leaf expansion for the freeway was built. She had tired of working in clay and was discouraged, perhaps because little of her enormous inventory sold and perhaps because she had exhausted all her ideas for clay. The road expansion offered a convenient finale to her work in clay "As a money-making venture it was not outstanding," she admitted. "There were numerous problems, but it was fun."

Mary did express some regret over the demise of her pottery studio. If the road expansion had not forced her to close, she might have been content to continue painting there. But it was this turn of events that helped her initiate the most significant and engrossing of her life's projects: the transformation of her home and yard on Beach Drive. Emma had her own very proper opinions about the appearance of the house and the yard, and Mary respected this. Mindfully, she consolidated all her supplies, her thousands of ceramic pieces and her paintings, into the house, and then kept on creating, patiently awaiting the day when the house and yard would be under her control.

Pottery shop inventory stored in the basement of her home, c. 1957.

"Just hope I live long enough to finish all I want to do."

Mary with Icky and Pooh, 1973.

6

The Creative Years

"I like the days best when I have a lot of projects—each so much fun that I don't know which to do first."

Mary and the blue gate, 1963.

Family tragedies and transitions were the prelude to Mary's most productive years, 1960 to 1973. Distressing yet liberating, the changes propelled Mary forward to begin in full force her work on the house and property.

With a phone call to the Nohl family on February 6, 1960, the decade commenced on a grim note: Mary's brother Max and his wife Eleanor had been killed in a head-on collision in Arkansas as they returned from a vacation in Mexico. Max's greatest accomplishment was his world record-breaking deep water dive in Lake Michigan. He had then devoted many years attempting to salvage sunken cargo in Florida, the Great Lakes, and elsewhere, with limited success.

Mary's reaction to Max's death was in many ways detached, ambivalent. His life as a diver and adventurer had taken their toll on the family, both emotionally and financially. As she reflected in her diary, Mary felt a sense of relief that his escapades would no longer distress her parents and felt freed from their troubled and adversarial relationship. "New sensation to be an only child," she wrote. "I am sure Mother and Dad know it is best this way. . . . Second article on Max in the *Milwaukee Journal*—reviewing his adventurous life. Bodies due back in Milwaukee tonight. . . . Getting painting and piano hours in without too many interruptions is difficult." Mary only briefly mentioned the funeral, and described how she had sorted through boxes of Max's

things and with finality, burned his diaries and most of his papers on the beach.

In December of the following year, Mary's father died at the age of eighty-seven, following a bout with cancer and a brief hospital stay. "Dad died around 9:30. . . . I got home from guitar class at 9:45—telephone ringing." Having observed the affection shown to him by a nurse, she entered a revealing (and rare) analysis of their relationship in her diary. "Our relations were never that. And he established them—which I regret. I've missed a lot." Near the end, she noted, Leo had wanted her to hold his head and hand. "Quite unusual for our austere relationship."

Leo Nohl had developed a reputation as an excellent lawyer and was equally successful as an investor and manager of his money. Mary estimated her father's worth at $700,000, "too much for me to even think about." Staunch and dignified, he was a respected contributor to the Milwaukee community. "Nice article in *Milwaukee Sentinel* about dad, except it alluded to Napoleon," Mary quipped in her diary after his death. "Mother is the one who is really missing Dad—to talk to. My activities keep me upstairs," where she painted, ate lunch at her bedroom desk, and gazed out at the soothing surface of Lake Michigan.

Mary's sense of propriety and respect for her mother's wishes had restrained her long-time desire to begin her work on the family home. But she knew the time would come when she would take

Top: Painted phone, c. 1960-1998.
Bottom: Detail of living room chair, c. 1960-1998.

over. "Keep thinking about the changes I'll make around the house when I am free to do so," she wrote. "Fixing up the house will serve as a distraction after mother goes. . . . Mother is really sinking. Keep wondering what it will be like around here with only me."

Mary did not totally restrain herself. As Emma's health declined, Mary, with growing awareness of her potential to take over, experienced a surge of creativity. In March 1960, she began small alterations on parts of the house—small enough so they wouldn't alarm her infirm mother. She brightened the garage windows with chunks of colored glass and, out of debris that had washed up on the beach, crafted driftwood figures. "I must be having my most creative years right now—getting lots of ideas about everything. . . . Everywhere I look. . . ." Working quietly around her mother, Mary secretly added her creations to the house and placed work in the yard. But she remained concerned that Emma would disapprove. "Think I'll put my (four) driftwood figures on the garage without telling mother. . . ." Weak, infirm, and unaware of her daughter's plans, Emma never noticed the additions.

In April 1963, the family doctor advised Mary that her mother's years "are about through." Always frail and delicate, Emma weakened even further. With her senility advancing, she finally was admitted to Bradford Terrace Nursing Home. Mary visited faithfully, at

first twice a day, then daily, for the five years that Emma languished.

The visits were stressful and tedious. In April 1963, Mary reported that "Mother talks about my fiancé and wants to see the ring and wants to know what line of work he is in." She wearied of attempting to communicate with her senile, nearly deaf and blind mother. Playing her guitar during her daily visits served as a distraction for them both, while her gifts and treats of cookies and ice cream expressed her genuine concern. While Mary monitored Emma's medical needs and witnessed her deterioration, she also felt a distinct relief from constant responsibility for her care.

Indeed, living alone was liberating; the following years were among the most gratifying of Mary's life. Finally unleashed, her creative drive flourished, unrestricted by the constraints of parental surveillance, freed from financial strings and the expectations of her father. It now had a chance to flow to fruition. After years of fantasizing, she dug in with gusto to this daunting but delicious task. The property was now hers—interior and exterior, roof, trees, yard. She launched her claim, beginning tentatively, then proceeding exuberantly, first by cleaning out her mother's dresser drawers, then her entire room, "so I can do something with it," as she remarked. "Can't decide whether to tell mother or not. She told me to take over and I really am."

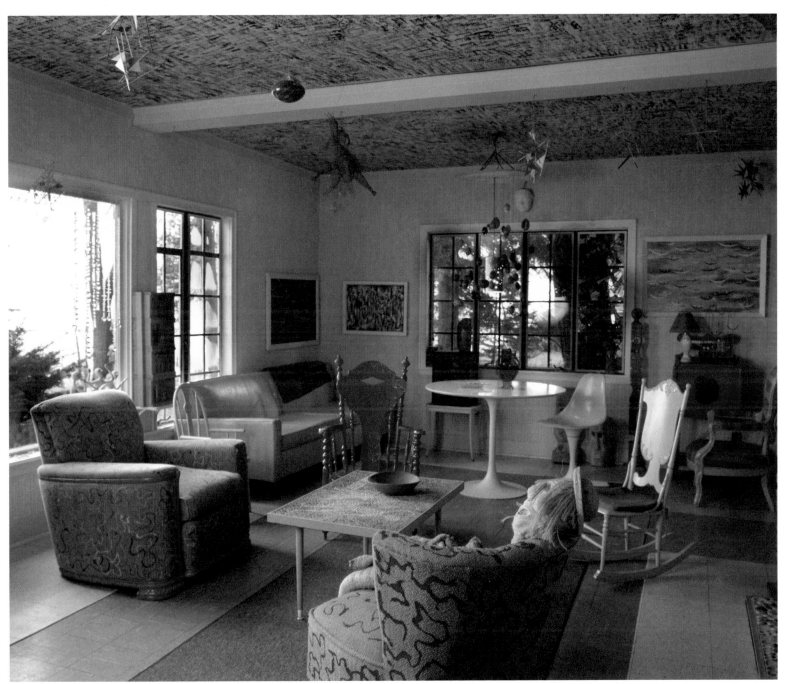

Living room, c. 1960-1998.

The Creative Years 71

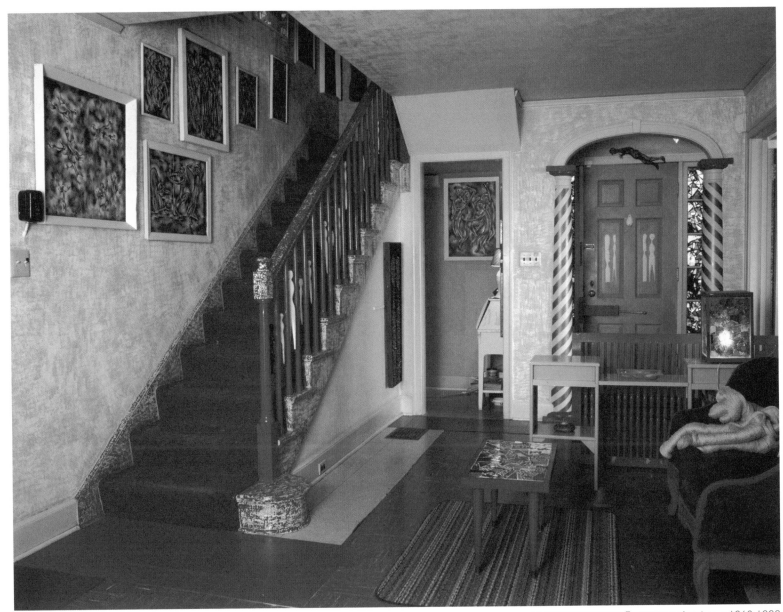

Entryway and stairs., c. 1960-1998.

Inside

Although she was initiating the total transformation of 7328 Beach Drive, Mary seemed most excited about changing the interior of the house. Each day she allotted a series of tasks to alter the place where she had spent most of her life. The number of tasks would make anyone frantic, but Mary's approach was methodical, each step with its logical and significant place in the transforming process. The daily eight lines in her diary chronicle the myriad steps toward her vision. "Keep telling myself to relax, I will enjoy more all this putting in order of 7328. . . . Can't decide which part of the house to work on. So many things to be done."

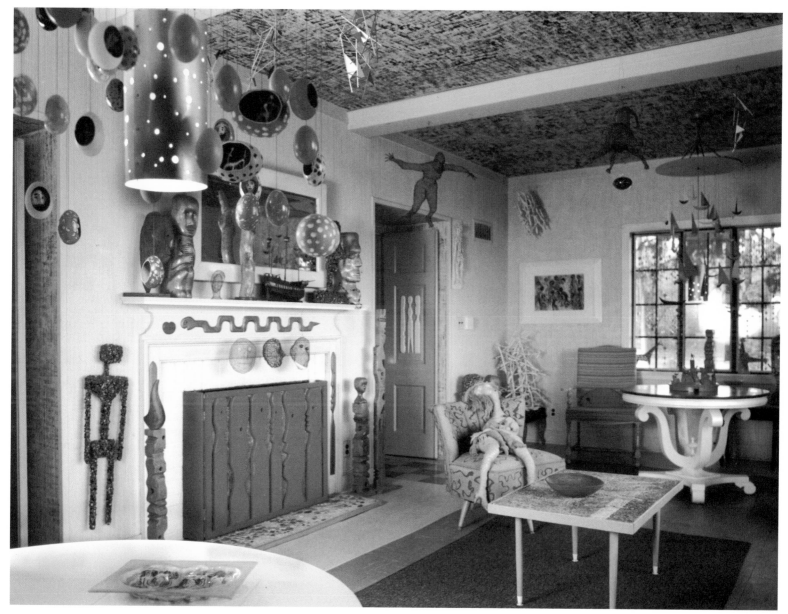

Living room, c. 1960-1998.

With her eccentric vision, Mary reconfigured everything: china, crystal, chandeliers, and antique furniture. Every room and every surface began to reveal her magic hand. Some of the furniture, along with many of her mother's belongings, books, and other household contents, she discarded or donated to charity. Other furniture she made over to her liking; she recovered chairs, for instance, with wine-colored corduroy.

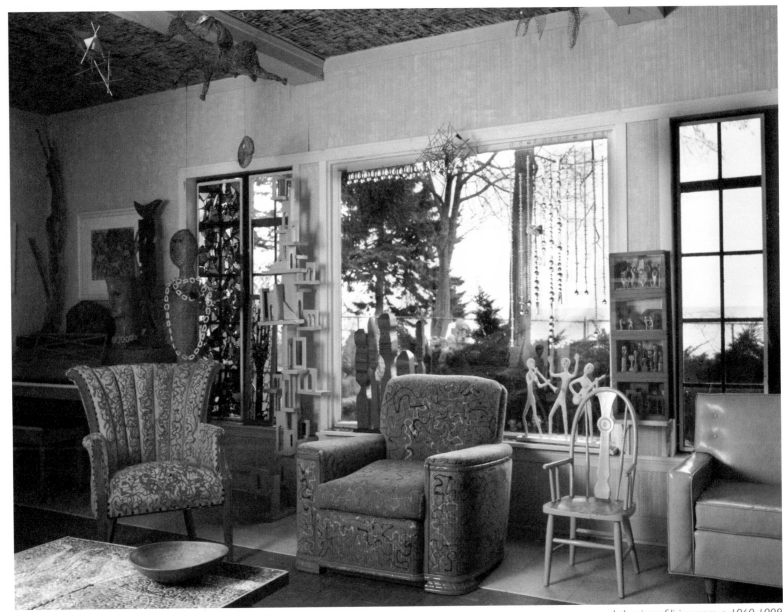

Lake view of living room, c. 1960-1998.

Mary went wild with color. She painted the legs of the antique mahogany dining room table white and covered it with black-gold-and-white-streaked vinyl. She painted the matching chairs and a music box red and the four-poster bed lavender, and she chose silver paint for the crystal chandelier. She bought turquoise paint for inside the garage doors, gray paint for the house, and pink for the library. "Buying so much paint at Badger Paint they're getting to know me." A multicolored stippling technique, applied with a piece of carpet attached to a mop handle, was so satisfying that Mary covered all the walls and ceilings with it in various combinations: black over red, red over turquoise, light blue, black, and white. Bright red paint improved the stair railing, and the addition of forty-one dangling, carved wooden spook figures and fish between the posts created subtle movement whenever someone climbed the staircase or closed the front door.

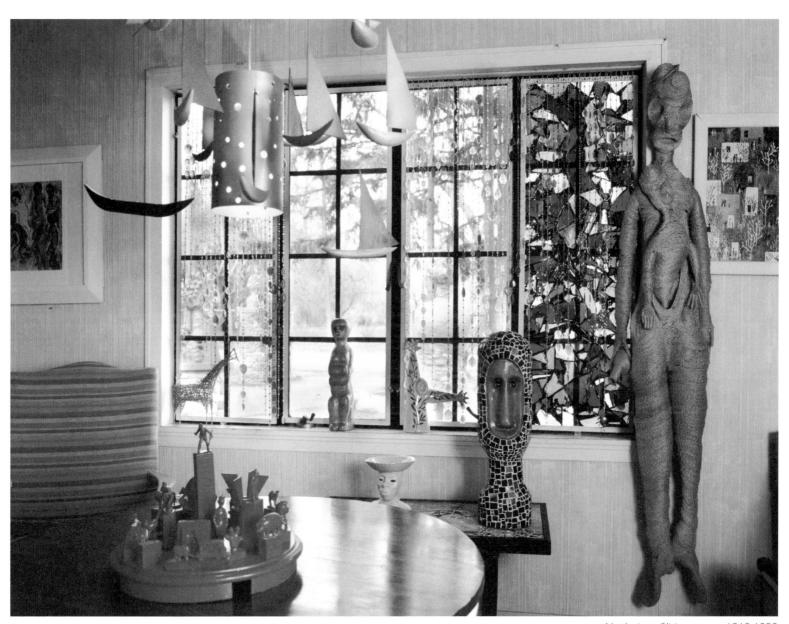

North view of living room, c. 1960-1998.

No surface remained untouched. Every room was undergoing alteration. Turquoise and gray linoleum tile on the floors added more color to the rooms and created a sort of "geometric abstract painting," as Mary described it. On the household rugs, she swirled black paint in energetic swoops, followed with a random splotch-and-drip pattern. A few years later, she perked up her wardrobe by applying a similar treatment, spiraling and splashing black paint on a red, fur-collared coat she would wear for thirty years and on a favorite outfit, a red sweatshirt that she paired with lime green bell-bottoms. Years later Mary would claim with pride that she had purchased no new clothes since the 1960s.

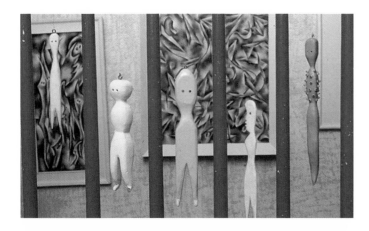

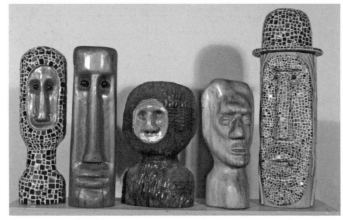

For a few weeks, scrambled eggs filled Mary's breakfast plate. Each morning, to preserve the egg shells, she carefully blew out the egg whites and yolks and with cuticle scissors snipped oval window openings in the shells to present tiny dioramas of cavorting figures within. She painted the eggs in bright colors and suspended them, along with egg-shaped stocking containers, from a turquoise disk to create a mobile, hanging it over the table in the front room. As she continued to make changes, she walked through the rooms, beaming with great satisfaction at what she had accomplished and always thinking ahead. "Getting set to do a lot of little wooden scenes in boxes on a pole. Can hardly wait to get started. Looks like fun."

Her unending stream of ideas resulted in more dioramas, constructed like small towers in her front room. In some, the viewer peers through glass windows at frozen scenes of tiny wooden figures climbing staircases, moving through archways or across small platforms. Mary said the tiny creations reminded her of the large-scale dioramas she had seen as a child at the Milwaukee Public Museum. But she adamantly denied any influence of similar works by such prominent artists as painter Giorgio de Chirico, who made mysterious paintings of stage-like settings, or Joseph Cornell, builder of small assemblages encased in boxes.

Mary was happy with the interior alterations. "Everything is improving at a great rate here," she declared. "The only thing that interferes with my complete enjoyment—mother might not approve [of] all things." This nagging thought did not deter her efforts, although Mary did feel guilty about what she was doing to the house her mother had once carefully maintained in a very proper manner. She informed Emma that she was putting gray trim on the house when in fact she was, in her words, "going crazy."

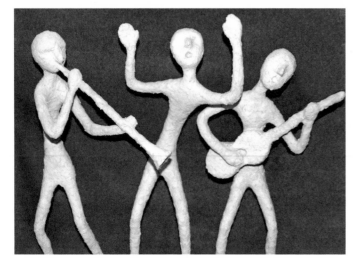

Top: Stair railing with hanging wooden figures, c. 1960-1998.
Middle: Carved driftwood heads, c. 1960-1998.
Bottom: Three musicians, c. 1960-1965; flour water and sawdust .

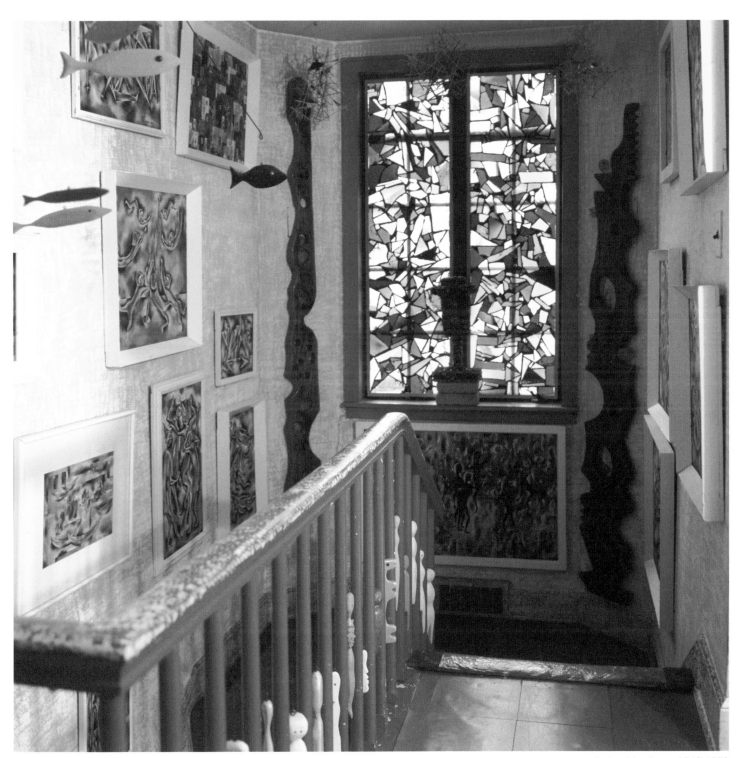

Stairwell landing, c. 1960-1998.

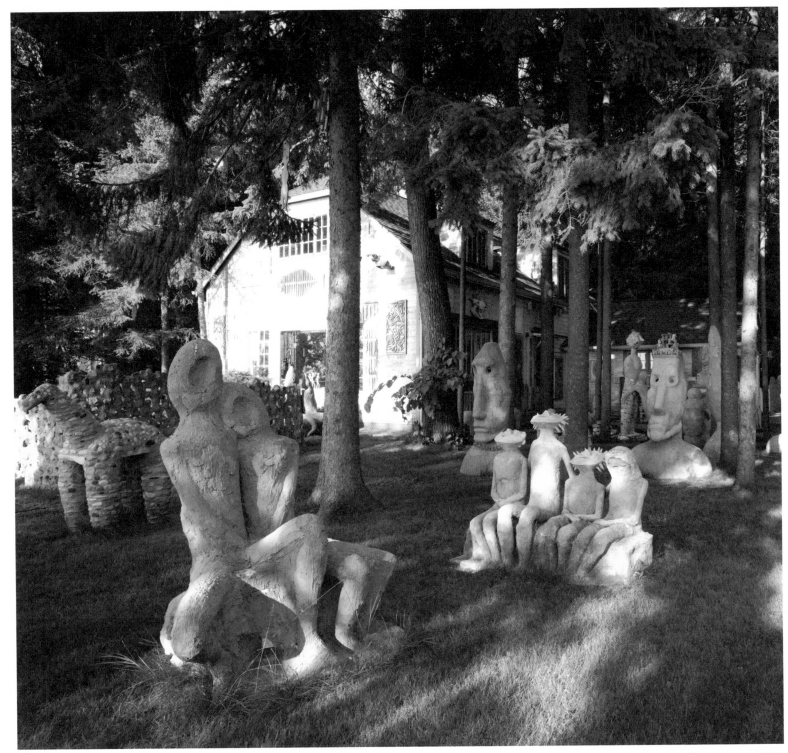

East facing yard, 2008.

Outside

Once Mary felt liberated, neither the walls of the house nor the property lines could constrain her. With a burst of creativity, she extended and expanded her reach, out the door and into all directions, even to the lake. Using pipes and concrete blocks, she anchored long-poled flags bearing her name out in the lake, purchasing waders to access them for repairs. She sawed "floats" out of plywood to bob on the waves: a pink whale, fish, serpents, and men in a boat—and anchored them out in Lake Michigan with bricks. As she grew bolder, she marked the property as her own by embellishing the house façade and bordering the windows with wooden fish, animals, and stylized human figures, adding mosaic panels made from painted beach pebbles.

Mary had an enormous supply of bricks; the thousands she had dragged home from the pottery studio served many purposes. But most she laid down for a walkway from the front door to the lake and encircling the house. "All the changes around 7328 are so much fun to watch. . . . Having a flood of ideas—from floats, mosaics, and abstract sculptures."

She fashioned a skeleton out of cloth triangles, built an outdoor fountain, and motorized ducks to revolve in a pond. She constructed a ten-foot-tall driftwood man for the front yard and positioned an imposing blue driftwood man over one of the five fountains she built. Playfully, she embedded black beach stones at the front doorstep, spelling "BOO." In November 1966, Mary attended a welding class, adding skills that expanded the possibilities for new projects. The goals she set for herself kept her motivated. "Trying to cast three sidewalk squares with pebble surfaces every day," she reported. "Working on cement fish torsos every second day."

Mary wrote that she had once seen a large chunk of wood carved into the shape of President Kennedy's head—an image she clipped for her idea book. "So I'm going to try some wood sculpture with a chain saw." Collecting large logs she found on the beach, she carved immense figures, several over eight feet high and massive in girth. One, neither human nor animal, has pointed ears and a startled expression; it is both haunting and playful, with hands, carved in relief, over its stomach. Two glass eyes stare straightforward, as do another pair of marble eyes, embedded in its chest—perhaps the spirit companion residing within.

She also carved trees still in their original place. "Overhanging the beach I had two carved figures made from a double truncated tree," she wrote. "They were about six feet high and talking to each other with their hats on. Some boys brought in a chain saw and sawed through sixteen inches of tree trunk and got away with one of the carvings. The next day I sawed off the other and got it up to the house for safer keeping . . . all three-hundred pounds of it, with the aid of my trusty winch." Mary's dealings with vandals would continue for her lifetime.

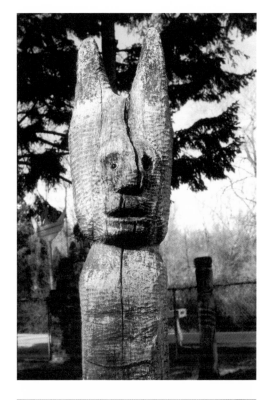

Top: Driftwood sculpture, c. 1960-1998.
Middle: House embellishment, c. 1960-1998; wood.
Bottom: Doorstep, "BOO," c.1960-1998; stone & concrete.

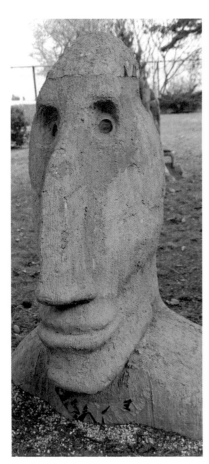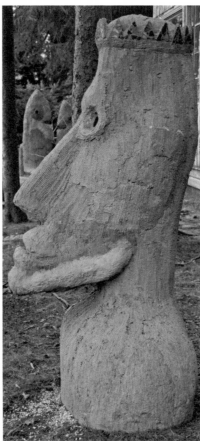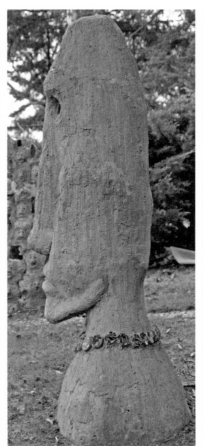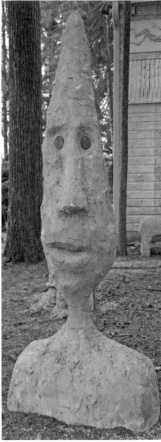

Concrete heads, c. 1960-1998; concrete and glass.
left to right: (1) 72" x 39" x 45", (2) 63" x 52" x 45", (3) 78" x 45" x 39", (4) 91" x 46" x 25".

By 1963, her most active year by far, Mary was thoroughly enjoying herself. "I keep reveling in my ownership and freedom to do anything that I want with 7328." Working in the living room, a space not previously available to her, she laid out wood pieces for a new driveway gate and simultaneously worked in the front bedroom on a pergola for the yard. The gate, a playful arrangement of figures and fish, demonstrated her skill in creating rhythmic pattern, the area in which she had excelled in art school.

As she painted the new gate Lullabye Blue, she was pleased to see people slow up in their cars to look. Pedestrians would stop to talk and admire what she was doing. This growing attention only encouraged her efforts. "I get such satisfaction out of doing all the jobs that have to be done around here—now that I'm boss," she said, basking in her independence. "Still have hesitations about changes I'm making, though it isn't possible Mother could ever get home."

Her pleasure extended to building with cement. She would haul loads of sand up from the beach in a wagon, as she and her father had once done to make the stone gateposts at the end of the driveway. Mary enjoyed the physical challenge of this vigorous work. "All the neighbors know when I'm out in the yard working on cement and stone sculpture. I have a red metal coaster wagon that I got at the dump. I wasn't too proud to quietly put it in my car. . . . When that wagon has a hundred pounds of stones in it headed up from the beach . . . we can be heard for blocks around."

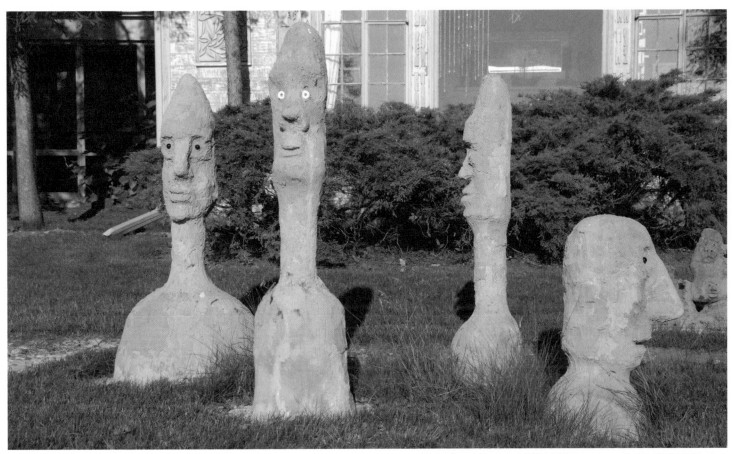

The Poets' Corner, c.1960-1998; concrete and glass; 56" x 94" x 54".

Mary looked at the expanse of her yard, relishing the opportunity to enhance it in any way she might choose. At the northeast corner of the house, she erected four tall busts made of concrete, likely influenced by the *moai* heads she had seen in Papua, New Guinea. They face east toward the lake, north toward the entry gate, and to the west, as though guarding the entrance to the house. These concrete busts are the most haunting of Mary's work. The largest is close to six feet tall—his attenuated skull and jutting jawbone render both a harsh and regal appearance. Pottery shards enhance his crown, and closely set glass marble eyes accentuate a striking resemblance to her father. Another huge head, which Mary sometimes referred to as "cone head," stands sentinel nearby. All are somber in expression and compelling both in size and in the mystery that surrounds them.

In the southeast corner of the yard, she created another area of similar but smaller enigmatic heads, calling this *The Poets' Corner,* never explaining why. Nor did she ever reveal what she was thinking when she erected these mighty heads.

Nearby, in marked contrast to the solemnity of the large busts, four life-size concrete figures sit on a bench, their heads thrown back in exuberant smiles. Not far from them grins another benevolent creature, a whimsical mixture of happy dog and dinosaur, his concrete coat dappled with beach stones. Also encrusted in stones, a large basin surrounds a concrete fountain inset with colored glass. And close by a concrete archway embedded with stones frames views of the lake, as if through ancient ruins.

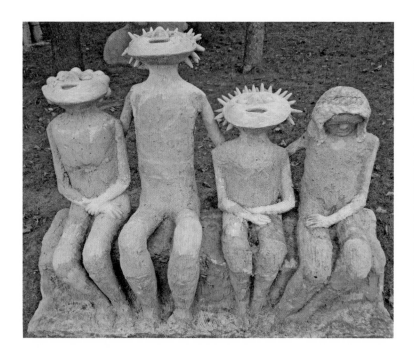

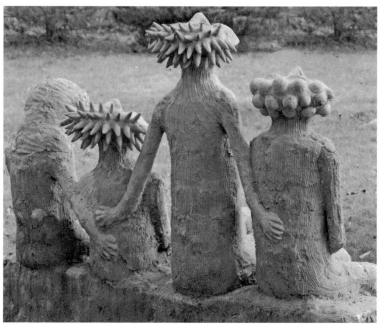

To the west of the driveway, in an area that is now wooded, Mary erected a huge, two-part piece she sometimes called *Hall of the Mountain King*, after Edvard Grieg's symphony, although the work appears more Asian than Norwegian. Intricately molded and dripped concrete forms lacy openings and bits of colored glass here and there catch the morning sun. Next to this, in a shift of scale, is an eight-inch-tall circular Stonehenge-like structure, almost hidden by leaves and pine needles. Although small, it is monumental in its presence and reflects Mary's love of ancient architecture. She referred to it as *Pompeii*. Mary imbued this work with mystery and traces of cultures long gone, of places she had seen, sketched, and admired.

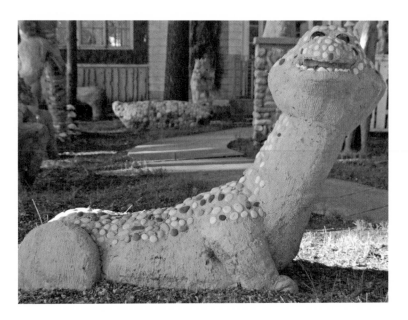

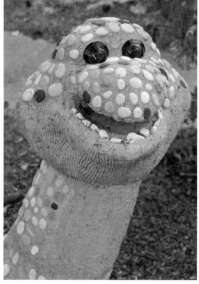

Above:
Untitled (children), c. 1960-1998;
concrete; 44" x 60" x 26".
Left:
Untitled (seated dog/dinosaur) and
detail of head, c. 1960-1998;
concrete and glass; 36" x 52" x 18".
Opposite page:
Top left:
Hall of the Mountain King, 1960-1998;
concrete and glass; 102" x 168" x 65".
Top right:
Ruins, 1960-1998; concrete and stones;
8" x 96".
Bottom:
Wall of Faces and detail, 1960-1998;
concrete and glass; 60" x 156" x 8".

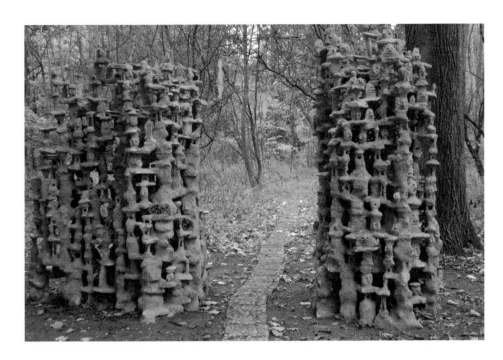

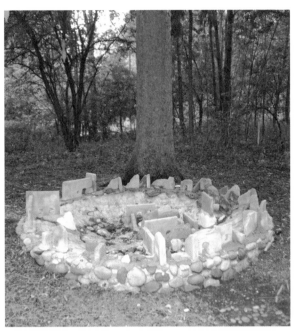

Mary delighted in her privileged position. "It will be wonderful if my health lasts because my interests are so many. I enjoy my time. I am a lucky dog. I am because I've pursued and developed interests. My big problem is jealousy among people who haven't reached the level of fun that I have. The higher you go in any field the bigger the problems are."

"I like the days best when I have a lot of projects—each so much fun that I don't know which to do first. So much to do everywhere around house and yard and fun to do it—though I get a little worn out after 6 or 7 hours of activity and I want to lie down."

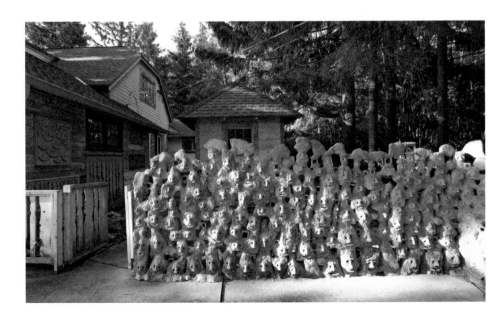

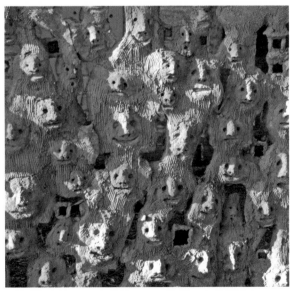

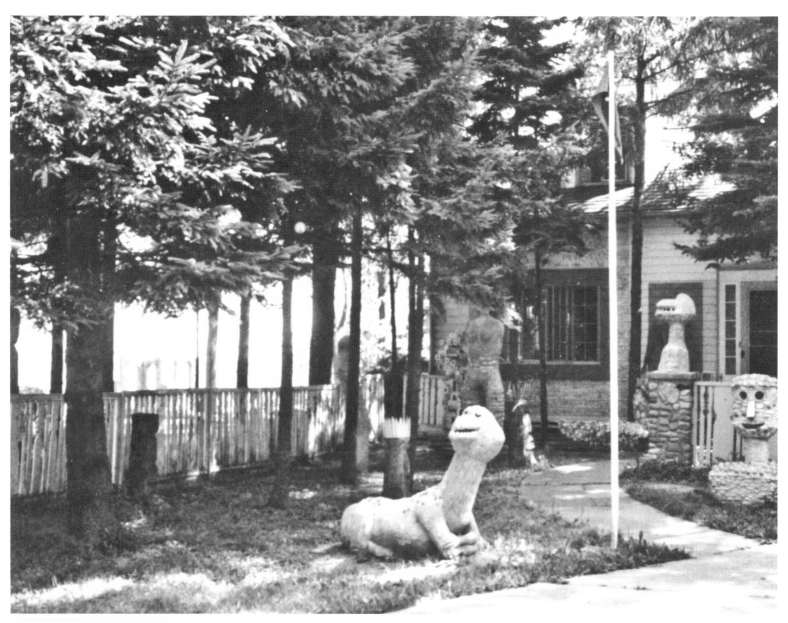

The Creative Years

In this photo taken in 1973, the white profile fence divided the entrance area from the lake. Later Mary removed the fence and hung the wooden profiles in the trees so that the vandals could not steal them.

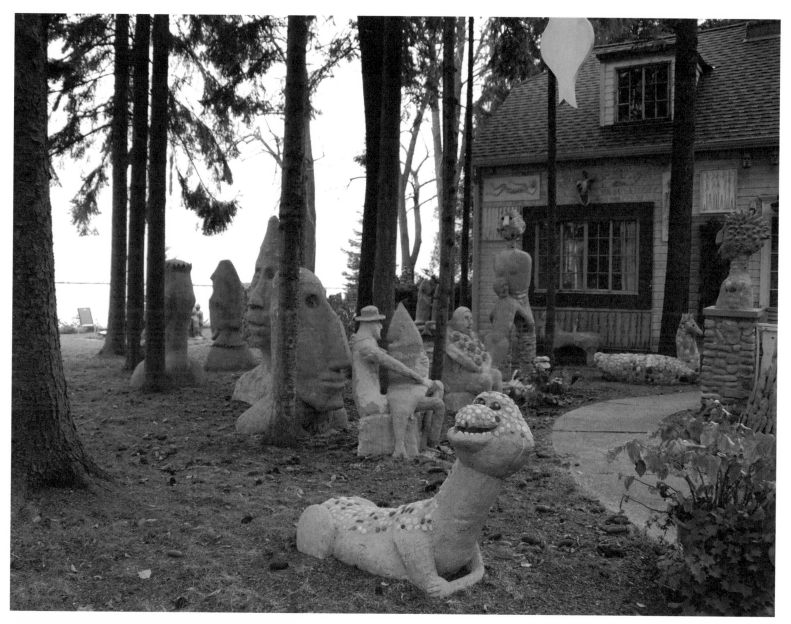

In this 2008 photo, most of the original concrete sculptures remain standing, but many wooden pieces have been removed or vandalized. Over the years, Mary added new concrete pieces and attached wooden embelishments to the house. The evolution of her property continues.

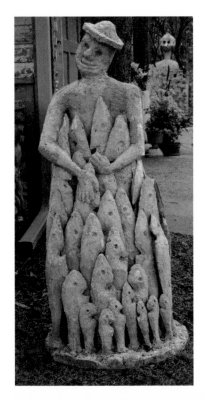

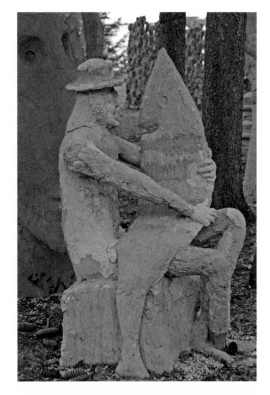

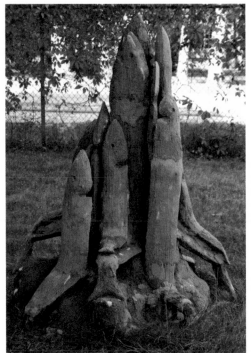

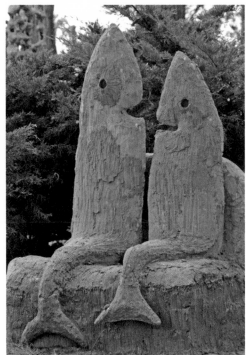

Left top: Untitled (man with many fish), c.1960-1998;
concrete; 60" x 30" x 22".
Right top: Untitled (man and fish), c. 1960-1998;
concrete; 52" x 33" x 25".
Left bottom: Untitled (many fish), c. 1960-1998;
concrete; 46" x 36" x 36".
Right bottom: Untitled (two seated fish), c. 1960-1998;
concrete; 58" x 40" x 30".
Opposite page:
Left top; Untitled (men with hats), c. 1960-1998;
concrete; 31" x 45" x 27".
Right top; Untitled (seated couple, west yard),
c. 1960-1998; concrete; 40" x 44" x 32".
Left bottom: Untitled (seated couple), c. 1960-1998;
concrete; 63" x 47" x 32".
Middle bottom: Untitled (children), c. 1960-1998;
concrete; 44" x 44" x 40".
Right bottom: Untitled (mother with children),
c. 1960-1998; concrete; 47" x 28" x 35".

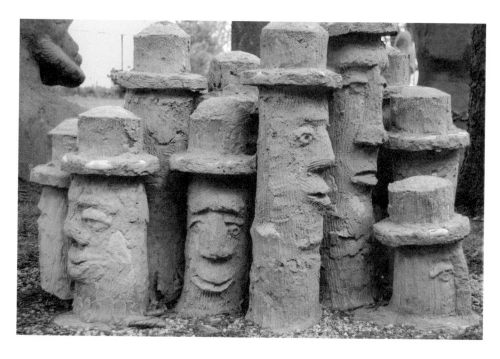

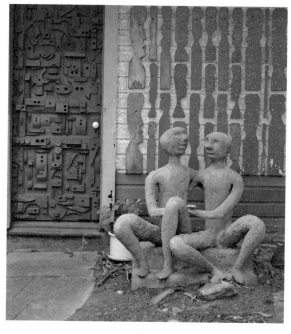

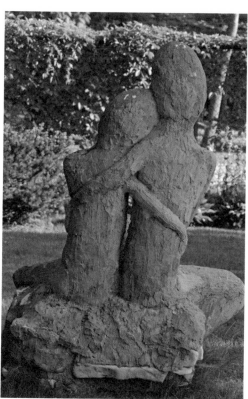

Materials

Although Mary had studied classical art techniques using traditional materials such as oil paint and watercolor, her own approach to materials was quirky and eccentric. Art education classes at the School of the Art Institute of Chicago had encouraged the use of every sort of material, and the influence of the Surrealists and their incorporation of found objects had a significant impact on her. But her original fascination with found materials and her desire to create with them began in early childhood and persisted throughout her life.

Anything within her reach and grab held potential for realizing her ideas. She rarely used anything in an orthodox way. Sand, stones, the endless supply of debris washed up on the beach, and her discoveries in the junkyard were her preferred materials. She was immediately able to imagine ways to make use of them; the fact that they were free likely enhanced their appeal to the frugal Mary.

As she wrote in May 1965, she cooked chicken bones "to dry them out for sculpture," mounting them on the kitchen cupboard doors in the shape of miniature human skeletons. From her own mixture of flour, water, and sawdust, she molded three-foot-tall musicians around wire armature and covered a papier-mâché bust with fur. "I think it will be sensational!" she exclaimed.

Mary's search for materials was incessant. One day while walking along Lake Drive, she spotted some "lovely shiny bolts" and picked them up. To her embarrassment, the telephone linemen working nearby suddenly appeared to claim them. "Frequently," Mary wrote, "I return from my walks with a great variety of souvenirs—balls thrown from cars, boomerangs, car tools, pliers and wrenches, and the bits and pieces in the flotsam along the edge of the lake defy the imagination. . . . I couldn't live without all the things that keep washing up on the beach." With her vibrant imagination, she saw great possibility in all she found. Each find set more ideas spinning and moving her into action.

Top: Chicken bone skeletons, 1960-1998.
Bottom: Mary's kitchen cupboards with chicken bone skeletons, 1960-1998.

Her basement was filled with an array of neatly organized detritus, at the ready, for her imagination to transform. Ropes, wires, and cords of all dimensions, from tiny to enormous, she coiled neatly and hung in rows from the ceiling according to size. She categorized plastic toys and rubber balls into boxes. Describing her attempts to bring order to her scavenged treasures, she wrote, "There are boxes of leather which include fragments of Dad's old brief cases. One box marked 'mouse traps' I was able to eliminate because I prefer the poison method. . . . There are boxes marked 'junk' which are not much different than the boxes marked 'miscellaneous'. There is even a box marked 'boxes', which is a large box with smaller ones inside. There are boxes of colored church window glass, carved linoleum blocks, small picture frames, hotel stationery. . . . There is a box of watches and clocks that don't work, pine cones, bamboo, kiln brick."

There were also shells, wood, sticks, stones, bones, combs, feathers, marbles, puppet heads. Jars full of bottle caps, old dog tags, outdated screw-in fuses, old razor blades, dried out ball-point pens, fish hooks, and lures. And perhaps the ultimate example of her pack-rat habit was a box filled with yellow felt sunflower campaign buttons sporting the slogan *Win with Landon*, aging mementos of the presidential campaign of Alf Landon, who won Mary's vote but lost the election to Franklin D. Roosevelt in 1936.

Mary was a compulsive saver and conservationist in every sense of the word. She threw away nothing, wasted nothing. Whether working in, on, or around the house or on her silver, paintings, or sculpture, tearing things apart and putting the parts back together in new ways was her approach.

"Someday I might run out of living space in the house because of my compulsion to save all the materials that I'm sure I'll need for some future project. Just for instance—some of my cement animals wouldn't have any eyes if I hadn't saved a carton box full of blue and green glass insulators from telephone poles that I found on a country road twenty years ago." Mary recognized the need to dispose of some of this, but "Try as I do, I am incapable of disposing of these accumulations."

Top: Collected items.
Bottom: Mary's workroom.

Mary and friends pouring concrete, 1973.

Techniques

In her ceramic work, Mary had conformed to traditional techniques and standard methods, following her art school training. However, once she packed away her pottery pieces into apple crates and stored them in the basement, she was ready to do things her way. For her ceramic work and paintings, Mary executed thousands of sketches. But for the outside sculpture, it appears that she worked spontaneously without preparatory drawings. She had in mind a notion of what the piece would be and worked directly to bring it into being. She had a broad knowledge of a variety of techniques but usually added her own twist. If she didn't know how to do something, she simply figured it out.

Her approach was to devise, invent, and improvise, using what she found and scavenged. Occasionally, when necessary to her vision, she purchased materials, but then fabricated the artwork in a method of her own ingenuity. She contrived two jute men, a woman, a baby, and a dog by slowly coiling strands of jute, carefully stitching each strand to the previous one, painstakingly forming three-dimensional but floppy figures. By carefully weaving and interlocking wire in a sort of open-work finger knitting method, she formed a five-foot-long man, a small cowboy on horseback, and a floating head. She suspended them in her front room where they revolved, ephemeral and ghostlike. The wind chimes that she dangled from the trees were simply "strips of window glass, notched with a carborundum wheel, and hung on old fish line that washes up on the beach."

For concrete sculpture, Mary mixed cement with beach sand and stones and formed it over a light armature made from anything that would work, embedding ceramic pieces, glass, or stones for decorative touches. Later, for theft prevention, she added heavy stones for weight and embedded them deeply into the cement. A favorite approach for finishing cement surfaces was to stroke a plastic comb through the wet cement to create a ridged, linear pattern—a light touch on massive bulk.

Over the years, various driftwood men, craggy and powerful, appeared in a variety of colors: blue, red, white. Mary nailed and glued the pieces together, then bound them with barbed wire. The driftwood figures were powerful and disturbing—and also destructible, which made them attractive to vandals. "I was awakened early one Sunday morning to the sound of a crackling fire, and relieved to find the fire was burning a driftwood figure . . . and not the house. This particular sculpture has been a target for the kids for years—about fifteen feet high and so encrusted with paint and so dried in the sun that the burning was like a series of explosions. Called the poor overworked police who sat in three squad cars outside the fence and watched it burn. . . . All that was left were two ten-foot pipes anchored in cement, and before the last sparks had drifted off I had plans for my largest cement animal." The pipes conveniently became the two front legs of a less destructible cement creation.

Friend Karl Priebe dancing with wire figure, 1964.
Untitled (woman with child), 1963; jute.

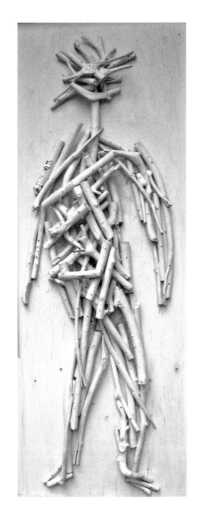

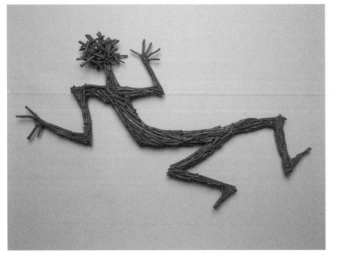

*Driftwood figures in yard and on house
c.1960-1998; found driftwood and wire.*
Opposite page:
Front view of house and east view.

Friends assisted Mary with this humorous and fantastic creature, fifteen feet high, with an open mouth and a goofy grin. Vandalism, unfortunately, would develop into a serious threat to Mary's work.

While it is possible that Mary had an overarching plan for the house and the yard, she did not indicate in her diaries what it was. Most of her ideas were generated by the materials that came to her. It is likely that she envisioned a transformation of the property by creating separate works and by gradually piecing them together to create the total. The root meaning of the word art, "to fit together," is exactly what Mary did as she proceeded. Each piece was significant to the whole. She fit together the disparate parts to create a complete environment filled with mystery and intrigue.

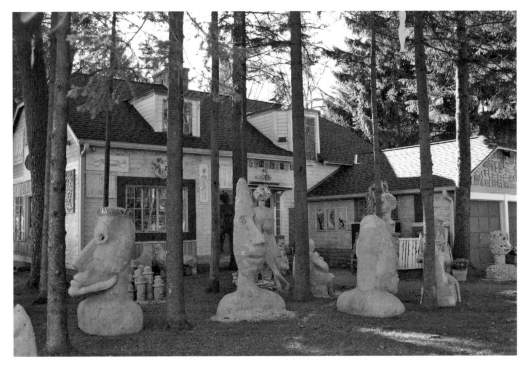

"Have two new drift wood men, one is dark green and the other light turquoise. Probably the only reason I still have them is that they are seven feet high and too heavy to carry off, besides being firmly attached to pipe set in cement, 3 feet into the ground."

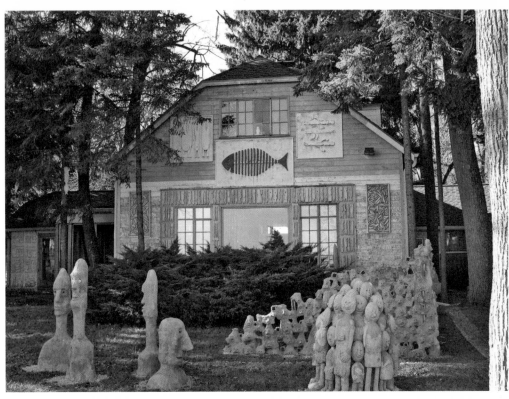

Painting

In the process of reorganizing 7328 Beach Drive, Mary located some of her old oil paintings. The single painting her parents had permitted on the walls of their home had been relegated to the tiny room called the phone booth. They preferred to decorate with sentimental works such as a reproduction of Jules Breton's "Song of the Lark." "Delighted with some of my paintings . . . that I haven't seen for a long time." She was determined to continue painting them and hung them throughout the house. She began to set them free.

Mary painted in a section of her small bedroom standing at a tall table surrounded by racks of her paintings. Listening to classical music on the radio, she glanced up occasionally to view Lake Michigan out the east window over her small desk.

Her painting was a continual up and down battle, a private struggle, the results of which were rarely seen by anyone. She entered a few paintings in the Wisconsin State Fair in the 1960s; several were exhibited and some were rejected. "I feel like trash" she wrote, apparently quite affected by this slight. But the rejection did not deter her from persevering. In addition to thousands of watercolors and casein paintings, she started approximately two hundred oil paintings in the 1950s, worked and reworked them over a forty-year period, never quite satisfied and never considering

them finished, thus never titling them. There was always one more change to be made.

"Never put titles on any of my paintings. . . . [But] some friends and I were trying to think of a suitable title for one . . . of four men in semi-flying positions, each juggling a large ball. So, naively, I suggested, without much thought—why not call it 'Four Men with Balls'. There was a whoop of laughter that shook the walls."

Painting pleased Mary, even if it caused her frustration. At age fifty-six, she wrote, "Oil painting continues to be my favorite indoor sport. But there are a lot of problems—the same painting revolts me one day and elates me the next, and I don't know which is nearest the truth. . . . Hardly ever paint without a background of FM symphony sounds, and when the painting is proceeding properly, my cup runneth all over the place. My fingers feel as though they were getting worn down to stubs—rubbing in transparent oil glazes. . . . Occasionally I see little parts in my paintings that I really like. Enough good little parts keep showing up to keep me in the race with paint and time. Have always known that my composition and drawing have been superb from the beginning. It is the administration of color that has been so puzzling. Just hope I live long enough to fix up all the paintings I've started. . . . The reason you date something is so you know when it's finished. I never finish anything, so how can

Sketches, c. 1950-1960; pencil and ballpoint pen.

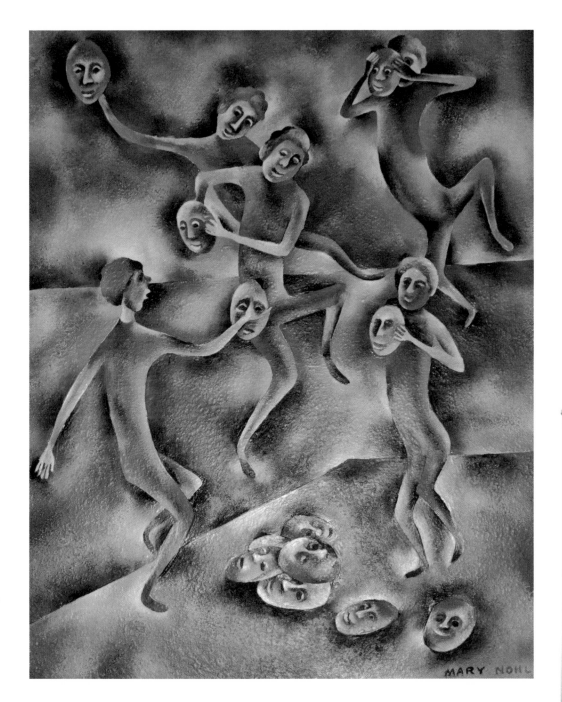

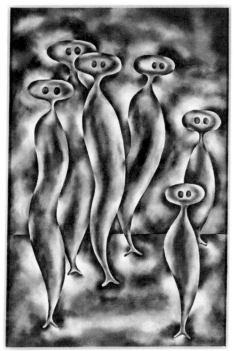

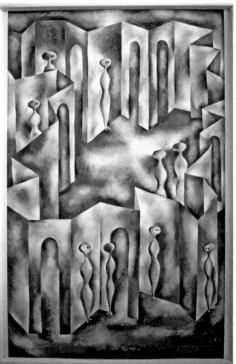

Above: Untitled, 1960-1998; oil; 36" x 23".
Top right: Untitled, 1960-1998; oil; 23" x 36".
Bottom right: Untitled, 1960-1998; oil; 23" x 36"

Opposite page, clockwise;
Untitled, 1960-1998; oil; 36" x 23".
Untitled, 1960-1998; oil; 23" x 36".
Untitled, 1960-1998; oil; 36" x 23".
Untitled, 1960-1998; oil; 23" x 36".

Untitled, 1960-1998; oil; 36" x 23".

I date it? . . . When I frame an oil, it doesn't mean that it is finished, it is just up for inspection and future changes."

Hundreds of small sketches were preliminary to painting. Her painting process was, of course, unusual, methodical, and regimented. "First I discovered I wasn't getting enough dark parts in one and upon further investigation, decided that they all needed more dark parts. And when 150 to 200 paintings need more dark parts—that spells trouble. Soon after I concluded that there were not enough light contrasts . . . then found they all likewise needed the same thing. And suddenly . . . they all without question needed more detail. . . . I have disciplined myself by not allowing me all the fun of new painting."

The majority of the paintings, most twenty-four by thirty-six inches, portray figures that are so different from the classical figure studies she accomplished as a student that it is difficult to recognize that the artist was the same. These androgynous figures seemingly dressed in bodysuits are sometimes decorated with subtle patterns. Their physiques are attenuated and tubular, lacking muscles, bones, and joint articulation. The legs often taper down to tentacle-like appendages, rather than human legs and feet. Single oval apertures, like divers' masks, often replace facial features; it's likely brother Max in his diving suit was the prototype for many of the figures that populate her paintings. Like her sculptures, they are simplified, stylized. Some appear to be people she observed in her travels. She might have seen the women in colorful dress in the West Indies or in markets in Mexico or India. But Mary said, "These aren't African tribesmen. They're people I see every day. People I've known all my life."

Usually in groups, they move, dance, or float, suspended in the viscous fluid around them. The undulating colors create ambiguous shimmering space in which the ghostly personages float. They are together but they do not touch and do not make eye contact. Most often the groups are in threes, fours, or fives and might represent

Mary and her family. The group of five might have represented the family if the first baby, Frederick, had lived; the four were the family as it was; and the three were the family after Max's death.

The figures inhabit architectural ruins and ascend stairways to nowhere; they hover and pass through arched doorways and mazes or ride in pod-shaped boats. They peer from trenches and passageways. Some dissolve into walls, spirits passing through matter. Bathed in auras of flickering colored light, they also swim underwater in Mary's transformed version of the world her brother had visited so often. Other settings echo places she had both seen and imagined, such as the remains of a Grecian amphitheater or the Indian Cemetery on Madeline Island in Lake Superior.

Untitled, 1960-1998; oil; 36" x 24".
Opposite page:
Untitled, 1960-1998; oil; 22" x 22".

Images and Sounds

By far the most profound influence on Mary's art was Lake Michigan. The city of Milwaukee was founded on the magnificent lakeshore where the Milwaukee, Kinnickinnic, and Menomonee Rivers meet and flow into the lake. Shipping, the fishing industry, recreation, and the sheer, wild beauty of the lake are significant features of the community.

Mary loved her beachfront location, enjoyed swimming, boating, and watching the altering moods of the lake. She collaborated with the lake and with the overall environment and was herself a part of it. Waves, boats, fish, mermaids, and underwater creatures appear repeatedly in her silver pins and pendants and in her concrete sculptures, such as the seated fisherman holding a fish equal to his size on his lap. Also an influence were her brother's deep-water diving record, accomplished in Lake Michigan, and his underwater salvaging work. Many of the carved wooden heads and figures in her paintings seem to peer at the world from diving masks similar to the one that Max designed and wore. Her extensive series of oil paintings depict figures that appear to be floating or swimming under water.

Like the symphonic patterns she learned to listen for as a child, the repetition of Mary's days was both regular and complex. She woke as the sun rose over Lake Michigan. Walking on the beach, she observed daily the random patterns of wet stones on sand or shimmering alewives swimming at water's edge. The changing pulse of waves washing on the shore, the shifting breezes, and the patterns of leafy shadows or stark branches extending over the yard all played a part as she composed a symphony of sculpture in her yard.

She contributed her part to the patterns with the repetition and variations of shapes of fish, boats, and dancing driftwood figures adorning the house exterior, in the wooden profiles hanging in the trees, and in the carved heads swinging from the eaves above the door. The repeated fish shapes on the house exterior, the tinkling of the glass wind chimes swinging in the trees, the triangular sails on the windmills, and the gurgling water in the fountain were only a few of her additions to the outdoor performance.

"The wind activates my sixteen glass chimes in sixteen different trees—which sound like ice in hundreds of highball glasses—which is a festive sound all year around. Add to that the gibberish of three windmills and the sound of the waves in the lake—and you just might conclude that I was well equipped for sound."

The windmills "made of bright triangles of cloth tacked on wooden frames (8 feet tall) . . . carry on loud conversations—noisy as any of the larger mills in Holland. Anyone could save themselves a trip and just listen here. Sometimes they sound like mourning doves, and other times like wild geese, and sometimes like TV commercials when you are only half listening," she wrote. "This windmill does not generate anything so useful as electricity—it makes only revolving color beauty for the eye" and it "whirled merrily in the lake breezes."

Fish images, 1960-1998; concrete, charcoal, stone, wood, silver, and ink.

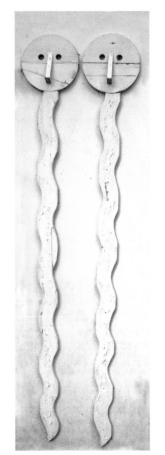

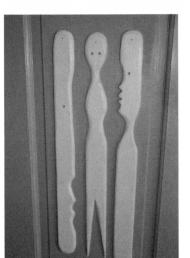

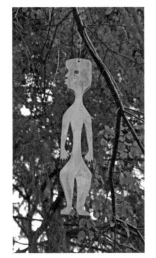

Wood silouettes, c. 1960-1998; wood.

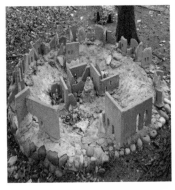
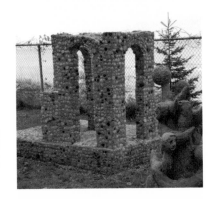

As Mary became comfortable in her independent ownership of the property, nature's cycles, the seasons, and the weather determined the pace and pattern of her work. In winter, indoor work was necessary. She attended to her painting and sketching, reworking her paintings and craft work. In spring, summer, and fall, whenever the weather allowed, cement work, wood carving, and repair work were on the schedule. The weather and natural forces played a significant role in crafting the outdoor work. Wind whirled her squeaking windmills and rippled the flags, caused the wooden profiles (previously slats in the fence) to sway; the wind sounded the chimes hanging in the trees.

Mary's broad travel experience and sketches from those trips provided rich reference images that fed her creative pursuits. The arches, passageways, and crumbling walls appear in sculpture and painting. Her great interest in ruins, whether in Mexico, India, Greece, or the farmlands of Wisconsin, were constants, often providing a backdrop for figures to move through in dreamlike fashion. The stone-covered structure with arched portals in the east yard likely derives from the ruins of Pompeii she visited as a young woman. Visits to Stonehenge in England and to the great temples of Egypt, as well as sketching trips to the Upper Peninsula of Michigan, all contributed.

Mary found inspiration everywhere. Over many years, newspapers and magazines provided great possibilities for subject matter. She drew from photographs in *Life* magazine and *National Geographic*. She clipped and pasted articles into her handmade brown paper idea books for future reference. She saved everything from articles on how to grow carrots from carrot slices to clippings about Henry Moore's sculpture, Tinguely's fantastic machines, or the Calder mobiles; from the huge fiber work of Magdalena Abakanowicz to homemakers' craft projects to whatever caught her eye. Filed among the clippings were photos of environments created by other artists, including Simon Rodia's imposing Watts Towers in Los Angeles and Fred Smith's Concrete Park in Phillips, Wisconsin. Although Mary did not see these sites in person, she was of like mind with Rodia and Smith, artists who built environments grander and even more elaborate than her own.

Left: Mary's architectural structures influenced by her travels, interest in ruins, and theater, c. 1960-1998.

View from Mary's bedroom.

"No amount of disorder will induce me to give up my front row seat on the changing moods of Lake Michigan—the ice hills against the blue water in the winter, and the afterglow of the sunsets in the summer, and the infinite variety in between."

7

The Witch's House

"Balzac says accomplished artists have no friends—either man or woman—so that just about proves I'm accomplished."

Mary Nohl felt an affinity with other artists, some whom she had known personally, others whom she could never have met. From her professors at the School of the Art Institute of Chicago to the ancient sculptors of Polynesia, there existed a connection to the creative muse that she followed. Creating was her greatest life commitment and a compulsion that directed her days.

Although Mary's extensive list of projects and an unflagging work schedule kept her focused, they also kept her personally isolated. Relationships were more difficult than the challenge of hefting huge stones or hauling bags of cement. Mary could be blunt and impatient. While she valued conversation and companionship and took interest in others, minor oversights such as an unreturned phone call, a casual thoughtless remark, or late arrival loomed large in Mary's eyes. Her inability to compromise and forgive led to serious splits or terminations of relationships throughout her life. She stopped talking to a high school friend but after thirty-five years couldn't remember why. Because she knew it was for a good reason, she continued not speaking to her. "My faith in people becomes less and less," she confessed to her diary. Indeed, her art and her work on the property were her main and essential focus.

During the first years of living alone, she was troubled by loneliness. As early as the fall of 1965, she lamented her lack of social contact. "I probably ought to see more people—and I would, if there was someone I particularly wanted to see. . . . Those days I watch more TV." Holidays passed when Mary did nothing to celebrate; she

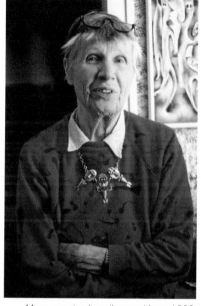

Mary wearing her silver necklace, 1999.

simply continued her daily routine of projects, alone. She told her mother that she attended parties so Emma would not pity her. "Mother worries about me and I worry about mother worrying about me."

Then with an unexplained change of heart and lift of spirit, at age fifty-three Mary decided to reform. When she reached out to people, they responded. "Lining up and calling people I haven't seen for years. I've carried my privacy much too far. I am going to see if I can revive a few friendships before it is too late." She reconnected with old friends, among them Ros Couture, a friend from their teaching days. They renewed their friendship and remained lifelong friends.

Mary was gratified about healing lapsed relationships and began to enjoy a full and active social life. She played bridge at the Woman's Club in downtown Milwaukee and at the Whitefish Bay Woman's Club, averaging five games a month. She hosted and attended ladies' luncheons and sorority events and liked serving shrimp Newburg and champagne. She attended theater, movies, and art events.

Within her reestablished friendships and revived social life, Mary often dwelt on the problems of her friends and their troubled marriages, divorces, and health and financial problems, and considered her own good fortune in comparison. While she was missing out on some meaningful aspects of life, she also was aware of avoiding complications. "When I see other people's problems— I'm glad I have my own instead—I always come back to that."

Top: Ros Couture with one of Mary's ceramic pieces, 1998.
Middle: Beach Drive lobster party, 1960.
Bottom: Mary and artist friends, c. 1958-60.

In December 1967, again reaching out to others, Mary initiated a semiannual letter, sent at Christmas and in June, a practice she continued until 1995. Throughout the year, she saved tiny scraps of paper with jottings of memorable events, filing them in the desk drawer beside her bed, then organizing them into a two-page letter that she typed on her high school typewriter and copied on an old mimeograph machine. She devised letterheads from drawings or block prints of fish, boats, trees, or dancing and floating figures interlaced with 7328, her house numbers. "Dear Friends and People" was the usual salutation.

"I look forward to the Christmas mail—hoping long lost friends will reappear," she wrote. And indeed, her first letter "unearthed people I hadn't heard from in thirty-five years," she reported. "I don't have any way of knowing how many are willing to read a duplicated letter, but I'm willing to bet that I have a captive audience—and that all of you are just that curious!"

From 1967 to 1995, the letters recounted the status of her sculpture, house, yard, and other projects, and disclosed her dealings with the village police and tribulations with the vandals who continued to plague her. She expounded on the antics of her dogs, described recent trips, discussed health and aging, occasionally offered her view on world events and revealed, as well, the minutia of her life, such as how she made a tuna casserole without the typical ingredients.

On January 20, 1968, Emma Parmenter Nohl died at the age of ninety-three after living five years in a nursing home. Her last words to Mary were, "He loved you." Mary wrote, "I suppose she meant dad."

Emma's death was a relief for her daughter. Mary took a month-long road trip to California to renew and revive following this ordeal. When she returned, she had planned to adopt a child but due to her age was turned down. "The woman [at the adoption agency] pointed out how continuous a job like that would be without a husband or relation. I suppose she is right," Mary noted. Instead, a trip to the humane society for a new puppy, Basil, was a sensible and satisfying substitute. "And some kid will never know how lucky he is that I didn't get to adopt him!" Several months later, Mary made a teeter totter on a stump, perhaps for the child she couldn't adopt. "Need someone to try it out with—can't do it alone," she

wrote. But looking out the window, she was pleased to see that it rocked by itself in the wind.

Emma's death also motivated other considerations. "About decided I should work on some large project doing good in Milwaukee. I can't just look for entertainment and travel as I am doing now—for the rest of my life. Doing my own creative projects apparently isn't enough for me."

Years later, as she neared the end of her life, Mary fulfilled this wish, although perhaps not in the way she expected.

With Emma's passing, a new phase of life opened to Mary. She tore into her work like never before, setting a schedule that was rigorous and precise, with little room for others. Mary began each day in the same way—peering around the yard to see what had been taken or damaged or destroyed by vandals during the night. "I pick up all the cigarette butts and beer cans that the group the night before left, and I tell myself that this is better than not being noticed at all."

She also picked up "stones that have been hurled at my tree sculpture during the night and return them to the lake. Some of the rocks weigh about fifteen pounds—larger than the regular throwing variety. I check to see if the glass eyes in the wood carvings have been gouged out and need replacing. I check to see if the wooden hats are still in place on the two gentlemen conversing in the corner. And, if the four arms are still in place on the driftwood men. When a driftwood arm is gone I can replace it in about thirty minutes—I keep a bank of spare parts. The arms are cabled and chained and aren't as easily removed as they once were." If she noticed that any major destructive event had transpired, she would call the police. "Then, I go down to the beach to see if any nice timbers or planks have washed up."

Without the constraints of a job or family or other demands on her time, she followed her daily routine faithfully, driven by an inner impulse. She could not stop. Perhaps the words of Edmund Giesbert, life drawing teacher at the Art Institute, encouraged her frenetic pace, "Never put off until tomorrow, but always do it today."

In addition to her art work, other scheduled activities balanced out her day. Observing Frank Lloyd Wright's advice that educated people should play a musical instrument, daily piano practice was

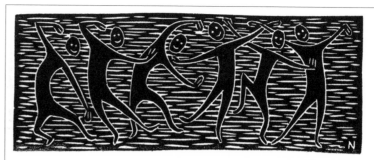

June, 1968

Achtung!

I don't have a heart transplant, but I don't believe that recipients of that organ should be the only ones entitled to bulletins. My first mimeographed letter last Christmas unearthed people I hadn't heard from in thirty-five years, and this second letter means that I hope I can unearth a few more. I don't have any way of knowing how many are willing to read a duplicated letter, but I'm willing to bet that I have a captive audience – and that all of you are just that curious!

Mother died January 20, after almost five years in bed in three nursing homes. As the nurses said – she earned her rest. It was an ordeal for both of us. And I feel so grateful to Dad who provided the means that provided the best of care for her. She was a devoted Mother, but I think she often thought that she had two very strange children, and just maybe she was right. She might have thought that about three, except that her first son did not live more than a year. It is my opinion that we get strange only after years of attempting to deal with the world.

In March I took my first trip longer than a week – almost a month of driving to, being in, and driving back from California. Next time I will fly, but driving 6000 miles was just right for this time. All the large things like the mountains and the ocean and the redwoods I liked the best, and small things like the bird that sang in the night, and noone seemed to particularly notice – I still think I might have only dreamed that part. Too many fancy food places combined with my evil food habits added five pounds where I didn't need it.

On the way home from California I decided I needed some kind of large project to occupy me back in Milwaukee. Working on the lake pollution problem or adopting a child seemed like two good sized projects, both worthy of attention. So far I haven't done anything about lake pollution, but I did go down to a Milwaukee agency to see what they thought of my qualifications for adopting a child, There had been a series of articles in the Journal on the subject of single men and women in their thirties and even in their forties adopting children. It turns out that I am not "even in my forties", so we decided that I probably should just get another dog – which I did. After owning two expensive high strung dogs I thought I'd give the Humane Society a

Semi-annual letter, 1968.

part of her program for a number of years. Later she substituted an hour of guitar, playing Bach, Chopin, Brahms, and Schubert. Some years she added classes or sports—modern dance, exercise classes, golf, bowling, lawn bowling, badminton, curling, and tennis rounded out her schedule. Her intense curiosity and love of learning, as well as her loneliness, were strong incentives to pursue wide-ranging activities.

Mary designated time for reading aloud to improve her elocution. She set a time for painting and drawing inside and sculpture and yard work outside. Daily walks, rain or shine, kept her in touch with the neighbors and the goings on around Beach Drive. She walked the road, the beach, and sometimes in the wooded ravines below Lake Drive.

Exercise chart and detail, 1962.

Throughout the years, she worried about her weight. Although large-framed, her weight was never excessive, but strict self-discipline kept her on various diets, monitoring food portions as scrupulously as her mother had done and as tightly as she controlled her daily schedule. In 1983, Mary wrote, "Every two days I make two large salads for my next two dinners. Every three days I make three one-half sandwiches for my next three lunches. Every four days I make two stuffed eggs . . ." Throughout the years she substituted foods, but always stuck to a strict regime.

Even her reading was scheduled. She would select six books from the library each month, read them, and then return them exactly on time. In later years, she cut back to four, but was unfailing in this practice. Her reading was impressively erudite, including the classics, history, poetry, philosophy, and art history. After Emma's death, she primarily chose biographies, including volumes about Eleanor Roosevelt, Gertrude Stein, Sigmund Freud, and Joan of Arc. Biographies of artists were her preference, Picasso, Cezanne, Jackson Pollack, and Amedeo Modigliani among them.

This strict regimen filled her waking hours. She found comfort and safety in regularity and predictability, knowing that all hours were filled and accounted for. If she missed something, such as her daily knee bends, she would make them up on another day, diligently, carefully keeping track on tiny charts. Missing an exercise session would aggravate her until she made it up and marked a check in the box. Sometimes she completed her required activities in advance, putting in extra guitar or piano practice in anticipation of missing a session. She was aware of this compulsion, remarking, "My exercises and guitar hour, relentlessly, day after day, sometimes seem a little much, but if I let up on the program, I'll end up doing nothing. Towing the line is important."

Between "towing the line" and her multitude of tasks, at the age of fifty-four, Mary rejected a suitor who briefly entered her life. She wrote in her diary that he "sounds interested and I'm sure I won't be." On November 6, 1968, Mary noted that Richard Nixon, for whom she had voted, became president, beating Hubert Humphrey, and also mentioned she told the suitor that "I was busy—don't want him to get serious, though I enjoy an occasional date." This persistent man took Mary to dinner and sent her roses and candy for her and her dogs, but Mary discouraged him. "Guess [he] has had

enough of my treatment—and I think it is best that way. Couldn't remotely consider marrying him."

Just after her final rejection of him, she traveled to Trinidad and Barbados and on her return was shocked to read in the newspaper of his sudden death on December 31. A month later, she made a near-life-size figure of a man by painstakingly coiling and stitching jute fibers. From then on he hung on the living room wall, a jute baby protruding from his belly. Clearly a man made of jute was easier to live with than a real man. And who could have fit into Mary's hectic and demanding schedule?

She was fastidious when it came to saving money. Her significant inherited wealth allowed her the freedom to live as she chose, yet she went to extreme measures to be frugal, to save every penny, and obsessively accomplished everything with a minimum of means, doing her own repairs and yard work, buying as little as possible, and always purchasing the least expensive items, from food to paint.

Mary claimed she was embarrassed to buy the slightly spoiled produce at the grocery but could not restrain herself from such bargains. She hated "to be seen taking some thrown out plywood. I'm sort of a joke around here as it is—scavenger joke." Repairing her own shoes was satisfying, but "People would laugh if they knew, so I don't tell them." Painting two hundred coat hangers red, to cover the rust in order to continue using them, did not daunt her. To keep her hair out of her eyes she concocted her own gel from flour and water. Recalling the library paste she had used in grade school, she smeared back her bangs with the white mixture, pleased with how effectively it held her hair in place. From hoarded soap-carving scraps, she formed new bars of soap: "enough soap for about 10 years for me, I think."

Devising ways to pinch pennies in every manner possible was complete pleasure. She was a woman after her father's heart, following his thrifty style throughout her life. Leo would have been proud of her efforts to conserve although would likely have regarded some measures as odd.

Household economizing, domestic duties, inventive recycling, and her frugal approach to art-making were intertwined. "My art has the theme of living," Mary once observed, perhaps referring to the blurring of lines between her art making and lifestyle. She ironed used brown wrapping paper to bind into scrapbooks. With strength and determination, she ripped the metal springs from a discarded mattress to contrive a sculpture called *Spring Man* that she attached to a revolving wheel. She washed the paint off old watercolor paintings in order to reuse the paper and sawed beef bones into slices for necklace links to grace the twisted wire man.

Mary's extreme measures of thriftiness and strict schedule helped ward off loneliness and the periods of depression that occasionally descended upon her. Like many creative people, depression plagued her, in spite of wealth, freedom, time to work on her projects, and a general sense of pleasure in her accomplishments. She noted these bouts in her diaries, reflecting, "Some of my best ideas have come after being depressed—so I suppose those periods serve their purpose. . . .

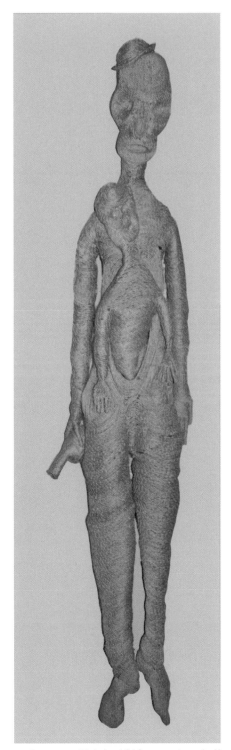

Jute man with baby, 1968; approximately 6'.

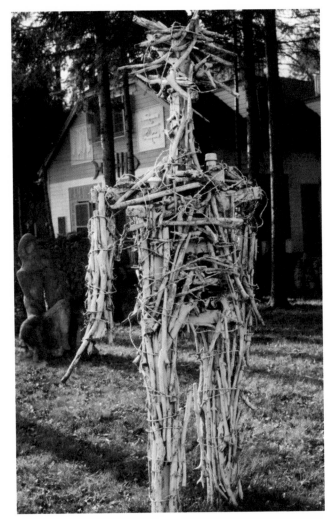

Driftwood man and details, 1965; driftwood and wire; 108" x 42" x 18".

Sometimes things look so good and other times I lack interest in any of my many projects." She usually bounced back. "Having a resurge of interest and energy—guess I just have to expect low periods—I should know that for sure by now," she wrote. "But being sad—just as Emerson's essay on compensation instructs—is important for knowing how to be glad."

Like anyone's, Mary's spirits were buoyed by compliments and attention. As early as June of 1963, passersby spotted the changes she was bringing about. "Lots of satisfaction in checking off items accomplished. It's fun seeing people slow up and stop at the gate to look. Two high school boys asked permission to walk around the house. Invited them in. Their enthusiasm is a tonic for me." In April 1964, a woman canoeing past on the lake had asked to come ashore to see things in the yard, to Mary's delight.

The attention spurred her on. "Brimming over with ideas for this place—and they are all so much fun to do. I'm really finally coming into my own at last."

But as Mary's house and yard emerged in its new form, the attention it attracted was both affirming and alarming. Rumors spread throughout the Milwaukee area that Mary was a witch. Some said that her husband and children had drowned in Lake Michigan and were buried in the yard beneath the concrete sculptures. Others claimed she had murdered her husband and had buried him in the yard under one of the concrete heads.

Mary was able to regard these tales with good humor; she seemed to enjoy the notoriety. In her 1970 Christmas letter, decorated with a drawing of a driftwood man, Mary wrote, "My 7328 is known for miles around as the haunted house—I suppose chiefly because of the driftwood men in the front yard. They look very bony white when caught in the headlights of passing cars. . . . Only witches live in haunted houses—and I am that witch! . . . I am genuinely pleased that I didn't live back in the days when witches were routinely burned—I would have been one of the first to go. Thought of putting up a sign—*Trespassers Will Be Eaten*—but if the sign was low enough to read, it would disappear. . . ."

As the legend spread, carloads of teenagers were enticed to her yard, many on dares, fearful but attracted to the power of the sculpture and the haunting environment Mary had created. "When

they knock at the door at a reasonable hour, and ask if they can look around the yard at my driftwood people and animals, I am pleased. They are not all bearded boys in opera capes, and girls with blue and green eyelids, but some are!"

They were persistent, going to great lengths to enter the yard and to damage or steal the work. When they made off with forty pieces from the four hundred foot wooden fence of "friends and relatives in profile" that bordered the yard, she installed a "dull picket fence." She used the remaining displaced profiles instead to enlarge the dog yard on the south side of the house, and, later, suspended them from the trees and made a widow's walk on the roof.

Then she erected a chain link fence. "I always vowed that I would never do it, but now there is a fence between me and the lake. . . . And now I am completely enclosed, safe and secure. . . . The only problem now—if I need a doctor for an emergency in the middle of the night, he will have to be a fence-climbing doctor. And if the house starts burning down, I'll need a whole battalion of fence-climbing firemen." One young man pole vaulted over the six-foot high fence and landed flat on his back. Mary called the rescue squad. Vandals made repeated attempts to ram the locked gates, even after Mary built speed bumps to stop them.

When this wasn't enough to stave off the vandals, she added, to the dismay of the local police, spikes and illegal coils of barbed wire to top off the fence. Late one night in 1969, a group of young men assembled at her gate and started chanting for the witch to come out. "Vandals do have their value. But when they dare me to come out—a little scary."

The visits occurred weekly, sometimes night after night. Nothing seemed to deter the determined vandals from getting into the yard—and dealing with them became a perpetual battle. Mary's methods of handling this problem may have aggravated the troublemakers and encouraged them to return, even after being arrested. Yet as an odd byproduct, the acts of destruction became a constant force of change, turning the yard and its work into an evolving exhibit that from year to year saw new works come and other works go at the vandals' hands.

Mary tried to take it in stride as she mounted a defense. "Have a spy hole drilled in the front door," she wrote, "with a sliding wooden

A constant battle against vandalism has been waged by Miss Mary Nohl, of 7328 N. Beach Dr., Fox Point. The artist stood among some of her stone and concrete works, which have been targets for many years.
—Sentinel Photo by Donald W. Nusbaum

Sculptor Fights Intruders With Barbed Wire, Dogs

Article in Milwaukee Journal, September 1973.

flap, reminiscent of Prohibition days, to get a full view unseen, of any developing crises." She cleared out woodsy areas where kids would sneak into the yard. A compressed air horn helped blast them out of the yard, and when it failed to function, she would resort to hollering. On one night, fortified with a few drinks, she slept on a beach chair in the yard and waited to surprise the trespassers with shots from her rifle.

"Removed a pane of glass on the north side of the house, and made a round rifle hole in a wood panel, and I use blanks and it sounds just as loud as the war in Vietnam on TV. On the lake side I just shoot through the screen. . . . The explosion and flash of the blanks has been very effective. . . . Every morning I make sure my pistol is loaded with enough blanks for the next night.

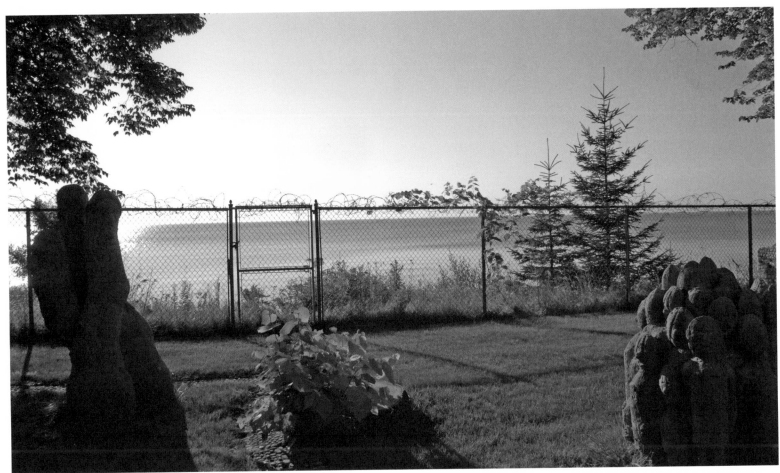

Lake Michigan and barbed wire fence, 2008.

Some kids run at the sound and I can hear others reassuring each other . . . that these aren't real bullets." Alarmingly, someone did return her simulated fire with a real bullet, leaving holes in the windows, but with no serious damage.

In spite of the battles with these thoughtless young people, Mary reveled in the attention and public acknowledgment she received. She relished the newspaper articles and television coverage. They spurred her on. "Sometimes when I am out in the yard a car will slow down out on the road and someone will shout, 'There she is,' and point in my direction. The first time it happened it was quite a sensation. Now I am either annoyed or amused, depending on my mood."

As Mary created, the publicity and attention increased. The local public television station did several spots on her. In 1988, the BBC filmed her yard for a program about six U.S. cities including Milwaukee. Numerous articles appeared in a variety of publications, from the Weight Watchers magazine to *The Milwaukee Journal*. Still, the more publicity she received, the more the vandals and the curious onlookers appeared outside her gate.

Mary, 1994.

In 1991, Mary agreed to an exhibit at the local Cardinal Stritch College just north of Milwaukee. "My exhibit … in February was fun. I had decided definitely not to go to the opening—because I didn't feel up to listening to people forcing out words of praise just because they thought they had to say something. And then I went over to the gallery two days before the opening to see how things were going and liked it so much—changed my mind and went and enjoyed every minute of the three hours. . . . Everyone wanted to see the witch lady."

The place was packed. Over six hundred people came, eager to see the art and the artist. The exhibit included ceramic pieces, wire and wood sculpture, silver, and paintings, work that had never been seen by her outside admirers. A year later, Mary showed a group of paintings at her alma mater, now University School of Milwaukee. The show ran for ten weeks. Mary's work was not finished. In spite of all she had created, she had more to accomplish. "Sometimes I get the feeling, as some philosophers have said, that life is just a big joke on all of us. But most of the time I feel all the pleasure of forging ahead—when I have the energy." And Mary usually found the energy.

"Called cops at 3 a.m.—seven kids in front yard—but not the looting type—so I didn't press charges . . ."

Mary, 1995.

8

Leaving the Lakeshore

"Making some resolutions to remind myself I have a lot to be glad about—good health, lots of money, many interests and reasonable friends."

On the first of January 1993, Mary began writing in what would be the final volume of her diaries. Over the years, she had made daily entries consistently. They had become part of her routine. "Sometimes I wondered why I kept on writing in diaries, but I don't wonder any more," she noted. "The fun of reading them now is reward enough." Yet gradually, and inevitably, her daily eight lines declined from crisp remarks written in a clear, tiny hand to scrawled and disconnected thoughts, worries about her health and the future. Frustration, anxiety, and the physical changes that accompany aging plagued her.

In the last decade of her life, Mary spent more time than usual reviewing, revising, and editing the huge quantities of family photo albums, letters, and scrapbooks. Surveying the history of her family and her ancestors was comforting; she felt more closely linked to them and to the past. Perhaps she sensed that others would read the extensive record of the Nohl family, and she wanted to leave a coherent picture of who they were. What she didn't want others to see she burned, including most of Max's personal papers.

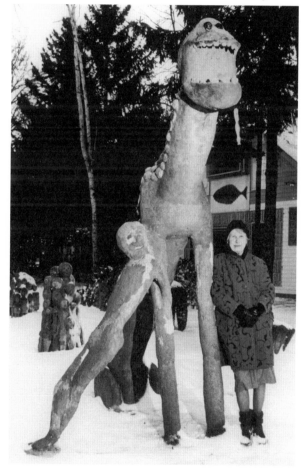

Mary in her yard, 1995.

Wisely, Mary had the foresight to put in order her financial and legal affairs with the same care she had taken throughout her lifetime. These responsibilities became more difficult with age, and the doubt and suspicion that had often clouded her relationships with others increased. She questioned intentions and her disputes with others multiplied. "I sure get rattled easily in my old age," she observed in August 1993.

Leo's careful investing combined with her own thrifty lifestyle resulted in a significant fortune for Mary. She sought advice about her sizable estate from friends, acquaintances, and professionals. Mary distrusted bankers, investment brokers, and, particularly, lawyers—those who could best assist her in the planning and decision making related to her estate. Finally, after years of deliberating and after consulting six different lawyers, whom she resisted paying, Mary created a will.

Her major concern was the fate of her life's work. In 1989, Mary first mentioned the Kohler Foundation's interest in preserving her property and work. Located an hour north of Milwaukee in Kohler, Wisconsin, the foundation preserves

artists' environments such as Mary's throughout the country. The foundation had developed an avid interest in her property, recognizing its uniqueness, creativity, and value as a cultural site. Its offer to preserve the house, yard, and art was agreeable to Mary, but releasing her life's work to the control and ownership of others and, likely, imagining her own absence, was of great concern.

Frequent negotiations, meetings, and correspondence with the Kohler Foundation occupied Mary's time and thoughts. She realized that bequeathing her home and property to the foundation was a singular, fortunate opportunity, but her doubting and stubborn nature was a stumbling block in finalizing the agreement. With great patience, persistence, and sensitivity, representatives of the foundation won Mary's trust and succeeded in 1996 in arranging a satisfactory contract of agreement that would accommodate Mary living in her house until the end of her life.

Following her death, the foundation would preserve the site, the house, and Mary's entire body of work. This accomplished, Mary felt great relief, assured that her many decades of work—both inside and outside—would transcend her lifetime. Her desire to share her art with the outside world would be sustained by the Kohler Foundation. "It's so nice to know that this is going to have a home," said Mary.

The Kohler Foundation painstakingly documented the bountiful contents of the house, moving some of her work to the foundation in Kohler. Foundation curators gave Mary thirteen books of photographs as a record of the work, including her silver jewelry, paintings, drawings, sculpture, wood carvings, and some of the thousands of ceramic works. In addition she donated an array of works to the John Michael Kohler Arts Center in Sheboygan, Wisconsin.

On March 26, 1993, Mary noted her total annual income as $308,358. Throughout her life until her last few years, Mary kept meticulous and exacting records of her financial matters and systematically reviewed her stock portfolio. Each month she recorded her earnings and regularly deposited her many dividend checks. She carefully guarded her inherited wealth. This inheritance, and the obsessive frugality on which she prided herself, resulted in a significant estate.

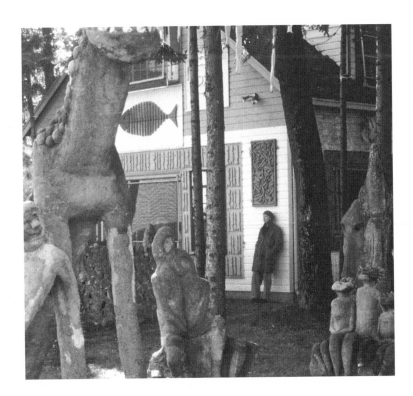

Far left: Mary leaning against her house, c. 1998.
Left: Larry Donoval, registrar at the John Michael Kohler Arts Center, with works of art by Mary; 2008.
Opposite page:
Mary and Ros Couture, 2000.
Mary, 1999.

Although her lifestyle was spartan except for her annual trips, Mary's gifts to charities were generous, in keeping with her parents' practice of giving to the community. Her early contributions following the deaths of Emma and Leo echoed their interests. She made donations in their memory to the Red Cross; to the Boys' Club in Menominee, Michigan, where Emma's sister had worked; and to many worthwhile Milwaukee community groups. She gradually began giving to organizations that appealed to her: the Humane Society, the Three Arts Club in Chicago, the Chicago Art Institute, and her Chi Omega sorority.

Lacking heirs, Mary's substantial estate created a gnawing worry. "Feel unsure about where my trust money will end up. Money is terrible," she notes on May 17, 1994. Mary considered various beneficiaries, including a local college and a number of other organizations, but was most inclined to leave her entire fortune to the Humane Society, where she had adopted her dogs—Icky and Pooh, Basil, Sass, Tinker, and Tico. She greatly admired the society's work with animals but decided instead to just give generous annual contributions.

Mary also made several sizable gifts of money to friends when they were in need. She sent a friend and her entire family on a luxurious cruise, believing they needed a vacation. Not wanting acknowledgement or even mention of the gifts, she was curious about how friends would spend the money.

After considerable discussion and thought, Mary donated $216,000 to the Milwaukee Foundation, now the Greater Milwaukee Foundation. Discussions with representatives about possibly giving the remainder of her estate to the foundation caused her great consternation. The diaries of 1993 to 1995 reflect her doubts and worries. After much browbeating, she bequeathed her entire estate to the Greater Milwaukee Foundation, designating the funds for support of local visual arts and arts education programs. Her total gift of $11.3 million was one of the largest individual donations the foundation had ever received. Although not likely Mary's intent, this became the "large project doing good in Milwaukee" that she had vowed to do following her mother's death.

As Mary approached eighty, she did not often go into the city of Milwaukee, but it is quite likely that a visit in June 1994 to the

Walker's Point Center for the Arts motivated her to direct her wealth there as well. At the small, unpretentious building on National Avenue, she watched with delight as a group of neighborhood Latino children in the "Hands On" class intently worked on a messy painting project. Her gift of $5,000 assisted the Center in continuing its mission to provide art projects for children of the neighborhood. She understood the value of creative experiences for children and realized that she could be influential in providing many more similar experiences on a grander scale.

Through this decision-making period of her life, Mary continued to follow her rigid schedule to the extent that she was able. The routine varied from day to day depending on her health and state of mind. "Paint, guitar, walk—the biggest items on a lot of my days," she wrote.

Five bridge games a month at the eminent Woman's Club of Wisconsin and the nearby Whitefish Bay Women's Club were also part of the routine and constituted a major social connection in her life. Mary often created unusual centerpieces for the tables using her ceramic pieces combined with flowers or greenery and rocks, and she sometimes gave the pottery pieces as prizes, to the delight of the winners. The women would often start playing at eleven in the morning, break for lunch, and stop just before dinner. They had been playing cards together for over twenty years, and Mary valued these longtime friendships.

"Been noticing my bridge playing friends gradually fade away," she wrote in 1991. "First they arrive with canes and then sometimes with crutches and walkers. It takes longer and longer for them to bid a pass—and which card to play becomes a monumental task. And then they no longer arrive at all. Everyone wonders, including me, who is next." In light of her diminishing circle of friends, Mary recognized her great fortune in her continued good health and ability to live on her own.

Considering the past and what the future would hold, she renewed her longtime friendship with neighbor John Willetts. They shared frequent conversations and occasional dinners. The bond they had created in childhood as early residents and playmates on Beach Drive was meaningful and strong in each of their lives. They would often sit on the porch, reminiscing about their early adventures, the parties, and the people who had lived along the road. John would

be a friend to the end. Occasional visits from other friends and acquaintances took on greater value. Mary noted each as a significant event in her diary. She often chose one of her tiny ceramic tea sets from a drawer filled with them to present to a departing visitor.

Although slowed by age, Mary's work was not finished. On her walks, she persisted in gathering driftwood and detritus for future projects. With good intent, she took trips to the dump to deposit unwanted junk but usually returned with a new carload of assorted wood scraps and other new treasures—and with new plans germinating. Her paintings, still in process, constantly spun through her mind. "Nothing can improve on my feelings of pleasure—than when I have a paint brush in hand . . . symphony music . . . and the lake is a lovely grayed blue all the way to the eastern horizon. For me, absolutely nothing is more delightful. And sometimes there is the feeling that my paintings might just be getting better!!!"

In January 1993, Mary noted that she was adding tiny dabs of white to each of the two hundred oil paintings she had begun in the 1950s. In May, she wrote, "It is a pleasure to feel my paintings are getting better," but by November, she observed, "Fighting the too-white look in my paintings. Probably too much final modeling." Two months later, she determined that adding a deep green to all the paintings would improve the lot of them. That completed, in June, she began a round of touching up the same paintings with brown and, finishing with brown, she applied accents of black to each one the following winter.

She accomplished this using brushes she had crafted from her own hair, having decided that the twelve brushes for $2.79 from the hardware store were too expensive. She simply taped tufts of her own hair to the plastic handles of the worn-down brushes. Unable to consider the paintings finished, the entire group remained untitled. She assumed that she would always be able to improve them.

Mary retrieved a painting she had given to this writer because she needed to add more white, as she was doing to all other paintings in the group. For fear of not getting the painting back, there was a moment of reluctance before relinquishing it to the artist. This twenty-three-by-thirty-six-inch oil painting on textured board is typical of the group she persisted in reworking. The painting portrays four color-dappled, horizontal tubular figures. They may be swimming or limply reaching out into space. Their faces are

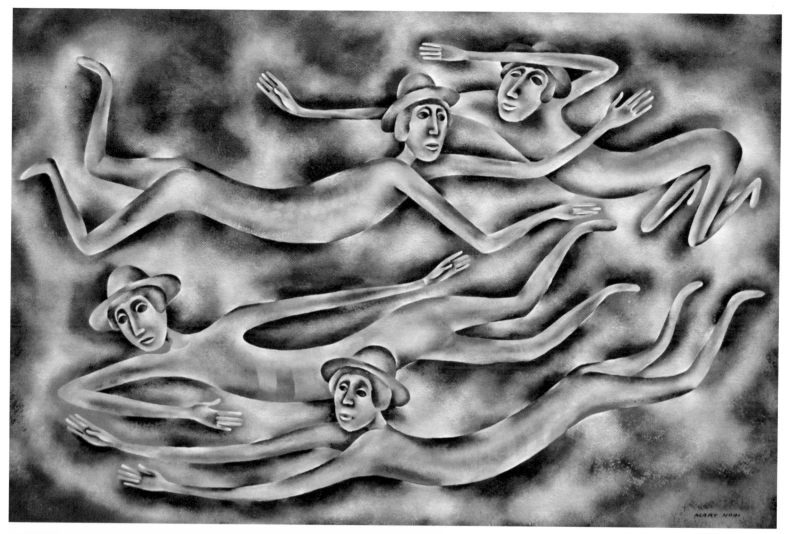

Untitled and detail, c. 1960-1998; oil; 23" x 36".

Miniature ceramic tea set, c. 1941-1955.

mask-like, their eyes vacant. They are androgynous and wear tight body suits and bowler-like hats, similar to those worn in the Andes that Mary would have observed on her Peruvian trip. Across their rubbery bodies, subtle patterns—checks or stripes—are visible. She created sharply defined edges where the undulating lights and darks touch the figures. Turquoise, pink, alizarin, green, and acid yellow bathe the figures and background.

Six months later, when Mary returned the painting, small changes were obvious. With her fingers, she had blended shimmering patches of white around and over the other colors, rendering the colors more pastel and even more lurid and pulsating. The floating, sexless figures still reach out to each other, not touching, not communicating. Who are these characters? What do they signify? Mary never revealed.

At age seventy-nine, Mary was still fit and strong. Her good self-care, consistent regime of exercising, and obsessive monitoring of her weight resulted in a lifetime of excellent health. She continued to walk regularly often from her house on Beach Drive, up the steep, graded hill to the bank and the grocery. Along the way, she still had an eye out for treasures, but she cut back her walks to every other day. "Better for me now. . . . My naps really keep me going and my walks keep my legs in good shape."

Without fear, she climbed a ladder to clean gutters on her house and to hang wood profiles, former fence pieces, in the trees. She handled repairs and construction work, not trusting or wanting to pay workmen. But her last eight years brought physical difficulties, both real and imagined. Anxiety and forgetfulness were other bothersome signs of her advancing age. She had to pay her first library fine in seventy years, an oversight that caused her great alarm.

Changes in her sleeping patterns found her waking during the night. She would reach from her small bed and turn on the little desk lamp to see her painting table with paints and brushes neatly laid out, just as she had left them. True to character, she incorporated this block of time into her schedule and painted in her pajamas from two to four in the morning, noting in her diary that she enjoyed this extra creative time and was surely making progress. She continued to paint with brushes and blend with her fingers until she attained the soft, amorphous color quality she preferred.

Besides insomnia, Mary dealt with mysterious bouts of "sparkly eyes" by lying down to rest. Numerous visits to her doctor indicated that nothing was physically wrong, but still she was concerned about this symptom and also was "worried about my head not working very fast."

A persistent pastime remained dealing with intrusions and intruders. Vandals continued to attack her yard. The driftwood man was damaged and the cement heads of the round-faced seated figures in the front yard were broken off. When kids threw eggs at the garage door and rammed the gates at three in the morning, she decided to build cement bumps in front of the gate to prevent future ramming incidents. She climbed a ladder a few nights later to install a floodlight that might deter vandals from entering.

"Try to use my energy for best purposes," she wrote on October 13, 1993, but the ongoing, ordinary maintenance work of the house and yard also filled her time. Several days later, she put up her storm windows and filled in the north end of the sea wall with old wood. Mary consistently followed her schedule, including holidays, but on December 24, 1993, she did pause to reflect that "I am thankful for much." And a week later on New Year's Eve, "Making some resolutions to remind myself I have a lot to be glad about—good health, lots of money, many interests, and reasonable friends."

During the following spring and summer months preceding her eightieth birthday, Mary had not reduced her work schedule, as the following diary entries indicate:

June 2 Working on small driftwood heads.

June 23 Working on stick figures.

June 25 Working on fence sections.

June 29 Working on white driftwood standing figure on panel by front door.

July 2 Working on driftwood panels for front of house and horse flying.

July 11 Having a resurge in small driftwood projects.

July 15 Adding barbed wire to the fence.

July 20 Hanging ten more wooden figures in the trees.

August 2 Working on straightening out cone head cement figure in yard.

August 7 Working on wooden profiles for ridge of roof, using old fence parts.

At the end of August, during the weeks before her eightieth birthday, she strengthened more cement heads that had started to lean, put new sails on one of the windmills, and painted panels on the side of the garage door dark red and dark gray. She got her neglected acetylene torch up and running again in order to rework old silver pieces. "Could really get hooked again on silver," she wrote.

Mary turned eighty on September 6, 1994. "Eighty years old—can't believe it," she wrote to herself. But ignoring its significance, she followed her usual routine as if it were any other day, not expecting or missing a celebration. It is not likely that she wished to celebrate; she was unaccustomed to it. Perhaps a friend called, maybe a card or two appeared in her mailbox—and she did allow herself one piece of candy after lunch—but otherwise it was business as usual. No fanfare, no cake with eighty candles to brighten her day, nothing at all to recognize the milestone.

It is hard to believe that at eighty she was able to execute the daily tasks she set for herself. She told her diary that she seemed to be running out of energy, yet at the same time she had a frenzy of ideas that constantly kept her in action. September of her eightieth year was a great time for outside work on the house. She painted and mounted more cutout wood embellishments for the roof, including wooden triangles for a five-color pole and fish on a pole. While she was up on the roof attaching new parts, she heard "a little kid out on the road yelling to mother—"Is she a witch?" It was a frequent occurrence.

Mary on Lake Michigan, 2001; video clip.

Mary contemplated her age and vulnerability. "My eightieth year in this world is inviting me to take all kinds of precautions. If, for instance, I should happen to be so thoughtless as to have a stroke, my dog Tinker might get hungry and thirsty before anyone noticed his plight . . . with me unable to move. So, now I have buckets of dry dog food and buckets of wet water at strategic places around the house—to keep him alive just in case. I am relying also on the *Milwaukee Journals* to gradually fill up the space between the gates and the house—and then I am sure someone would notice something was wrong."

During that winter, Mary experienced another surge of energy and ideas. She started a carved driftwood snake for the dining room and a long driftwood plank with Christmas ornaments positioned in irregularly spaced holes for the living room, and she split bamboo poles into small strips so she could fit them together for small sculptures.

Although Mary continued her creative work, she slowed considerably. Bouts of ill health, along with mounting fears, anxiety, and periods of depression, nagged at her. Her last diary entry on September 13, 1995, reads, "Continue dizzy. Called J. Willetts—he came over—helped me over the hump."

Mary experienced good and bad days. Her health and spirits lifted and plummeted, but overall she recognized that she was failing. Stays in the hospital for actual and imagined maladies were followed by evaluations and medication changes. Mary knew she no longer was able to live alone. Friends and neighbors Sally Mollomo and Tommy Willetts, John's son, helped arrange for caregivers Maria Rodriguez and Vicki Preslan, who eventually became her much-needed helpers, alternating three-day shifts. Adjusting to the presence of others in her beloved, private space was a painful and difficult transition for Mary. But the two women, kind and understanding, assisted her in maintaining her schedule, preparing meals, and taking over the chores of the household.

But Mary's drive to create did not let up. During her most alert hours of the day, she channeled her creative drive into abstract drawings. On eight-and-one-half-by-eleven-inch sheets of paper, she drew faces swirled within curving lines. After drawing several hundred, she omitted the faces, focusing on the repetitive, looping, and intertwined lines. She filled page after page, using a rainbow of felt markers, sometimes filling the spaces between the lines by rubbing in pastel crayon and chalk with her fingertips. When she finished one hundred of these, she slipped them into a brown envelope and created one hundred more until the next envelope was filled. Working at the drawings until shortly before her death, she

Untitled, c. 1996-2001; marker pen; 8½ x 11.

built a sizable stack of envelopes stuffed with the 3,150 drawings she had completed between 1996 and 2001.

Sitting on her bed with a drawing pad resting on her knees, Mary drew nearly every day, surrounded by reminders of her long life's journey. More in touch with the past than the present, she was content to exercise her creativity in this way, adhering to a schedule, to a pattern that had made her life meaningful.

Her dainty infant christening gown was pinned to the wall above her head, her prize-winning model airplane twirled from the ceiling. At the foot of her bed was draped an enormous Nazi flag made of black and red wool—too warm and too useful to discard. (Mary had salvaged this from John Willetts' garage. He had gotten it in Germany where he had served during the war.)

Mary wrote, "My model plane had been stored for years in a hat box—and then for more years it had been hung at the end of a long dark closet. With great pleasure it was rescued—the white rice paper yellow, shredded with age—the balsa wood propeller missing. It now turns in slow lazy circles on a thread from the ceiling of my bedroom in the warm air from the furnace ventilators. Wall space is scarce around here—my oil paintings got there first. But there has been plenty of ceiling space left for my mobiles made out of split

bamboo and glue and colored cardboard, and still lots of room left on the roof for wood sculpture shaped by my band saw." Edging strips from computer paper threaded between drinking straws swung gaily across the ceiling. In this room, nearly to the end of her life, Mary pursued creating, content with her lot.

In one of her last mimeographed letters to friends, from December 1995, Mary wrote, "Have a large number of unfinished oil paintings that need attention, but have recently become involved in some watercolor, ink, and chalk compositions that are giving me great pleasure." Mary had grown forgetful, and during frequent visits from Ros Couture, her longtime friend, the two would look at the "compositions" (drawings) over and over. Mary was proud of the great number she had made and wanted Ros to see them still one more time.

Caregivers Maria and Vicki adjusted to Mary's ways, and she eventually trusted and depended on them. They did their best to help her pass her days with ease. In the late fall of 2001, as workmen repaired the roof (a few years earlier Mary would have been doing it herself), Vicki observed that Mary was failing. She weakened and would stumble. She couldn't walk upstairs. She lost interest in eating and, most telling, she stopped drawing.

Untitled, c. 1996-2001; marker pen and watercolor; 8½ x 11.

Mary sketching in her bed, 2000; video clip.
Self portrait, c. 1933-1935; pencil.

Thoughtfully, her caregivers positioned a hospital bed in the center of the living room and removed the protective grate she had once attached to the east picture window. Although she slept many hours, while she was awake, Vicki and Maria would raise up the bed so she could gaze at her favorite view, Lake Michigan. She had never tired of watching this soothing and magnificent sight. The constantly changing moods and hues—turquoise, brown, pale green, blue-green—and the red morning sun sliding up from the horizon gave her comfort.

Sometimes Vicki opened the colored glass windows on the south side of the house so Mary could hear the familiar and calming sounds of the waves. Between the house and the lake she could see her concrete sculptures—*Palace Fountain* and *Ruins*—and could remember her pleasure in hauling wagon loads of stones and sand from the beach to create them. She talked about her father, recalling how they had built the concrete and stone posts when the family first purchased the property. She reminisced about her long-ago childhood—the exploring, inventing, and mischief that had filled her days.

Ros often stopped by, and Mary would want to chat about the good times they had shared. One day, when Mary was fading in and out of consciousness, she asked, "Ros, do we have everything taken care of?" Ros reassured Mary, "Yes honey, everything is signed, sealed, and delivered." Ros had encouraged and advised Mary behind the scenes throughout the agreement process with the Kohler Foundation. This matter was still on Mary's mind, but with Ros's reassurance, she closed her eyes and could rest peacefully.

Here in the house where she had lived most of her life, in the place and space she had defined in her unique and idiosyncratic manner from her pure creative self, she lived out her last days. All her creations, her memories and photo albums, sketchbooks and travel journals—all the evidence of her life in art surrounded her, here in her "best beloved home." "Most of the fun here was in doing it," Mary once wrote. And as she lay there, surrounded by her art, she must have recalled the years of fun she had experienced in its creation. Mary was content and gratified. She was free to leave, knowing the fate and future of her accomplishments were safe and secure.

Neighbors stopped in to see her, and Ros visited every few days to sit with her and offer reassurance as she made the transition. Slowly Mary let go of the world and the world she had created.

She was not afraid of dying. According to Vicki, "Her mind had decided that this was it, this was the time." She struggled but then peacefully slipped into a coma, content with one long last look at the clear water of the lake as it washed up on her beach.

Mary Nohl died on December 22, 2001, at the age of eighty-seven. Maria Rodriguez, who had been at the home caring for Mary, summoned Vicki Preslan, and friend and neighbor John Willetts arrived soon after. Stepping to Mary's bed, he kissed her on the forehead, saying, "Goodbye, my lady."

Mary's longtime friend Ros Couture carried out Mary's wish to be cremated, then organized a memorial service for January 12, 2002, at Forest Home Cemetery, honoring her request that there be no religious rituals. Graced with fountains, trees, and roads winding past English gardens, the historic cemetery is a Milwaukee landmark, the final resting place for the city's founding fathers, mayors, military leaders, and captains of industry, from beer barons to insurance magnates to motorcycle manufacturers. Included is the grave of philanthropist Frederick Layton, who donated his extensive art collection to the city through his Layton Art Gallery, where Mary once showed her silver work.

Mary had contemplated her own funeral years earlier after watching the televised funeral procession of Robert Kennedy. "When I think of the size *my* funeral will be—bothers me a little," she wrote in June 1968.

She was right; although notice of the memorial service appeared in two newspaper articles about her, the group attending her service was meager on that cold and foggy morning. Yet the occasion was appropriate for the life she had led, combining both quirky and conventional elements.

The historic Gothic chapel, with its reddish stone exterior, beautiful leaded glass windows, and warm wood furnishings, provided a sedate setting for a scene both zany and poignant. A flickering

Walkway between the Hall of the Mountain King *towers, c.1960-1998.*

video monitor, its volume too low to hear, was positioned at center, in place of an altar. A video of Mary discussing her life and work provided the prelude to the memorial service. Clippings and photographs about her and her art covered a bulletin board and table.

With the sparse handful of people scattered here and there on the polished pews, Ros conducted the service. Humorous recollections brought forth chuckles that brightened the dark, cold chapel. Ros told about a camping adventure with Mary in Upper Michigan, laughing about how their air mattresses had instantly deflated in the middle of the night. She told how she had valued their many years of friendship. A young woman expressed her thanks to Mary for encouragement to continue her art. A few others offered brief remembrances of Mary that typified her commitment to her art and her eccentric ways.

In addition to Ros and a few friends, attending were Mary's lawyer from her father's former firm; a spokesperson from the Greater Milwaukee Foundation, recipient of her fortune; and a member of the University of Wisconsin-Milwaukee art department, which had received grants from the Mary L. Nohl Fund to create a gallery in her name. Representatives of the Kohler Foundation to which Mary bequeathed her house and art also were present, as were Mary's kindly caregivers, Vicki Preslan and Maria Rodriguez.

Following the memorial remarks, the small group filed past historic gravestones—bearing such prominent names as Bradley, Allis, Davidson, Schlitz, Blatz, and Pabst—to the Nohl family plot. Here Mary came to join Emma, Leo, Max, Eleanor, and the infant Frederick in the family plot. A burly workman driving a miniature forklift emerged from the fog, delivering a small cask holding the urn of ashes to the gravesite. Drawing aside a square of intensely green Astroturf—a material Mary would have loved—he swiftly lowered the remains into the hole. Ros said a few final words and then Vicki, whose ongoing argument with Mary over the question of God's existence had kept them both very entertained, stepped forward to speak.

"Let's all hold hands and say the Our Father," she said brightly, grasping the nearest hands and having the last say in their argument.

And who could resist that invitation? The prayer said and hands released, the huddle of figures said their goodbyes, dispersing into the cold grayness to meet again for lunch and martinis at The Chancery restaurant.

"Mary was her own person, she was very different," Ros would later tell a reporter from the *Milwaukee Journal Sentinel*. "She did not run in the same channels as other people. She did her art the way she wanted it, and didn't care what anyone thought, and never cared

Sketches of cemeteries from Mary's travel notebooks, c. 1937-1998.

about showing. . . . She kept creating from morning to night, all the years I knew her. She had a childlike quality about her, a naiveté."

Emblematic of Mary's creative and unconventional life was the winning model plane she had built in her childhood. Still, who could have predicted that her inventiveness as a child would persist and manifest itself in the total transformation of the family property? Not likely her father, although he nourished Mary's imagination, determination, and ingenuity. Nor likely anyone who knew about her many opportunities and privileged circumstances. The significance of her childhood is captured in a passage from *The Manifesto of Surrealism* written by André Breton, an artist Mary admired in her student years: "Childhood comes closest to one's real life—childhood, where everything conspires to bring about the effective, risk-free possession of oneself."

Mary carved out her own anomalous life path, realizing in her idiosyncratic way her full potential as an artist. She moved beyond the traditional role of art teacher to found her own pottery studio. Following its demise, she worked on her lakeshore house and yard, scavenging materials and incorporating every technique imaginable. Disciplined and driven, her decades of concentrated and creative efforts produced from her "best beloved home" a cherished feature of the Milwaukee landscape. While her work was solitary, the response from visitors encouraged and motivated her further. The haunting environment she created spoke to young and old. Even today anyone who peers through her fence into the world she created is touched by its power and magic.

With her fierce commitment to create, Mary Nohl left her mark—inside and outside. As Mary herself put it, "Creativity in every direction is my goal."

"Keep getting more ideas—all of which I have to try."

Mary's tombstone at Forest Home.

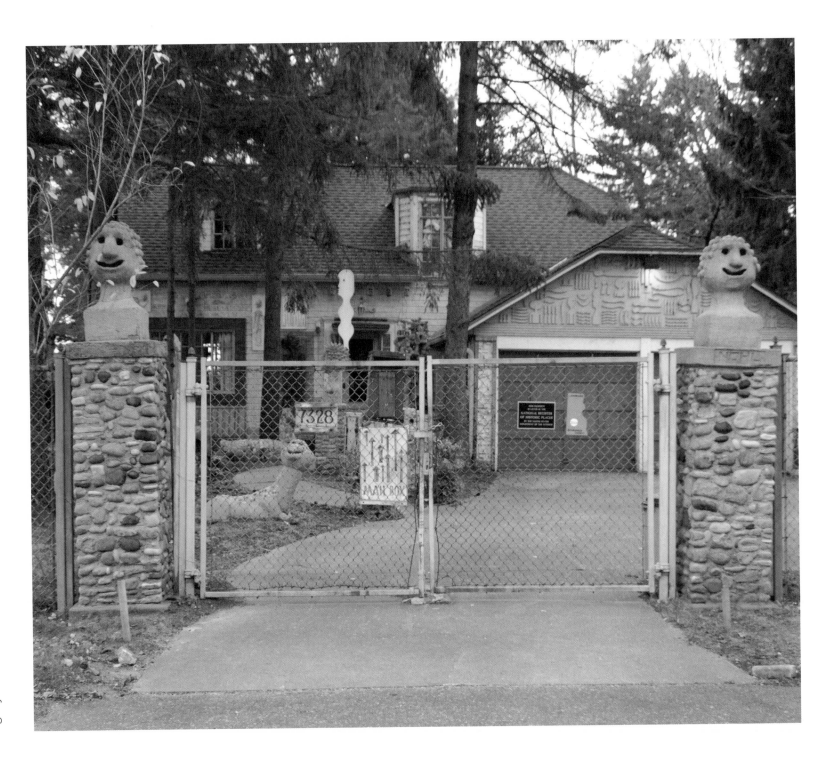

9
Legacy

"I never ran out of ideas."

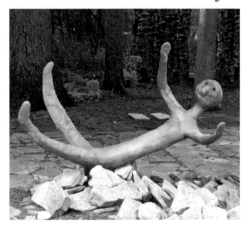

With determination, drive, and a lifelong commitment to creating, Mary Nohl transformed her house and yard on Beach Drive into a magical site. Following her death, this inimitable landmark became her greatest gift to the Milwaukee community, and has received much-deserved recognition. The site is listed on the National Register for Historic Places and the Wisconsin Registry of Historic Places, and was nominated as a Milwaukee County Landmark. In 2005, the Wisconsin Preservation Trust designated the site as one of the ten most endangered properties in Wisconsin. Mary was also posthumously awarded the Wisconsin Visual Art Lifetime Achievement Award in 2008.

The haunting environment of art that evolved from Mary's solitary and singular efforts challenges what is expected in a well-manicured, suburban neighborhood, and pushes the limits of what can be tolerated. The attention Mary's site attracted created controversy in the neighborhood during her lifetime, and even in the years since her death, her work continues to provoke. The Wisconsin Preservation Trust has noted that an active minority of Fox Point residents has aggressively fought to make the site disappear. Some of the neighbors consider it an eyesore, while others believe it attracts unwanted traffic to the exclusive beachfront neighborhood.

The Kohler Foundation, now the owner of Mary's property, downplays the objections, contending that "many of the passersby are simply there to see an unobstructed view of Lake Michigan's shoreline," one of the few along the North Shore of Milwaukee. Strongly supportive of maintaining the property, the Wisconsin Trust for Historic Preservation warns: "Without support from within and outside of the Village of Fox Point, the Kohler Foundation will be forced to develop an exit strategy and the art and home will have to be removed from the site."

A unique treasure for the larger community, Mary's work is deeply rooted both spiritually and physically to the place where she created it. Each piece is integral to the whole, created in relationship to Lake Michigan—the source of her inspiration and materials—and to the surrounding works, the house, and the land. The Trust believes that "The dismantling of Mary Nohl's site would be a loss to the greater community of Milwaukee, the State of Wisconsin and beyond." At the time of this writing, there is no resolution to the controversy. The fate of Mary Nohl's property is unknown.

Although not everyone appreciates Mary Nohl's art, certainly everyone in Milwaukee is enriched by another of her gifts—her donation of $11.3 million to the Greater Milwaukee Foundation. With this gift, she fulfilled her desire to "do some large project doing good in Milwaukee." Area art organizations and, in turn, the community at large benefit by the many art opportunities made possible by her contribution. The Mary L. Nohl Fund assists organizations in providing arts for children, art centers, and individual artists, at a time when many other resources for school and community art programs have been reduced or discontinued. The fund also makes annual scholarship grants to the Milwaukee Institute of Art and Design and provides annual grants to the Boys and Girls Clubs of Greater Milwaukee for visual arts projects and activities.

"This is the warlock, I want you. I love your pad. Your secret [sic] admirer."

"How I wish I lived near you. I am sure we would be friends."

"Dear Mary Nohl, I loved all your carvings. Too bad you could not come out. I think you are a good recycler."

"I've heard from people that you are a witch. I am heavily into SA-TAN. . . . I would like you to read my bible that I have been working on."

"Will you please come out of your house at 8 p.m. on Saturday so we can talk to you about your nice art work. Thank you."

"We are the women who left the tooth at your house on our last visit through town."

"You may not know this, but some people call you a witch, but we may be the only ones who see you as a regular person. We're sorry to hear that all these kids terrorize you. That's the most awful thing a person can do to a nice artist like you."

A small sampling of her fan mail, 1960-1998.

"The Mary Nohl Fund has been a wonderful asset," says Jim Marks, vice president and director of grant programs at the Greater Milwaukee Foundation. "The Fund has supported . . . visual arts projects throughout the city . . . particularly in Milwaukee's central city neighborhoods. . . . The fund is also the Milwaukee area's most significant source of grants for individual artists, both established and emerging. Having made more than $2.7 million in grants from 2002 to 2007, the Mary L. Nohl Fund has become a leading supporter of the arts in Milwaukee."

In addition to the local attention, Mary's work has generated positive recognition nationally and abroad. Articles about Mary and her property have been featured in numerous newspapers and magazines, including *Raw Vision*, a scholarly art periodical. In 1999 Taschen Publishing of Bonn, Germany, sent a standard release form to Mary for permission to use photographs of her work in a survey of the one hundred best sculptural environments in the world. Printed in German, French, and English and titled *Fantasy World*, this coffee-table book includes Ferdinand Cheval's extensive environmental work *Palais Ideal* in France and Simon Rodia's remarkable Watts Towers in Los Angeles, sites grander and even more complex than her own. John Maizels, the author, wrote, "Though she has suffered over the years from local prejudice and vandalism, Mary Nohl has continued with her work undaunted."

While vandalism was one response to Mary's art, a far greater segment of the public was attracted to her art in positive ways. Students, children, professors, priests, artists, and people from all walks of life encouraged Mary with their notes and cards of praise and gratitude. They left messages in her red, hand-constructed mailbox, sometimes including a rose, cookies, or their own drawings. Written on school notebook paper, business cards, paper napkins, grocery store receipts, and even pages from the *I Ching*, the messages were testimony of their appreciation and love.

Many, especially the young, felt they were kindred spirits with Mary, an artist they had never seen yet yearned to know in person. They asked her to come outside to talk or call the phone numbers they left for her. They asked her to view their artwork and even sought her advice on personal matters: "You seem to be a person who has great strength," wrote one admirer. "I was hoping you could give me some advice when dealing with people."

Sometimes the notes waxed philosophical, as in this soul-searching poem:

> I love your house.
> I come to look at it when I am in search of peace.
> Can I ask you, though,
> How do you manage to exist
> In this world that's not ours?

And sometimes the letters were sweet and playful, even comical:

> "As we were gawking last night, the nature of your creations had aroused our curiosity to the point where the outside of the fence had become an intolerable position. We are sorry for invading your privacy, but how can you blame us? We're only human, you know. I suppose the inside of your home is even more interesting than the outside. . . . I hope you continue creating and if you really are a witch (that's what we've heard) I hope that if you see a tall guy with a crutch, a blonde-haired girl and a guy who looks like a gypsy peeking in your fence, you won't turn us into toads. . . ."

Mary cherished these messages, and read them over and over. Heartfelt and uplifting, they reversed some of the harm that had been done to her property, and made her feel that her lifelong work was indeed worthwhile.

Today her house and yard stand as a monument to her creative spirit, an inspiration that lives on. Through her life's work—and her generosity—Mary Nohl continues to touch people near and far and surely will shape the artistic paths of generations to come.

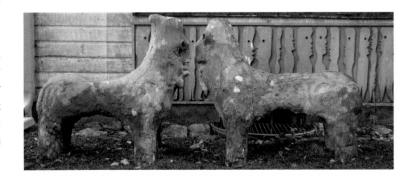

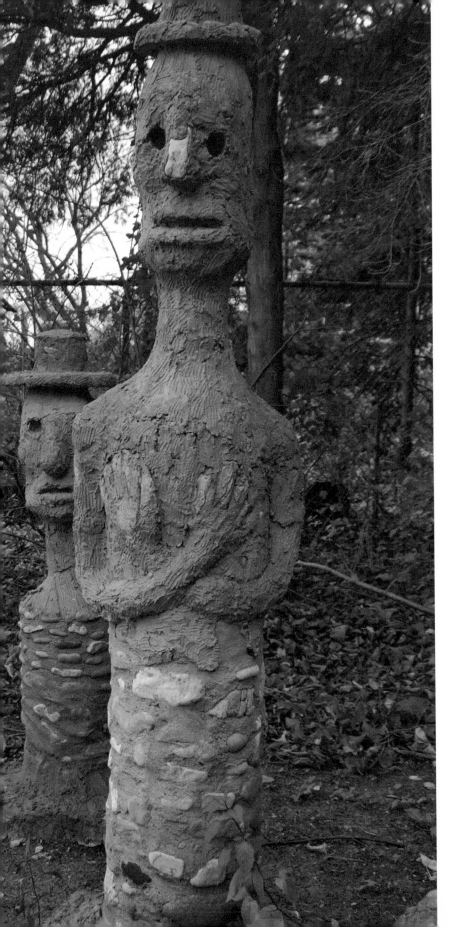

References

In-person Interviews and Unpublished Sources

Bianco, Jane C. 2004. *Mary Nohl: Her Best Beloved Home*. Masters thesis, University of Wisconsin.

Brabender, Amy. 2006. *A Self-Made World: Place, Memory, and Magic in the House and Garden of Mary Nohl*. Masters thesis, Bard College.

Brehmer, Debra L. 1995. *Handcrafted Universe of Mary Nohl*. Masters thesis, University of Wisconsin–Milwaukee.

Couture, Rosalind. September 2004 and December 2007. Personal interviews.

Mollomo, Sally. March 2007. Personal interviews.

Mary Nohl Archive. Kohler Foundation. Kohler, Wisconsin, Semiannual letters, diaries, sketchbooks, idea books, travel books, photos, scrapbooks, letters, drawings, Max Nohl's papers.

Nohl, Mary. 1989-2000. Conversations with the author.

Preslan, Vicki. September 2006, 2007. Personal interview with Barbara Manger and Janine Smith.

Willetts, John. Summer 2005, 2007. Personal interviews with Barbara Manger and Janine Smith.

Published Sources

Anderson, Jan. March 6, 1979. "Nights of vandalism haunt Fox Point home." *The Milwaukee Journal*.

Auer, James. December 24, 2001. "Nohl turned garden into gallery." Obituary, *Milwaukee Journal Sentinel*.

Binns, Charles Fergus. 1910. *The Potter's Craft: A Practical Guide for the Studio and Workshop*. New York: D. Van Nostrand Company.

Bird, Mimi. August 21, 1986. "Figuring her out: A look at Beach Dr.'s Mary Nohl." *The Herald*, CNI Newspapers, New Berlin, Wisconsin.

Brehmer, Debra. October 1997. "One corner of the world." *Milwaukee Magazine*.

Breton, Andre. 1924. *The Manifesto of Surrealism*. Available from http://www.scribd.com/doc/186128/manifesto-ofsurrealism-andre-breton

Cardinal, Roger. 1972. *Outsider Art*. New York: Praeger Publishers.

Danoff, Michael. 1975. "Mary Nohl, Sophisticated naïve." *Midwest Art* (February): 1:12. February 1975.

Forest Home Cemetery brochure. *Where Memories Stand the Test of Time*. Milwaukee, Wisconsin.

Gardner, Helen. 1991. *Art through the Ages*. Orlando, Florida: Harcourt Brace and Company.

Gardner, Helen. 1921. *Understanding the Arts*. New York: Harcourt Brace and Company.

Greater Milwaukee Foundation. February 2003. "9.6 million gift will support visual arts." *Greater Milwaukee Foundation Newsletter*.

Gould, Whitney. February 19, 2007. "Artist's 'wonder house' amazes." *Milwaukee Journal Sentinel*.

Gould, Whitney. February 26, 2007. "Artist's house stirs critics, but opinions aren't always neighborly." *Milwaukee Journal Sentinel*.

Jensen, Dean. September 27, 1973. "Sculptor fights intruders with barbed wire, dogs." *The Milwaukee Journal*.

Hughes, Robert. 1981. *The Shock of the New*. New York: Alfred A. Knopf.

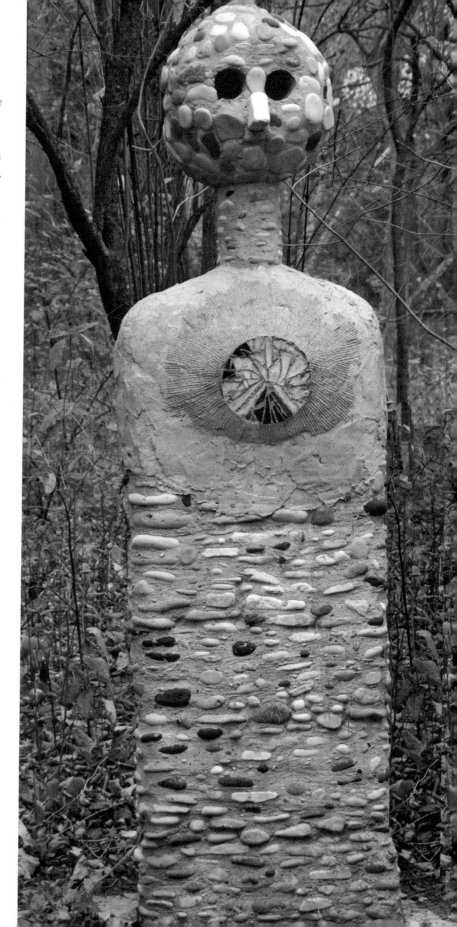

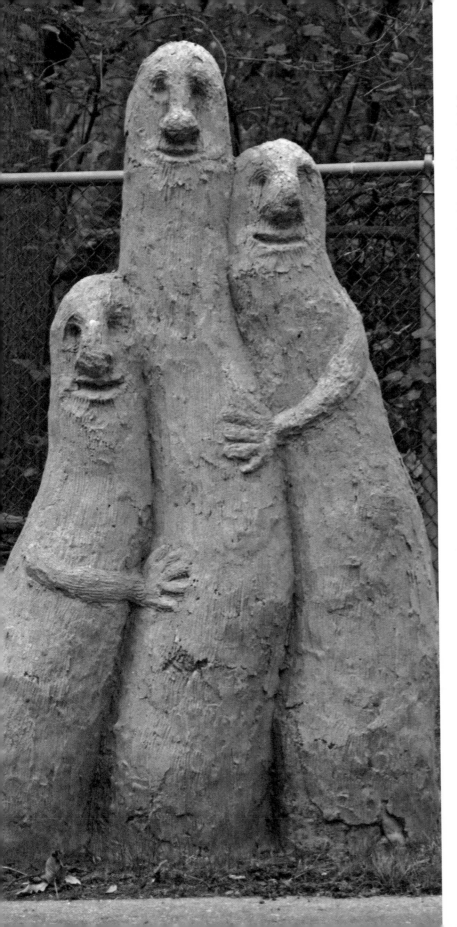

Leach, Bernard. 1945. *A Potter's Book*. 2nd ed. London: Faber and Faber.

Maizels, John. 1999. *Fantasy Worlds*. Ed. Angelica Taschen. Bonn: VG Bild-Kunst.

Manley, Roger and Mark Sloan. 2005. *Self-Made Worlds: Visionary Folk Art Environments*. New York: Aperture.

Masilow, Marlene. March 1995. "The road less traveled: Mary Nohl's Art Transcends the Rumors That Surround Her." *Northshore Lifestyle*, Bayside, Wisconsin.

Milwaukee University School Year Book. 1930. pp. 13, 17, 19, 33, 37.

Ozenfant, Amédée. 1931. *Foundations of Modern Art*. Reprint, New York: Dover Publications, 1952.

"One creative life." 1991. Alumni Profiles, *USM Today*, Milwaukee, Wisconsin (Summer): 29: 4.

"Pottery business prospers for one woman concern." December 2, 1951. *The Milwaukee Journal*.

Rhode, Marie. January 23, 2002. "Lines drawn over artist Nohl's home." *Milwaukee Journal Sentinel*.

Rhode, Marie. February 27, 2005. "Artist's legacy lingers." *Milwaukee Journal Sentinel*.

Roberts, Fred M. May 1960. "Tribute to a diving pioneer." *Skin Diver*.

Slota, Debbie. March 10, 1995. "Odd art attracts onlookers." *Pioneer Outlook*: 47:5.

Stingl, Jim. January 11, 2002. "Pilgrimage to 'witch's house' was a rite of passage." *Milwaukee Journal Sentinel*.

Stone, Lisa, and Jim Zanzi. 1993. *Sacred Spaces and Other Places: A Guide to Grottos and Sculptural Environments in the Upper Midwest*. Chicago: School of the Art Institute of Chicago Press.

"Strong design is credo of versatile Mary Nohl." August 16, 1953. Publication unknown, article in Mary Nohl Archive, Kohler, Wisconsin.

"Mary Nohl, 13, beats boys in plane contest; Girl wins two classes with model in city tourney." March 25, 1928. *The Wisconsin News.*

Umberger, Leslie. 2007. *Sublime Spaces and Visionary Worlds.* Princeton Architectural Press, New York, in association with the John Michael Kohler Arts Center, Sheboygan, Wisconsin.

Wisconsin Trust for Historic Preservation. 10 most endangered properties program. Available from http://www.wthp.org/10 most.htm.

www.kohlerfoundation.org/new_NohlSite.html.

John Michael Kohler Arts Center Credits

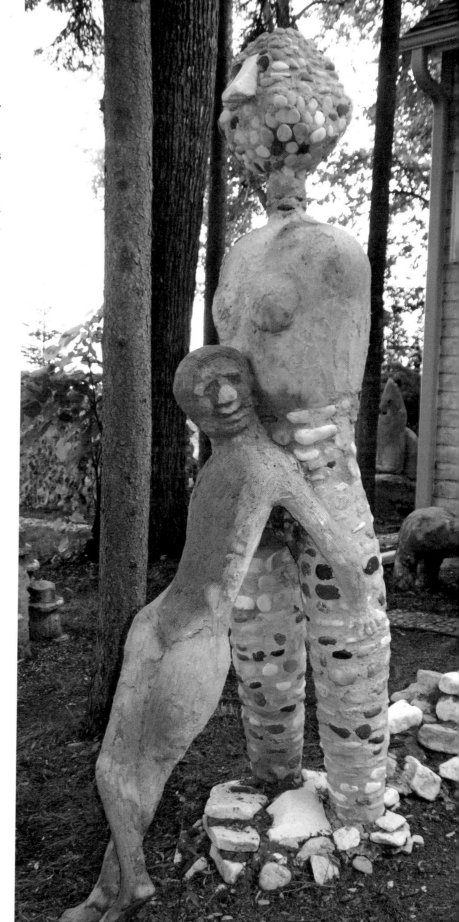

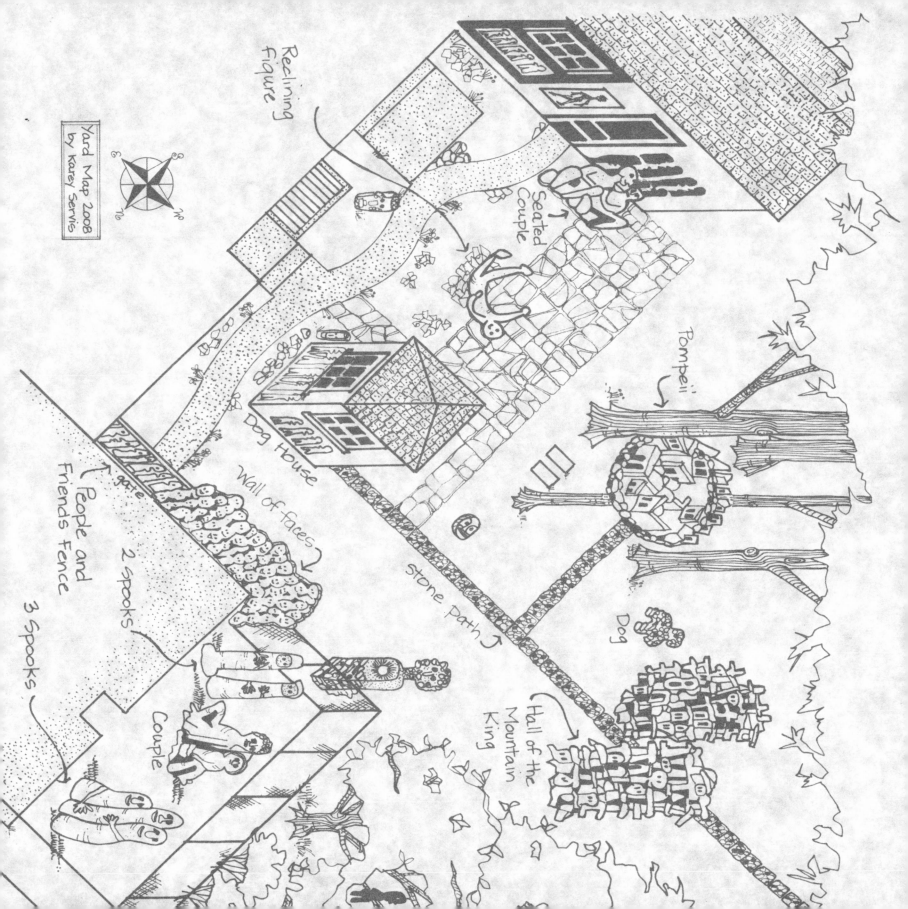

Yard Map 2008
by Karey Servis

Reclining Figure

Seated Couple

Pompeii

Dog House

Wall of faces

gate

People and Friends Fence

2 Spooks

3 Spooks

Couple

Stone Path

Dog

Hall of the Mountain King